Fashion & Advertising

RotoVision

A RotoVision Book

Published and distributed by RotoVision SA
Route Suisse 9
CH-1295 Mies
Switzerland

RotoVision SA
Sales and Editorial Office
Sheridan House, 114 Western Road
Hove BN3 1DD, UK

Tel: +44 (0)1273 72 72 68
Fax: +44 (0)1273 72 72 69
www.rotovision.com

10 9 8 7 6 5 4 3 2

ISBN: 978-2-940378-24-1

Art Director: Tony Seddon
Design: JCLanaway
Photographers' portraits: Immo Klink
Lighting diagrams: Rob Brandt, based on sketches by
Eddie Otchere and Magdalene Keaney

Reprographics in Singapore by ProVision Pte.
Tel: +65 6334 7720
Fax: +65 6334 7721

Printed in Singapore by Star Standard (Pte) Ltd.

Dedicated to James Keaney, the first photographer in my life, my dad.

Fashion &
Advertising

Magdalene Keaney

Contents

Introduction

So what does it take to make it as an advertising or fashion photographer? What this workshop-oriented book shows is that there is no single or static answer. Talent, determination, vision, charisma, hard work and a healthy dose of plain good luck are surely elements, but the measures and mix are much less dependable or prescribed. Trying to pin these down or emulate success on the basis of a particular example is problematic because what is sought after in contemporary image-making can shift and change so quickly. If the pathway is unclear, so is the destination. What exactly is success? Is it creative freedom, or longevity of career? Does it require an exhibition at a prestigious gallery or a publishing deal? Or maybe just covering the rent? As Jason Evans points out, "You don't need a chauffeur and a cappuccino to make good fashion," which is probably just as well when you're starting out.

Not that doing the driving, carrying equipment, or making tea is a bad thing. While the technical training of the photographers I have talked to ranges from self-taught to degree-level qualifications, with the exception of just one, they all began their careers as assistants. Alexi Lubomirski describes his four years working for Mario Testino as "Priceless. To see how he had conquered the photography world was very inspiring. It was a 24-hour job, seven days a week. We did everything." Warren Du Preez assisted photographer Thomas Krygier and gained confidence in his creative process in addition to technical skills. "I learnt the concept of capturing images and imagination. It gave me the faith to pursue what I believed in the sense of making images. My assisting helped open some doors and get momentum." Elaine Constantine, Jason Evans, and Sølve Sundsbø all formerly worked for Nick Knight. (Leading New York–based photographer Craig McDean was also a previous assistant to Knight.) Evans has described his experience as "styling and snapping. Deconstructing on the job with juvenile contention and disregard for the golden rules. My agenda was to learn

from Nick Knight and Simon Foxton [the stylist].[1] While Constantine only assisted for a relatively short time before putting her portfolio together and going it on her own, Sundsbø worked with Knight for a number of years. He maintains, "Everything that I do now is colored by that experience of being put in someone's world so intensely as I was as an assistant. The work I do now is still influenced by those years."

While the history of the fashion photograph dates back to the late nineteenth century, it was not until improvements in printing techniques around the 1920s that magazines such as *Vogue* and *Vanity Fair* moved away from graphic illustration and began engaging photographers to produce portrait and fashion photographs for the then black-and-white and not-at-all glossy pages of their publications. Significantly, looking back on these early images now, it is clear that the imperative of beauty or style—albeit a changing aesthetic—has remained crucial to the commercial viability of the image. Says Sundsbø, "One of the most important things you learn is that you can have a good idea but, at the end of the day, the person has to look amazing. No matter how great the fashion is, if the person looks terrible you are unemployable. No one will hire a photographer who can't make a person look great."

At the beginning of the twenty-first century, advances in film stocks and papers; printing and postproduction techniques; the Internet; and, most significantly, digital technologies eradicating the need for film, have all resulted in massive changes to the way fashion and advertising photography is commissioned and produced. This evolution and revolution, which began with Photoshop in the early 1990s, continues, but contrary to widespread assumptions, the analogue process retains relevance in commercial and editorial practice. Certainly, most of the photographers featured in this book still work with Polaroid and film and indeed, the majority of stories reproduced here were shot

1 Jason Evans, *W'Happen*, produced to accompany the exhibition Real Life?, Shoreditch Biennale, London, 1998.

…alogue. Digital postproduction, however, has emerged as a more mandatory tool. Gone are the days when John ...kehurst's groundbreaking Egg story would be run without being retouched, as it was in style magazine *The Face* in 1993. Even natural light proponent Paul Wetherell observes that while the retouching on his *Self Service* story was minimal, "maybe smoothing slight lines on the face or neck … nowadays, yes, you do use digital. Magazines expect and want it." A one-to-one relationship with a retoucher who understands a photographer's aesthetic preferences has emerged as one of the most important dynamics in contemporary editorial image-making.

That relationships are crucial to establishing and maintaining a successful career in fashion and advertising has been emphasized by each interview in this book. As Warren Du Preez astutely notes, "it's not getting an agent that will change your life, it's your relationships that will change your professional life: your relationships with art directors, magazines, and clients." This global industry with creative centers in New York, London, and Paris is remarkably compact. Once you start noticing photography credits in magazines, it soon becomes apparent that there is a surprisingly small number of photographers, stylists, hair and makeup artists all working for a similarly small number of publications, in most cases represented in clusters by a limited number of well-established photographers' agents. It couldn't be put more clearly than by Toby McFarlan Pond. "No one wants to work with a difficult person … it's all about your reputation. People get to know what you do. It's an incredibly competitive world and it's really subjective. If a job goes badly, at the end of the day the responsibility is with the photographer."

The importance of reputation in getting the big jobs is made clear by the fact that, in recent seasons, just a handful of big-name photographers—Steven Meisel; Mario Testino; David Sims; Craig McDean; Inez van Lamsweerde and Vinoodh Matadin; and Mert Alas and Marcus Piggott— have between them shot the majority of campaigns for leading design houses and brands, including Balenciaga, Calvin Klein, Dolce & Gabbana, Prada, Louis Vuitton, Valentino, Gap, Jil Sander, and Miu Miu. Of these Meisel, McDean, and Inez and Vinoodh are represented by Art and Commerce, a high-profile New York–based agent; while Testino, Sims, and Mert and Marcus are represented by Art Partner, founded in 1992 by Mario's brother Giovanni Testino. They have all contributed to the traditionally dominant Condé Nast publications as well as a selection of the relatively new seasonal magazines which, at best, are brilliantly conceptualized and executed fashion/art objects in themselves.[2] These magazines speak to an already engaged, style-literate audience. It is not unusual for an issue to contain several dozen pages of main fashion by a single photographer as part of a mandate to secure the most highly sought-after creative teams and present lavish portfolios as the trump card of the publication. Their emergence is an important defining marker of fashion and advertising photography now; moving away from the content and presentation of the more raw style magazines of the early 1990s, epitomized by *The Face*, *i-D*, and *Dazed & Confused*. While *The Face* is now sadly defunct, *i-D* continues to maintain creative credibility despite increasing pressure for fashion credits and luxury brand advertising. *Dazed & Confused* has also continued along a more experimental trajectory, still commissioning relatively unknown or newly established photographers and launching sister title *Another Magazine* to cater to the sophisticated, high-end, high-fashion market. *Tank*, though newer, maintains a similar "braver attitude toward new talent." Founding editor Masoud Golsorkhi articulates its function as a research and development platform for fashion photography.[3]

I have always believed that a photographer's name is important. Would you know Annie Leibovitz or David Bailey if they pointed a camera at you in the street? It's ironic, or

2 Including *V* and *Big* (US); *Pop, Arena Homme Plus, GQ Style* and *10* (UK); *Purple* and *032C* (Germany); *Self Service* (France); and *Doing Bird* (Australia).

3 Interview with Masoud Golsorkhi, *Metro*, June 29 2006, p 17.

maybe clever, that we instantly recognize the faces and products they popularize, but rarely know a photographer by anything other than their picture credit. Sometimes, by virtue of a particularly long or successful working relationship, a photographer's name becomes more specifically associated with a particular brand or personality: Cecil Beaton and Audrey Hepburn in the 1960s, Guy Bourdin and Charles Jourdan shoes in the 1970s, Herb Ritts and Madonna in the 1980s, Mario Testino and Diana Princess of Wales in the 1990s, Nick Knight and Dior in the 2000s. Knight has commented of his relationship with Dior that "John [Galliano] and I have constructed a language we speak when we speak Dior. It starts, for example, with a discussion about the lens we'll use and what it will see. I take it seriously because my images get global exposure. The Dior image is omnipresent."[4]

Yet there is a contradiction in all this singularity. A name supplies an author's identity, but fashion and advertising photography involves a creative collaboration between designers, art directors, hair and makeup artists, models, printers, and retouchers. A good team is as crucial to the success of an image as the right camera, lighting, and exposure. Joe McKenna, one of the most influential and creative figures in the industry, says, "I'm a big believer in teams. I feel a lot of the big photographers are letting themselves down by not working with very good teams anymore."[5] Fashion and advertising are certainly pluralistic practices and undoubtedly chronicle something of the tastes of the time during which they were produced. To a certain extent this makes such images derivative, but in many cases this is also what gives a story its particular strength or poignancy. Fashion photographers often gain inspiration and ideas from what is happening around them: their friends, people they see on the street, in clubs, or bars; from the music they listen to. Such visual and cultural clues can be seen in the work of Alasdair McLellan, who started out by taking pictures of his friends in his hometown of Doncaster,

in the UK. The intimate and beautifully lit portraits from his youth, which he later compiled and used as his first portfolio, have remained a touchstone of his approach to editorial and commercial work, though he now shoots using top models around the globe. Shooting two separate covers and several stories for i-D's Youth issue (November 2006), his vision was described by the magazine as "a new and inspiring take on the theme of youth … threading the issue together from cover to cover … a project that defines the times." David Sims who, like peers Corinne Day and Elaine Constantine, managed to work his own aesthetic agenda into editorial and commercial photography in the 1990s, has explained that he was influenced by the renowned photographer Diane Arbus. However, the reference point for one of his most famous images, a model wearing only briefs, apart from a scarf over his face (taken for a Helmut Lang advertising campaign), was the video for The Clash's "Bank Robber."[6] Constantine has recalled, "When I started doing fashion for The Face it was a reaction against the typical girl in a studio looking off into the middle distance, pouting and trying to look interesting. It seemed like the total antithesis of everything I felt at that age. I wanted to represent the excitement of the things I'd done or experienced when I was 16."

Like many photographers, Richard Avedon found ideas and visual reference in paintings and the history of art. He himself has forcefully articulated this in relation to the work of Egon Schiele whose plain backgrounds, lightness, sexuality, and gesture can be seen in his 1970s pictures of Jean Shrimpton.[7] "… the first thing I saw in Schiele was a kind of marionette imagery… I realized that Schiele used apparently aberrant gestures to create a new language of expression that is much more convincing than the artist's traditional inventory of postures and poses…"

Avedon was probably the photographer most mentioned in conversation during my research for this book, and his work was on the bookshelves of almost all the photographers'

4 Robin Muir, "The Image Makers: Nick Knight," in British *Vogue*, September 2006, p 339.

5 Ashley Heath, "Joe McKenna," in *032c*, Winter 2006/7, p 142.

6 Murray Healy, "A Misspent Youth: A selection of the teenage portraits from the personal archive of David Sims," *Pop* magazine, Spring/Summer 2005, p 247.

7 Richard Avedon, "Borrowed Dogs," in *Richard Avedon Portraits*, The Metropolitan Museum of Art and Harry N. Abrams, New York, 2002.

studios I visited. Not surprisingly, he compiled and lived with an extensive collection of photographs, including significant bodies of work by Arbus, Irving Penn, and Peter Hujar, as well as historical images by Julia Margaret Cameron, Nadar, and Baron Adolf de Meyer.[8]

Avedon studied with Alexey Brodovitch at the famed Design Laboratory in New York. Brodovitch, who was the visionary art director of *Harper's Bazaar* from 1934 to 1958, was crucial to the understanding and reception of Avedon's imagery and is said to have warned him of "the demonology of the commercial photographer … a tedious and damaging little myth that photographers who make their money at their trade by flogging dresses and perfume can't be as serious as those whose who live on grants and the meager returns on books." Many contemporary photographers have resisted categorization into either the art or fashion camp.

Photographers such as Wolfgang Tillmans, Juergen Teller, and Inez van Lamsweerde and Vinoodh Matadin produce work for art galleries, fashion magazines, and record covers. For van Lamsweerde, "having the pages of magazines as well as the walls of galleries as an outlet keeps me independent. I feel lucky to choose the ideal venue for each idea… Both talk about the time we live in, both are multilayered and can be read on many different levels." Recently Tom Hunter became the first photographer to have a solo exhibition, Living in Hell and Other Stories, at London's National Gallery, and this was followed a month later by his first fashion story for British *Vogue*.[9] In a similar vein, photographer Dan Holdsworth maintains an art practice, and applies his distinctive approach to landscape photography to advertising jobs to help finance his personal projects and exhibitions.

While fashion photography is, for the most part, transitory— literally seasonal—it is, of course, possible to identify and discuss the characteristics, approaches, influences, and innovations of photographers whose careers have begun even within the last few years. My conversations with each of the photographers included in this book form the basis of a chapter dealing with a particular approach to working, such as using natural light, working in a studio, or pioneering the use of digital platforms. At the same time, none would be comfortable with this as the single limiting or defining character of their practice as image-makers. For example, Toby McFarlan Pond is undoubtedly one of the most accomplished and creative still-life photographers in the business, yet doesn't purely identify himself as such. "If you work in a commercial environment like I do, you are defined by what you do, but I don't really think of myself as just a still-life photographer… It wasn't that I chose still life. I was more into abstract imagery for record covers… I guess what I do is solve problems." Similarly, though Richard Bush has become well known in recent years for his work with beauty, he does not see himself exclusively in those terms. Yet most photographers would agree that creative exploration needs to be presented to prospective clients in the commercial market within a logical structure or framework. While each issue, each campaign, each season must celebrate change, movement, and newness, they also demand a degree of stability, enabling style or vision to be identifiable. Warren Du Preez, who has worked both as a commissioner and a creator, has observed that "People like you to have a consistency and are confused if you show portraits and fashion and still life together in your book."

In making this book I have interviewed a group of image-makers who I consider to be 10 of the best working today, covering a range of approaches and technical considerations. I have covered what is practical and instructive while at the same time recognizing that it is neither useful nor desirable to simply attempt to recreate or copy the work presented. Use your imagination. Make mistakes. Grab the opportunities and the connections your hard work and skill present you with, and run with them no matter how small they seem. Have fun, and as Brodovitch once famously and simply asked of Avedon, "AMAZE ME."[10]

Magdalene Keaney

8 *Eye of the Beholder: Richard Avedon Collection*, Pace/Macgill Gallery, New York, 30 August—16 September 2006.

9 Tom Hunter's Living in Hell and Other Stories was exhibited at the National Gallery, London, 7 December 2005—12 March 2006. His first fashion shoot for British *Vogue* was published in January 2006.

10 I was reminded of this brief by a project of the same title on SHOWstudio (see www.showstudio.com).

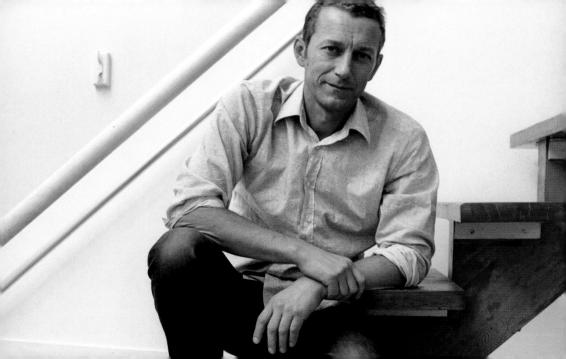

Nudes and body work

John Akehurst was propelled into a career as a photographer through his love of design and fashion, fostered at college. He worked in New York as a freelance assistant for Albert Watson, among others, before returning to London where he began his career shooting front pages for magazines. Akehurst's first major editorial break came with his now-iconic story, published in *The Face* in 1993 as The Egg. The still-startling abstraction in this story has remained central to his approach to photographing the body, with its emphasis on form and shape, influenced by such photographers as Bill Brandt, Edward Weston, and Irving Penn. Akehurst produces fashion, beauty, and nudes for clients including Cacharel, Gap, Nina Ricci perfume, Aveda, Kylie underwear, and Michael Kors. His editorial credits include British, French, Japanese, and Chinese *Vogue*; *The Face*; *Arena Homme Plus*; *Pop*; *Numéro*; *10*; *Big*; and *Self Service*.

It is hardly surprising that photographing the body is crucial to working as a photographer in fashion and advertising. Akehurst's story The Egg demonstrates that the nude can be conceptualized and presented in an editorial context through more than the most obvious explicit imagery. Though with certain precedents in the history of photography, the story was a radical break in approach to the nude, even for a style magazine such as *The Face* which was known for championing the work of young, cutting-edge photographers. It illustrates the importance of imagination, and of producing original work that you believe in rather than what you think others want to see.

The story made an immediate impact when it was published. As a result, Akehurst received commissions to apply his vision to the campaigns of high-profile clients for both fragrance and fashion. Not content to remain static, Akehurst developed a more sophisticated lighting system in his later work, which allowed him to reinterpret the concept. Shooting Liberty Ross for *Harper's Bazaar*, he adapted it to highlight aspects of character and personality. Photographing the nude stands as a particular photographic discipline with obvious commercial applications, such as underwear and swimwear, while also feeding into markets for fragrance, beauty products, and still life.

MK: I wanted to start by asking what your portfolio looks like. You shoot fashion and beauty as well as body and nude work for editorial and advertising, so there is a range of things going on, and I wondered how you presented that.

JA: I've got a number of books. Several in New York, several here in London. At one point I had separate books for fashion and beauty and body. In the end I didn't think it was beneficial, so we changed it to one book that's solely beauty, and the other ones are a mix. They go in sections with one thing leading into another. So you might start with fashion and go into beauty, and then body stuff at the end. I think of it all as photography. Of course, there is a different mental approach for shooting clothes than shooting the naked body, and a different set of disciplines again to shooting makeup and hair. I think now more and more photographers are working across beauty and fashion. Body imagery is something I do naturally, but it also helps broaden my market slightly. I enjoy shooting abstract nudes, but there is a limit to where your explorations can go, and then you have to try to take that into the commercial industry. I can't really function without the mix because each aspect feeds the other. I love clothes and I love pattern and texture. I really enjoy fashion design, which is how I got into the industry. When I was at college I met fashion students and it fired my imagination.

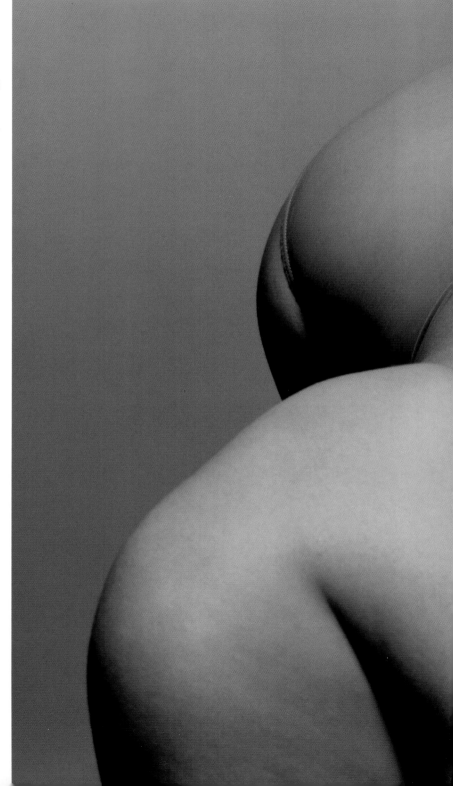

The Egg
Published in *The Face*,
August 1997.
I look through the camera in
terms of form. I'm looking for
something that works visually
and has depth.

12

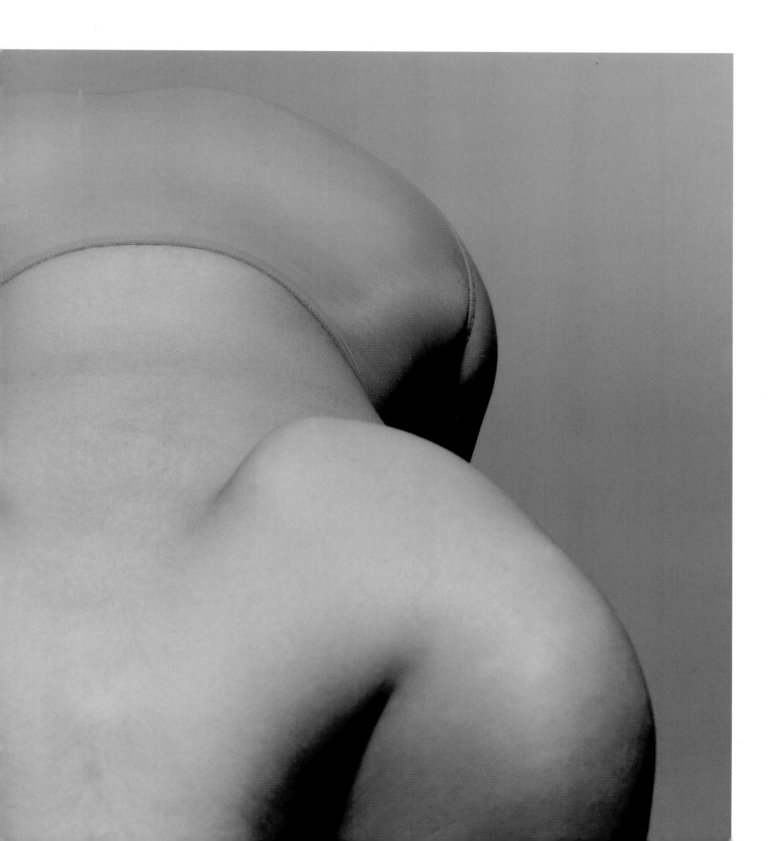

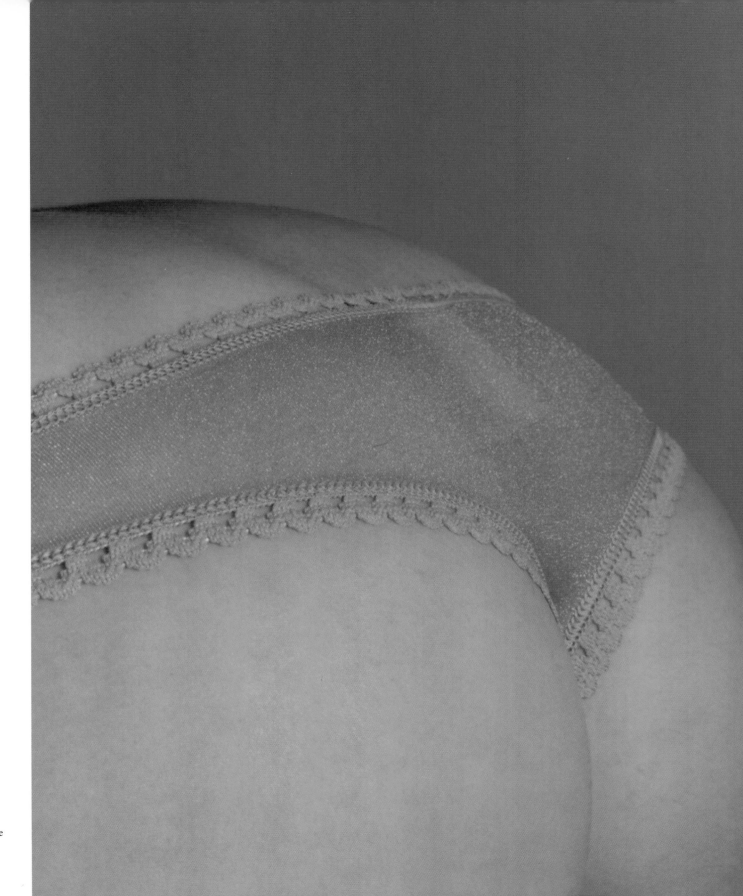

The Egg
Published in *The Face*,
August 1997.
It's not a strict document
of fashion; the idea is to take
the fashion and move into
something else.

MK: What's your take on the intersection of photography and design. I presume you see it less as straight documentation and more about creating an interpretation that might extend the design ideas.

JA: It's both. You can't say it's one or the other. You are recording and interpreting the feeling and ideas of the designers, but hopefully you have some part in inspiring the next season of fashion at the same time. Everyone looks at magazines, everyone looks at old fashion, and it goes in cycles. I think creation and recording go hand in hand. You are recording clothes, but the way you record them is creating a new image that may not be what the designer intended. It's not a strict document of fashion; the idea is to take the fashion and move into something else.

MK: You mentioned that in the various kinds of imagery you produce there are different disciplines and approaches to how you work. What are some of the differences? What are some of the things specific to shooting nudes and bodies?

JA: When you are shooting the body you normally don't have any fabric issues, and if you are not working to a specific brief it can become about pure form. I look through the camera in terms of form and I'm looking for something that works visually and has depth. Then you might also be looking for small signs that give some indication of character within that purity. With clothes you are looking for a mood or a story or a feeling. It's often about building a character and making sure the clothes are projecting through the picture, or the picture is reflecting the idea of the clothing. For me it is often a wider shot with fashion. With the body it is often much more abstract, but then clients also want things that are less abstract. In the end you move it into something else and there can be a similarity with fashion because you might be creating character within that. There aren't really hard-and-fast markers between them.

MK: Is it different on set? Do you work with similar teams of, say, a stylist, hair, and makeup?

JA: It is different on set, but I have a core group of people who I work with on both. I think more about the specific things I'm trying to achieve on a shoot and who can do that best. Often in my body work I've ended up minimizing those things, but you still need the team. Although it doesn't look made up, the skin will have been moisturized and have makeup used on it. The same with hair that may not look really structured, but has still been styled. Loose hair looks natural, but is actually hard to achieve. So it's freer and those elements are not interrupting the flow of the image, but are certainly still part of the whole.

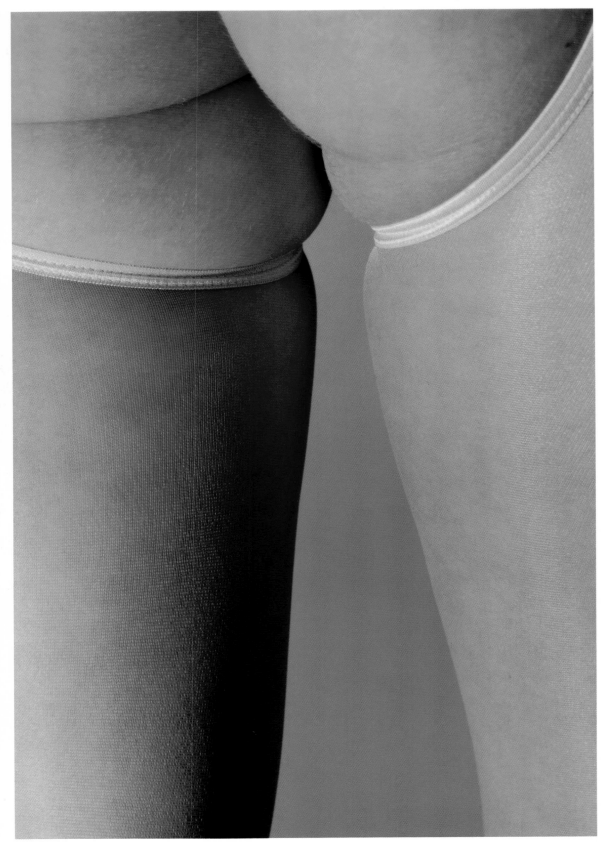

MK: Are there any general rules or guidelines that you have when approaching shooting nudes or the body?

JA: I think it is about looking. Looking at your subject and thinking about what you are trying to project, whether that is hard light, or shadows, or sheen. Or if you want sensualness coming forward, or you are looking for something graphic. The light comes from there, from what you want the feeling to be. I learnt a lot when I assisted Albert Watson [a preeminent fashion and commercial photographer since the 1970s], who was phenomenal with lighting. When you develop as a photographer you draw on things that you know, and you try different things out. As you find things that work well, you continue using them and drop things that aren't working, or you try them in a different situation. It's a creative process and you will have mistakes, but the idea is to eliminate them as you are working so that you end up with something much stronger. Each day that you are shooting you try something and you might discard it and try something else. You might shoot a Polaroid and it will be great, and then you try to shoot the same form with the same light later, but it's difficult to get it back. There might be one thing out of place so you try to reshoot it, but that can be difficult, so there is an immediacy that is important. Very often it is something you have to create and capture at the same time. Casting is important. Often my body pictures work better with girls who have great proportions rather than long bodies.

MK: The Egg story that you shot for *The Face* was one of the first things you did with nudes. It elicited a fantastic response. It's such a strong and different statement for the time. How did you come up with that?

JA: It was my first major editorial story. I'd been shooting pages for front of magazine before that. It was 1997 and I wanted to do something different because I felt there was a lot of similarity in what was going on in magazines. I had a vision to do something abstract. I thought it would be good to do something that wasn't about the model's face or expression. I took that idea to Charlotte Stockdale [the stylist]. I think this was our first story. She took it on board and decided on flesh-colored underwear as the way to deal with fashion. We talked about body shape and through discussion we decided to shoot it on glamour girls because at that time the fashion girls were mostly too skinny to get full shapes. We decided to shoot the whole thing tone on tone, so we had skin-colored backgrounds and it was shot in a studio. I shot it on a standard lens quite close up, so it takes on a large form. I wanted to fill the page with flesh.

The Egg
Published in *The Face*,
August 1997.
It's a creative process and you
will have mistakes, but the idea
is to eliminate them as you are
working so that you end up with
something much stronger.

16

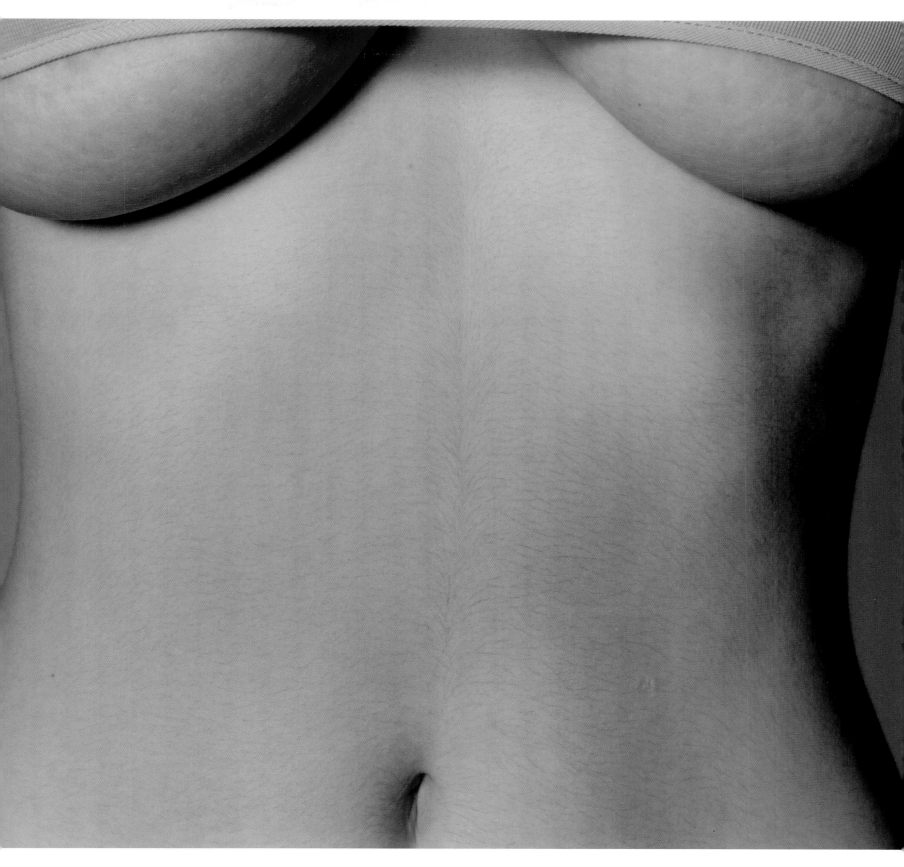

John Akehurst: Nudes and body work

MK: As it was the first time you'd shot something like that, how did you make the decision to use a standard lens and go in close? How did you know that would work?

JA: It was probably the only lens I had! Well no, I could have rented something I suppose, but I liked that particular lens. I was mostly shooting with a 90 and 110mm on a Mamiya at that time. You pick up the one you like the best and see how it goes. I still do that.

MK: How did you use light?

JA: It was fairly simple. It was probably one light and mostly overhead. It's hitting the background as well because the model is very close to the background. There is no postproduction on it. The prints are quite straight. They were just 10 x 8in and went straight to *The Face*. It was probably printed on Fujiflex, which is a high-gloss, deep-color, soft paper. I don't really like cropping afterward. I like to get the image in camera. I think it has more force.

MK: You've continued to work with and develop an abstract approach to nudes and something of that has also been applied to commercial work that you've done subsequently.

JA: It was a strong story and something quite close to me. To take it further was quite difficult. When you dilute things you can lose them totally. Trying to take the idea of abstract nudes into something with a lot of fashion in it is workable, but it becomes a different type of picture and discipline again. You might continue with an idea, say fullness of body, but introduce a character into that. Later I shot again with Charlotte [Stockdale], for *Harper's Bazaar*, working with Liberty Ross. I think *Harper's* had seen *The Face* images and wanted a skin story, but in an upmarket, fashion magazine way. Again it was a flesh-toned, neutral background with closeup on body shapes. The lighting was similar, but I developed it so we had quite an unusual fill-in light. Liberty Ross was great to work with because she was so sensitive to the camera and clever. I was working with Val Garland doing makeup and Malcolm Edwards doing hair, and they had a lot of input. We had a great team. That became the commercial form of The Egg. It became skin on skin in a slightly abstract style.

Liberty Ross
Published in *Harper's Bazaar*,
January 2000.
I worked with Val Garland
doing makeup and Malcolm
Edwards doing hair, and they
had a lot of input. We had a
great team.

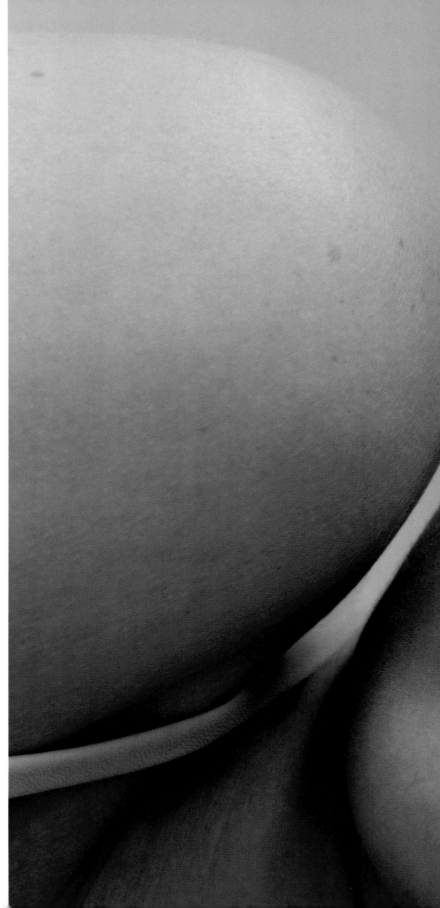

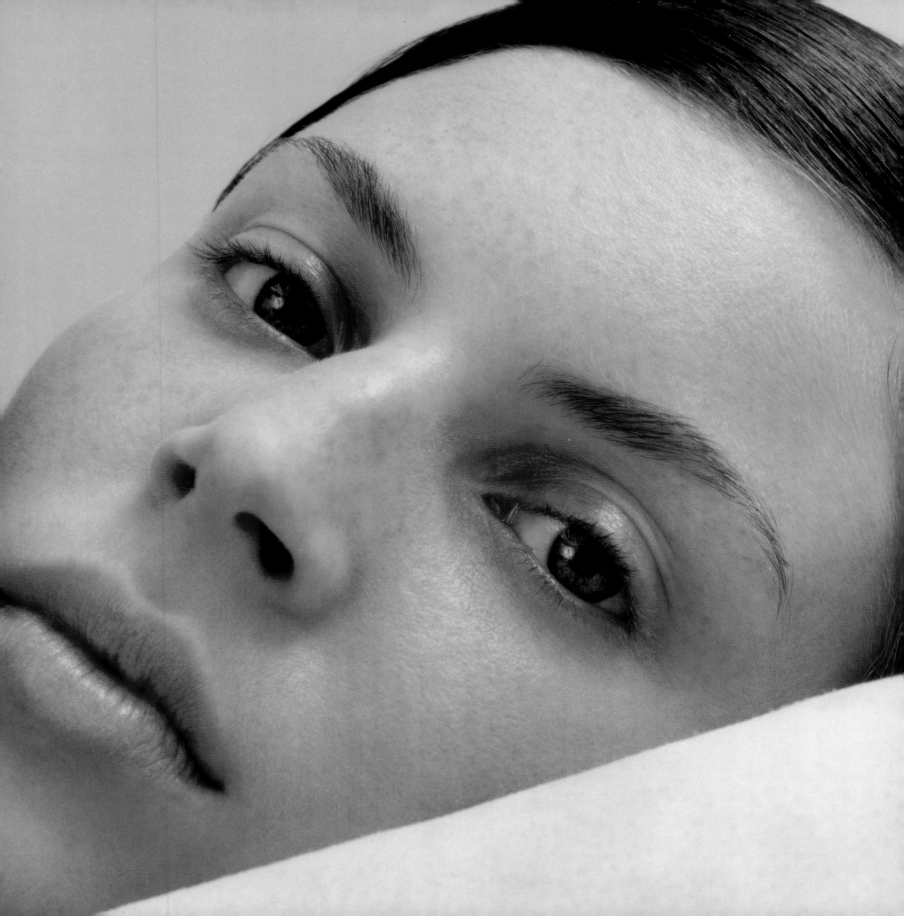

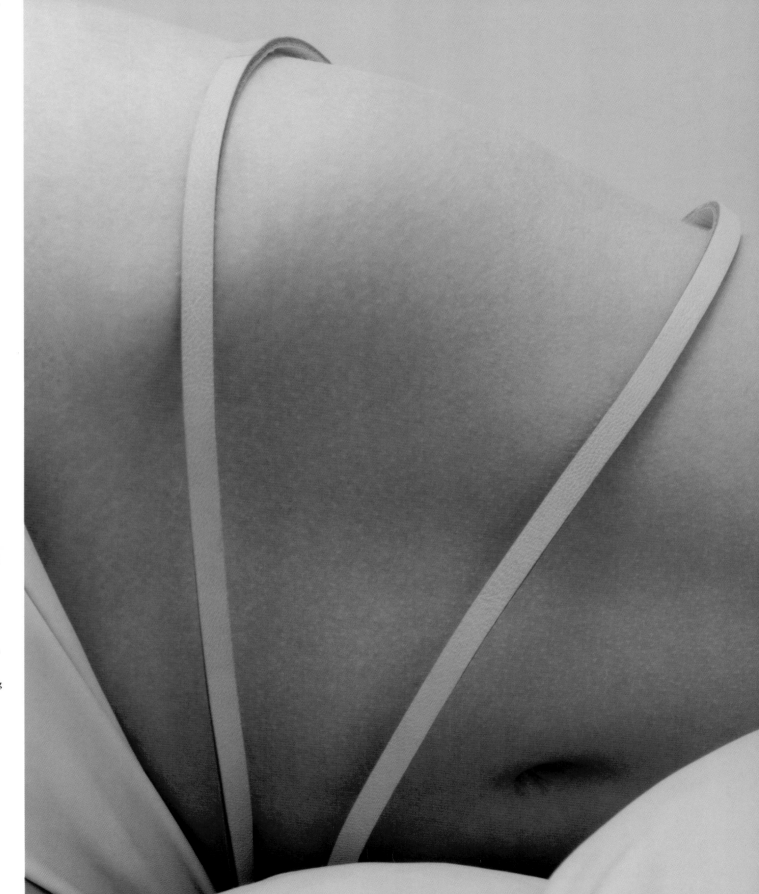

Liberty Ross
Published in *Harper's Bazaar*,
January 2000.
Trying to take the idea of
abstract nudes into something
with a lot of fashion in it is
workable, but it becomes a
different type of picture and
discipline again.

MK: Was using a more complicated lighting system about creating a more high-end fashion feel?

JA: Yes. I think so. It was also partly pushing myself. You always have new ideas you want to try out. It gives the images much more sheen and finish. I think the technique is more refined. The motif is different too. You've got a face, you can see that it is Liberty, and the mindset was to look elegant. For *The Face* we wanted to project something new and a little bit odd to surprise people. Working for an established fashion magazine you know that there are limits.

MK: That style was then adapted for a commercial brief. Did you have less control working for Michael Kors?

JA: I was working with Fabien Baron [the Art Director] and Karl Templer [the Fashion Editor]. Fabien wanted something new and took the elements that I'd been working with, the idea of skin on skin, neutral, flesh-colored background. He directed me, but also gave me free reign, and Karl had a lot of input. It developed out of the three of us. It was the right situation and the right concept and the right team to make a great commercial perfume image. Someone like Fabien knows so much about photography and design that he can move you in the right direction within your own realm as a photographer. It was a great shoot.

MK: What then would you see as the developments from *The Face* to Michael Kors?

JA: The lighting is similar to the Liberty Ross story. For Kors it is slightly bigger again—one light and a sophisticated fill-in. It's just the difference of being on a commercial job. Normally, in editorial, Charlotte and I would please ourselves. We work very closely together. When that goes into a job situation there are other things to take into consideration to fulfill commercial needs. In this case I still had the freedom to shoot pictures. That is different from being given a brief which is one of your pictures and being asked to redo one element.

MK: What were some of the things that were needed commercially for the Kors campaign?

JA: It was really just about abstraction—about skin and beige and shooting great pictures. There wasn't a commercial restraint in that sense. It was more making sure the background was a similar tone and color to the girl. We wanted it to be sensual without being raw. The Egg is weirder in that way, like cropping through the neck to cut out her head and face. When you are shooting perfume you are not looking for ways to make the body look abstract, your intention is completely different. The form fits to the idea.

John Akehurst: Nudes and body work

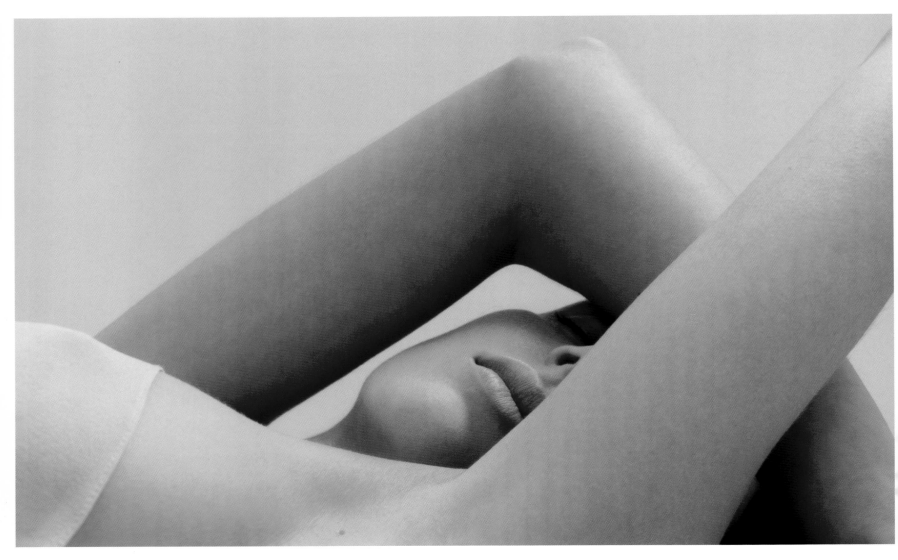

Liberty Ross
Published in *Harper's Bazaar*,
January 2000.
Liberty Ross was great to work
with: she was so sensitive to the
camera, and clever.

MK: That leads us nicely to your more recent work for French and Chinese *Vogue* where you've pulled back a bit more.

JA: You pull back so there is more a sense of the whole girl. There is still an abstraction in the shapes, but there is more information in them. The Lily Cole shot is a pale skin story for Chinese *Vogue* where she is completely white. She is tremendously white and we used additional makeup to make her whiter. We also used a very pale ivory paper in the background so it was a similar match to her skin. It is very frontlit and there is very little shadow in there so that she merges into the background. I wanted to make her more like an etching on the page. It's still about making lines and simplifying.

MK: How do you communicate ideas to models?

JA: I explain what I'm trying to achieve and then let them develop it. I like to work together. Sometimes you direct, sometimes found things are better than directed things. The best images are collaborations. It might be surprising how much of a nonsexual process it is for me in shooting nudes. It's not cold, but it is formal. The result can be sensual, but it's not highly sexualized as it is for someone like Helmut Newton or Guy Bourdin.

MK: Lastly I wanted to ask, if a young photographer came to you and asked for your advice on succeeding in the industry, what would you say?

JA: First I'd ask why. You have to be interested in fashion and imagery, not just a lifestyle. You need to have an idea of what you like doing and why you like doing it. When I started I was ruthless about what I would shoot and what I wouldn't shoot. I've said no to quite a lot. Assuming you've got talent you make yourself by what you choose to do and what you choose to turn down.

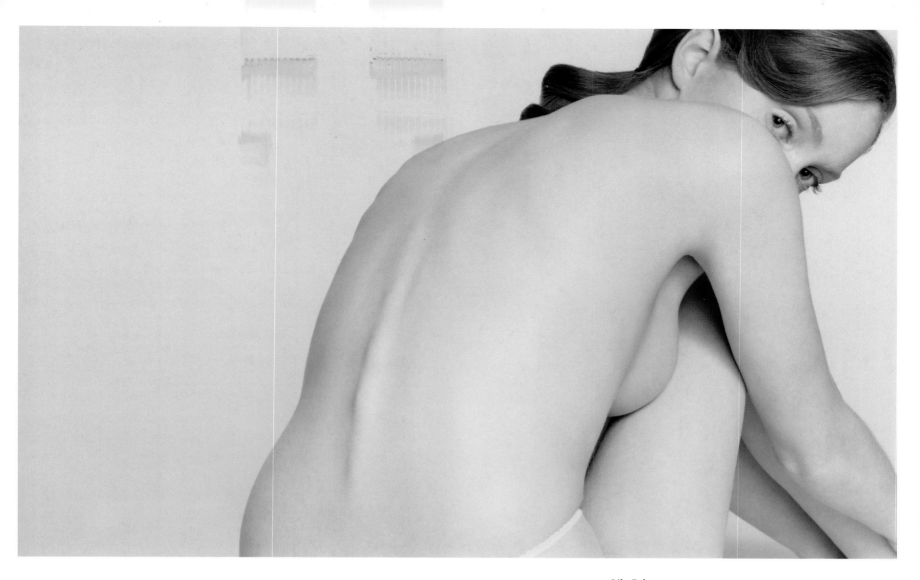

Lily Cole
Published in Chinese *Vogue*,
April 2006.
Lily Cole is tremendously white
and we used additional makeup
to make her whiter. We also
used a very pale ivory paper so
she merges into the background.
I wanted to make her more like
an etching on the page.

John Akehurst: Nudes and body work

Workshop

To shoot these graphic, abstract images, Akehurst used a simple lighting setup with one light, mostly overhead. Because the subject was placed very close to the skin-colored background, the light hit the background as well as the model, heightening the effect of tone on tone.

Akehurst's essentials

- Minolta Meter IV

- Assistant kit bag with gaffer tape, scissors, clips, A clamps, etc

- RZ kit: Mamiya RZ bodies x 2, with winders, grip, prism, and 90, 110, 140, and 180mm lenses

- Film packs x 4 (if shooting film)

- Polaroid backs x 2

- Schneider loupe

- Studex carbon tripod with large flat head

Specification

CAMERA: Mamiya RZ67 with 110mm lens

LIGHT: Profoto 2400 pack and head, Profoto beauty dish

FILM: Kodak Portra 160NC

EXPOSURE: Flash, f/22

Suggested reading

Dancer, IRVING PENN, Nazraeli Press, 2002

Fighting Fish, Fighting Birds, HIRO, Harry N. Abrams, 1990

Guy Bourdin: 67 Polaroids, GUY BOURDIN, It'S Publishing, 2004

Photographies 1997–1998, VALÉRIE BELIN, Artothèque de Caen, 1999

Souvenirs Improbables, SARAH MOON, Delphire, 198

Trouble and Strife, DAVID BAILEY, Thames & Hudson, 1980

Weston's Westons: Portraits and Nudes, THEODORE STEBBINS, Museum of Fine Arts Boston, 1990

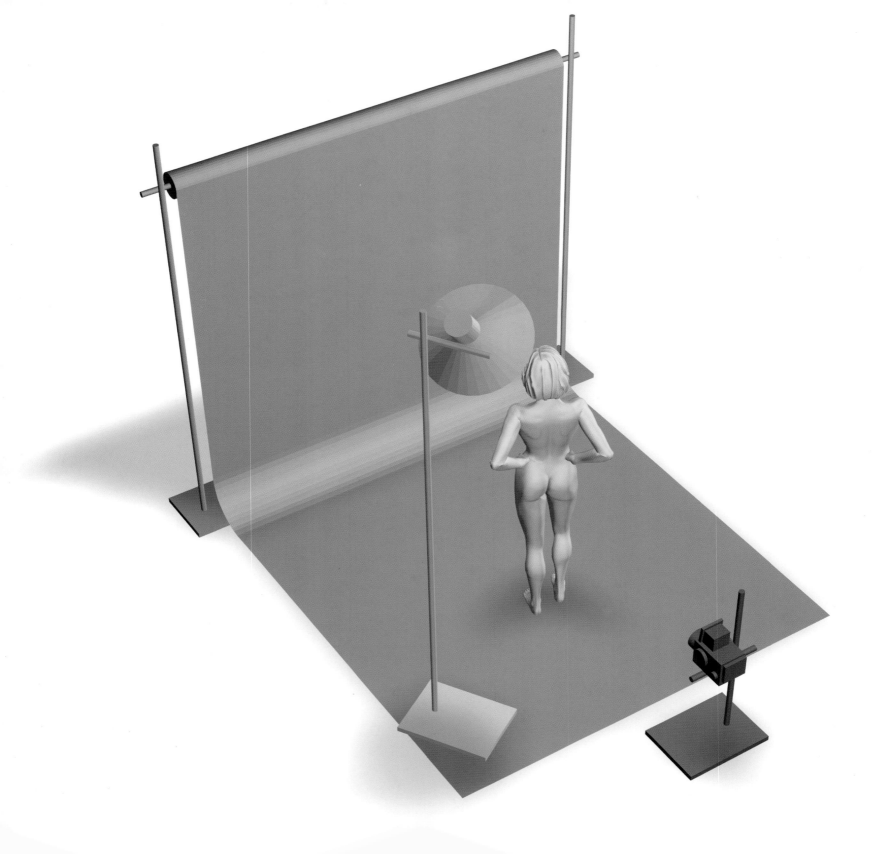

Richard
Bush

Beauty

Self-taught, and without any time spent assisting, Richard Bush has established a stellar career as one of the most interesting and exciting forces in fashion and beauty photography to emerge in the 2000s. Bush was discovered after taking his portfolio, by appointment, to an advertising agency that then recommended his work for inclusion in *Creative Review* magazine's illustrious Creative Futures—an annual showcase of the best talent in visual communication. This exposure led to early collaborations with acclaimed hair stylist Eugene Souleiman and pioneering makeup artist Val Garland. While continuing to work with industry leaders, Bush has also sought out collaborations with the best stylists, hair and makeup artists of his generation. Bush, who is open to experimentation and following a fluid working process on the day of a shoot, combines an intuitive feel for light and composition in camera with a sophisticated and refined vision of the potential of postproduction. His imagery is deceptive in its apparent simplicity, falling left of center with often surprising visual elements such as unusual angles, and odd juxtapositions of form, color, and texture.

This chapter is an exploration of the possibilities of producing innovative beauty photography. Beauty is primarily concerned with the presentation of ideas around hair and makeup, focusing on application and style as well as highlighting new products.

In the best cases this moves past documentation to become a creative synergy combining the skill and vision of the photographer with the skill and vision of the hair or makeup artist. Thus, a photographer's relationship with both of these artists is crucial, from the development of an idea, to casting and working together on set, all leading to the final image that appears in the magazine. In this way a photographer will work as closely with hair and makeup for a beauty story, as with a stylist for a fashion shoot. A fashion stylist will normally also be part of a beauty shoot, particularly where a model's clothes can be seen, or where the development of a character is integral to the pictures. As Bush's photos show, beauty provides an opportunity to work more abstractly than, and without as much constraint to narrative as other areas of fashion and advertising photography, perhaps in a similar vein to still life. Shooting beauty well is also a valuable commercial asset as it is a lucrative field with a relatively high volume of clients in comparison to high-end fashion.

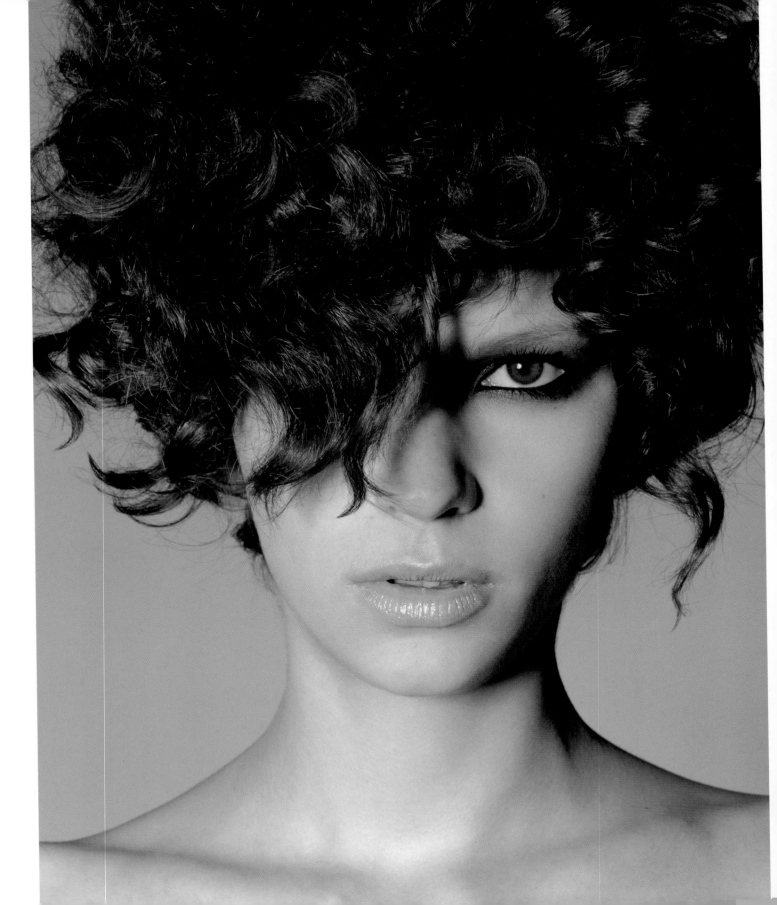

MK: In this interview we are focusing on your work with hair and makeup, that is, as a beauty photographer, but I'm not sure if that is exclusively how you would position yourself within the industry?

RB: No. But as a new photographer, beauty gets you work more than fashion so if you can do both, it is useful. I think it has been circumstantial to some extent, because of who I met when I started. I think that every photographer comes to a point at which they have the opportunity to shoot beauty, and if you can work with good people and shoot it well, then the rest just happens. The opportunity came after I did Creative Futures [*Creative Review*'s annual showcase of visual communication talent]. I met Val [Garland] and that is where it started for me. A lot of fashion photographers might shoot beauty, but few are considered able to do both equally well. Beauty is lucrative because you can get usage that you just can't get with most commercial fashion.

MK: How does your approach to shooting fashion and shooting beauty differ?

RB: You do sometimes have to think about fashion when you are shooting beauty because you might want to create a certain character, or the magazine needs fashion credits. The approach in beauty is simpler in a way because you are not dealing with a stylist or a fashion editor. You just have hair and makeup so you've got a tighter unit. Inevitably you have some models who are good for beauty, who have the canvas that you need to begin with, which is pretty much common knowledge in the industry. Someone can be a bit tricky to shoot for a hair or makeup story even though they are very beautiful. So on that level you get a slightly different casting.

MK: What makes a face good to work with in beauty?

RB: I think it is symmetry. On one level it's just the translation from the light to the lens to the page, so it's intangible, and when you try to dissect it it starts sounding a bit silly. Good skin for sure, particularly if you want it natural and don't want to have to go too far in postproduction. Obviously with hair, unless you are doing wigs, you want healthy, naturally beautiful hair. Someone such as Eugene [Souleiman] knows exactly whose hair he likes and what hair is good for what idea within a story.

MK: So working with Eugene or Val, they are going to be a key part of the casting.

RB: Yes definitely. They do the [catwalk] shows so their feedback is so important. Val knows what faces can take the makeup we are thinking of for the story. Eugene knows what hair is going to work. Doing the shows, they know the girls, and they work with so many different photographers with so many different models that they are crucial to inside information in a casting. Then again, sometimes you can't get the option on the person you want, so you have to work within the limitations of your casting which can be positive, because it makes you think outside the box a bit.

MK: Is your relationship with the hair and makeup artist similar to your relationship with a stylist on a fashion shoot?

RB: It can be. Being a new photographer and working with people as established as I did at the start, it definitely was a key relationship. As I've gone on I think I've looked to develop my own generation and my own teams, which is really important. I think there is more potential for conflict between a fashion editor and a photographer than with hair and makeup and a photographer. Usually, on a beauty shoot, if there is a stylist they take the back seat. But sometimes their input and direction is brilliant, especially if you are talking about evolving a character, not recording a pure hair and makeup image.

MK: So as well as working with figures as established and famous in the industry as Val or Eugene, you are also keen to build relationships with newer, like-minded people.

RB: Yes. Like Val's assistant Petros [Petrohilos] who is an excellent makeup artist. I've worked with him a lot. We recently did a story for *Vogue* Nippon that I think worked really well. You need to mix it up and have different energies for different shoots, and being more practical, you need to be able to get your options. People like Eugene or Val are not the easiest people to get options on because of their standing in the industry. I was fortunate because I had an apprenticeship with them, but also when you are so new people direct things more than you realize because they've had so much experience. That's why I say it is important to promote your own generation from a creative point of view and mix it up and make a few of your own mistakes.

Criniéres
Published in *Numéro*, April 2004. (With hair stylist Eugene Souleiman.)
I think if you are working for quite a creative magazine you can have a more purist approach and go with what happens on the day.

Richard Bush: Beauty

MK: How does the commissioning process work for beauty? Will the editor of a magazine ring your agent first, or would they approach the hair and makeup artist to suggest a photographer?

RB: Most of the time magazines deal with the photographer first. I think nine times out of ten, magazines deal with photographers directly, though they may expect you to have a certain team. Fashion editors are sometimes approached first, but that's because, if it is a fashion story, they will have come up with an idea. It can happen in various ways. Last time we shot *Vogue Nippon* we did a beauty story and a fashion story combined.

MK: Is that challenging for you as the photographer?

RB: Well, we separated it. It can be in terms of the casting. You need to get a person who is going to be strong for both ideas. It was two days on the fashion story and one day on the beauty. Usually when Eugene or Val or Petros and I go into a shoot we are quite "freestyle." We start with a basic idea and build on it.

MK: What is an example of a basic idea you might have?

RB: Colors. Or Eugene might say "I want to do eighteenth-century big hair with punk." Sometimes people bring references. I think if you are working for quite a creative magazine, like *i-D* or *Self Service* or *Numéro*, you can have a more purist approach and go with what happens on the day rather than having to work within the angle of what might be in the rest of the magazine. It's important to remain experimental, and beauty lets you do that.

MK: I think that there is a very strong sense of experimentation and vision in your work rather than documenting hair and makeup ideas.

RB: I think I started with a certain portrait or documentary style. I think experimentation is important. If you have the ability, as a photographer, to get a big model and transform her, I think people find that exciting. The Criniéres story that I shot with Eugene did that and it ended up all over the place. She looked amazing, and that sells.

MK: Can we talk about that story in more detail?

RB: It was commissioned by *Numéro*. They wanted me to work with Eugene and they definitely wanted us to shoot Eugenia. We had to have two models because Eugenia had to leave early. It's shot in the studio, which I often do because, for beauty, I think being based in the UK you are more restricted by the light and weather conditions. I have to say I prefer the way skin can look under great natural daylight in color. I suppose people associate me with the studio, but I have been shooting much more on location recently. I was shooting with a large-format 10 x 8 camera. I liked the way she looked in black-and-white on the day. I shot some color Polaroid, but I thought it was better in black-and-white. It felt right for the character. The light looked good on her skin. It probably could have worked in color, but we didn't go with it.

Criniéres
Published in *Numéro*, April 2004. (With hair stylist Eugene Souleiman.) Polaroids are useful because they allow you to judge if things are working, or if the light should be softer.

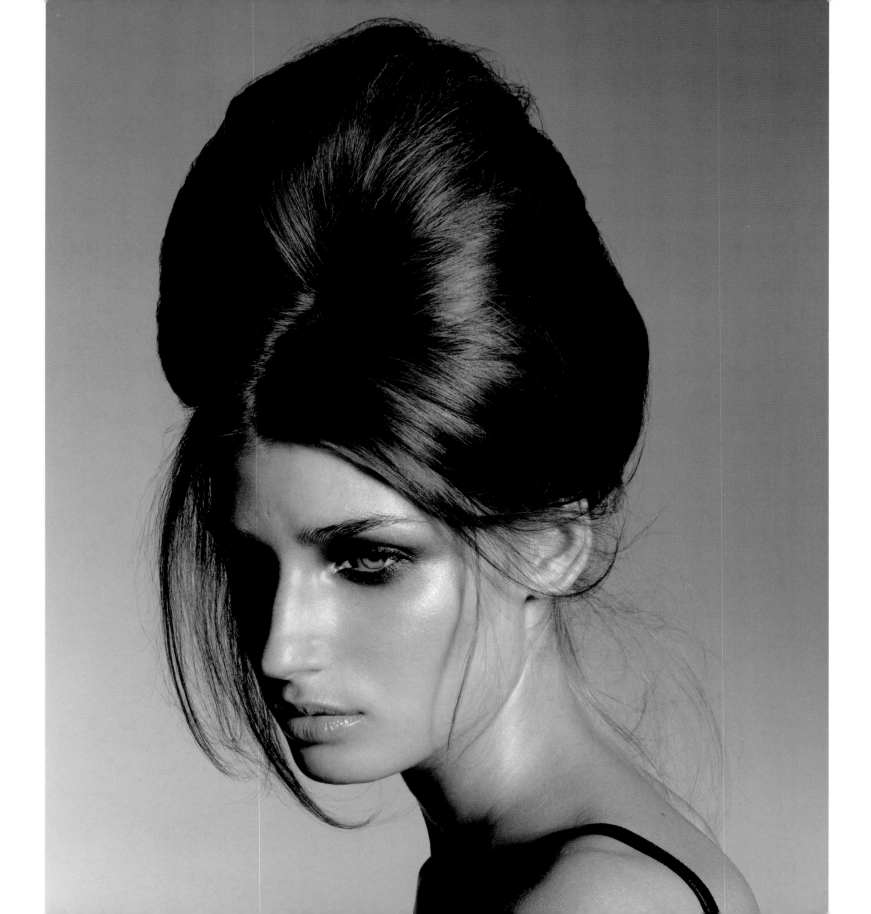

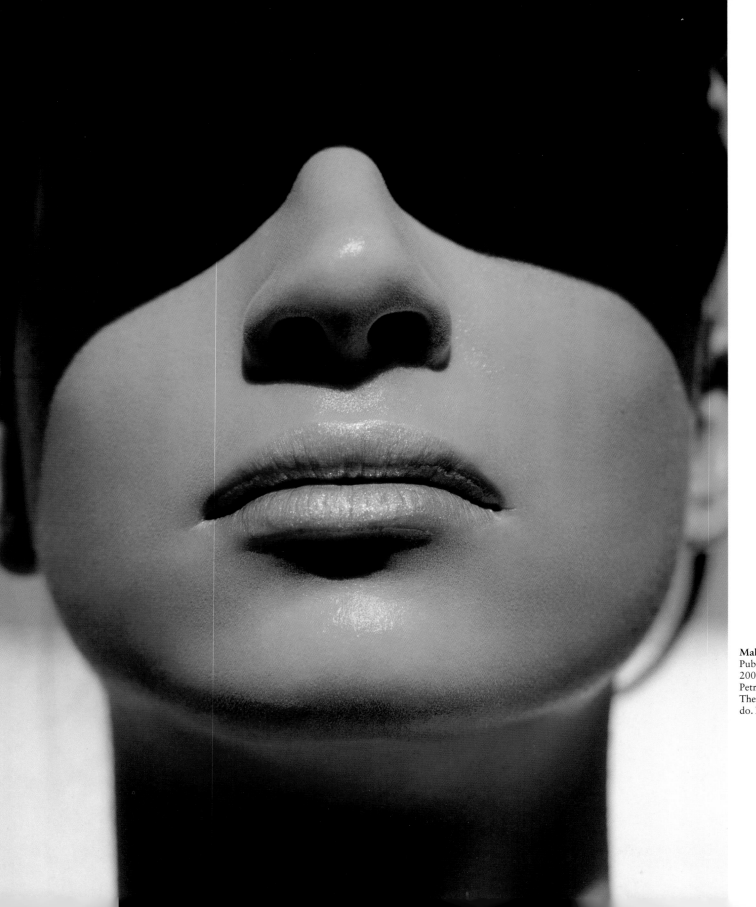

Makeup story
Published in *Vogue* Nippon,
2006. (With makeup artist
Petros Petrohilos.)
There is a simplicity to what I
do. I'm not into much gimmick.

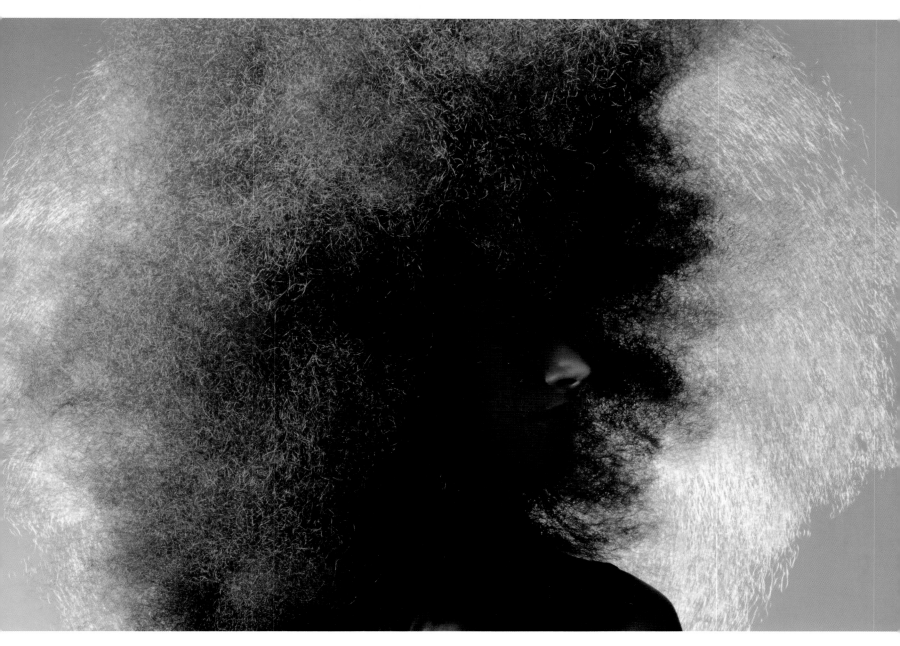

Criniéres
Published in *Numéro*,
April 2004. (With hair stylist
Eugene Souleiman.)
It's important to remain
experimental, and beauty
lets you do that.

MK: It's a very basic setup, not really using any props or anything.

RB: I always have certain basic props, but to be honest, with beauty there is always so much going on you don't need them. Maybe a cap to create a shadow in light, as in the *Vogue* Nippon story with Petros. But you don't need much. There is a simplicity to what I do. I'm not into much gimmick, but I wouldn't rule it out if it were right for the shoot. It's what you capture and how you visualize it afterward that is important.

MK: Would you agree that as it is so simple, the light is very important?

RB: Yes. I changed the light with the shots. In the big hair pictures, where she has a massive Afro, I kind of put her face in silhouette and used the light behind and round her a bit. For the ones that were much more her sitting there, it needed to be more dramatic and hard and directional because the hair was quite soft and she had quite a soft feeling about her, even though her face was angular. Polaroids are useful because they allow you to judge if things are working, or if the light should be softer, or how things are going on the day. I shoot film first rather than Polaroid because you can waste time trying to find it. I'd rather shoot some film, shoot a Polaroid, and keep shooting the film. I think when I was newer there was a bit more tweaking on the shoot. So perhaps I used Polaroid more earlier on, but less so now.

Richard Bush: Beauty

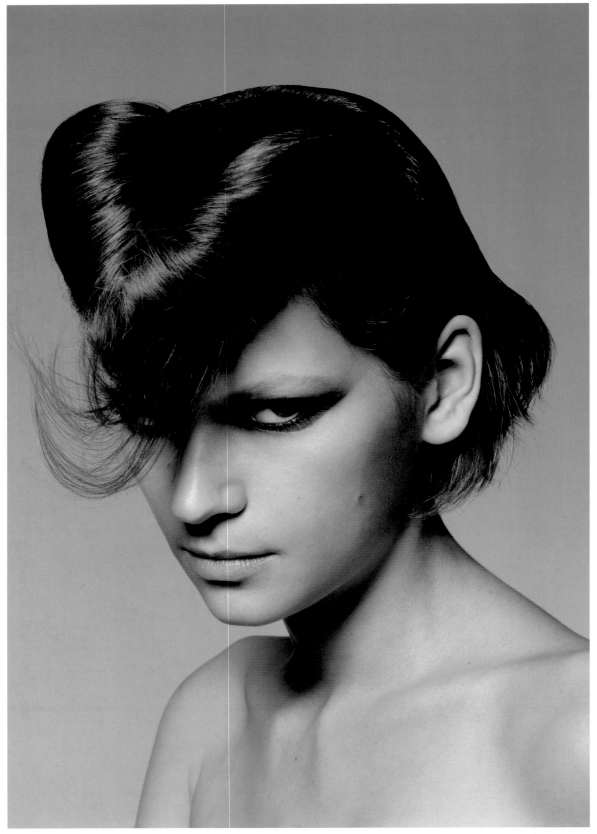

MK: Do you prefer to shoot digital or film?

RB: I shoot both. I can capture an image both ways. In terms of skin and color, I think digital is more work in postproduction, swinging colors around. I think some photographers have more of a setup that involves constant postproduction, so it is probably OK for them. Right now I still like the chemistry of film, but maybe in a couple of years I'll be ready to move on to digital properly. I have discussions with clients and they definitely notice the difference in quality in hair from a digitally shot image to a real negative-shot image. I think it is about the highlights and the detail and the texture, but there is a lot of room and possibility for technology to get better and improve.

MK: The Celebration of Color story with Val is in a lot closer; you've pulled back a lot more in the hair story.

RB: You have to. If you've got a big hairstyle you can't come in close and crop it out. Inevitably you get a slightly different style of picture, which seems more portrait-based but is still beauty. When you do makeup you can isolate the lips or the eyes or other parts of the face.

MK: The story you did with Val for *Vogue* Nippon works like that.

RB: It's product-based but it's conceptual. You can see there may be an eye, but you have the feeling of the makeup, the texture of it and color, you have the fact that it is an eye which is quite abstract anyway. If you were to crop the eyebrow out it would become super abstract. If you go close like that, things become a little odd because you are not so used to seeing them in that way. You have to remember that Val does the makeup for the McQueen [Alexander McQueen, fashion designer] shows, and I think this is a classic example of her imagination and "freestyle" ability. She is very quick. If it doesn't work or she can't make it look good, she wipes it off and starts again.

Criniéres
Published in *Numéro*, April 2004. (With hair stylist Eugene Souleiman.) This was shot in the studio, though I have to say, I prefer the way skin can look under great natural daylight.

A Celebration of Color
Published in *Vogue* Nippon, April 2003. (With makeup artist Val Garland.) This is product-based, but conceptual. You can see the eye, but you have the texture and color of the makeup.

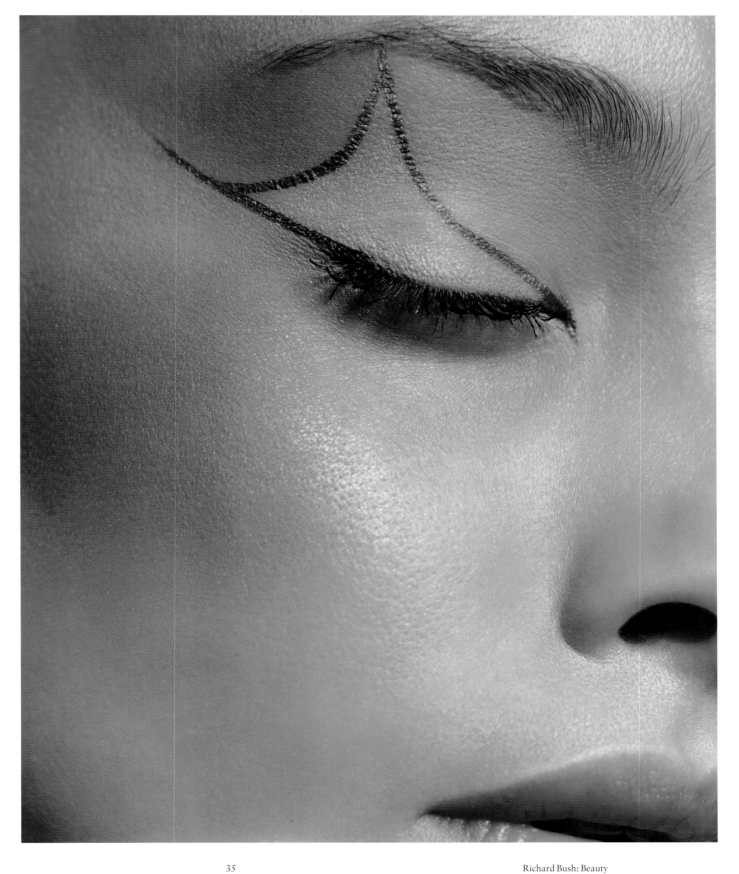

Richard Bush: Beauty

MK: Had you worked anything out before the shoot?

RB: I think Val knew what colors she would use, and the style of makeup. We had a conversation about texture, about doing the closeups and isolating parts of the face. A lot of it is about the contrasts, so in *Stripes of Glitter* you have glitter, but you have raw skin and nothing on the lips. Eugene also often works with contrast in mind. It comes to him quite naturally. It might be super-hard, gelled hair down the side, and then it's all soft. It works. Lots of good imagery is based on contrasts.

MK: What are some of the technical considerations, coming in so close in color?

RB: I think on 10 x 8, when you start getting in close and try to shoot an eye, it can become a nightmare because you have so many technical things to think about. If you are extending a 10 x 8 camera way beyond the focal length of the lens, it becomes a headache exposure-wise so you have to be spot on. If you pull back a bit and then crop afterward you get better depth, but then sometimes a lack of depth is nice. For example, the blue eye has a certain softness around the edges so it leads your eye around the image. You can work with depth quite well with a 10 x 8. Part of it is sharp and then it softens off.

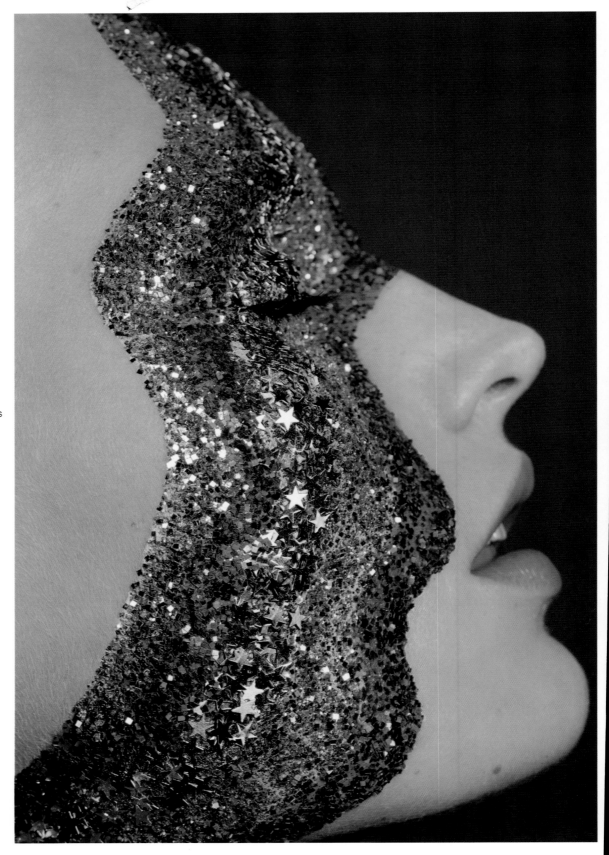

Right and far right:
A Celebration of Color
Published in *Vogue* Nippon,
April 2003. (With makeup
artist Val Garland.)
This is about the contrasts, so
you have glitter, but raw skin
and nothing on the lips.

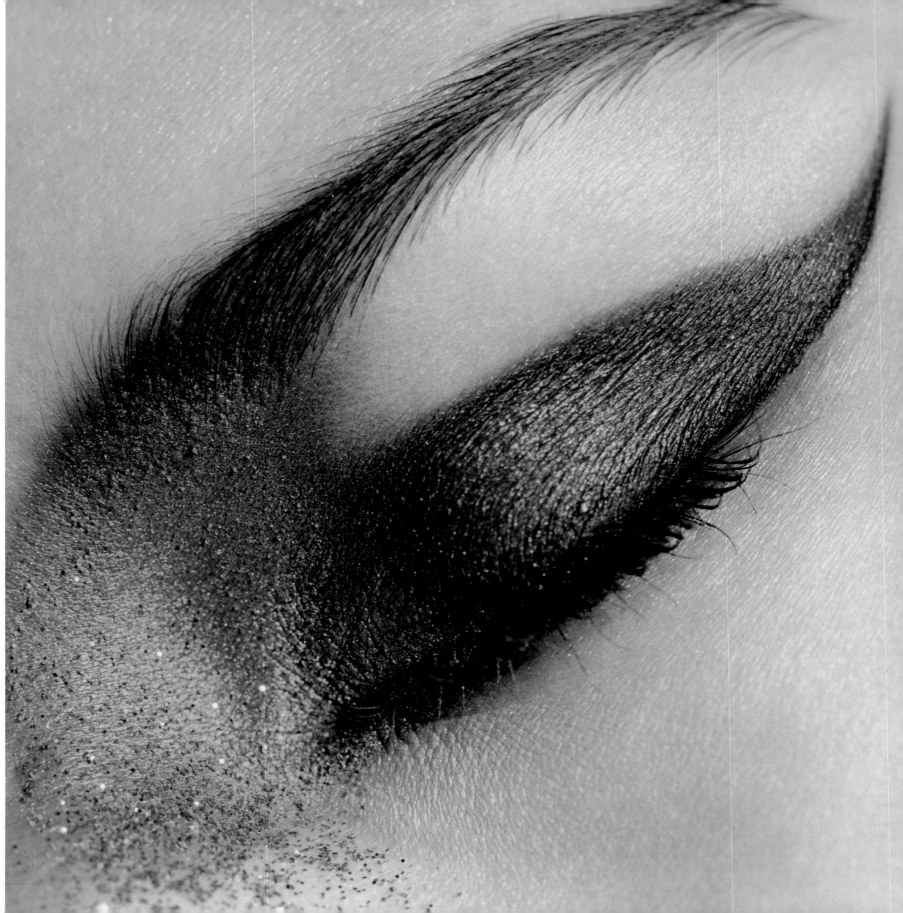

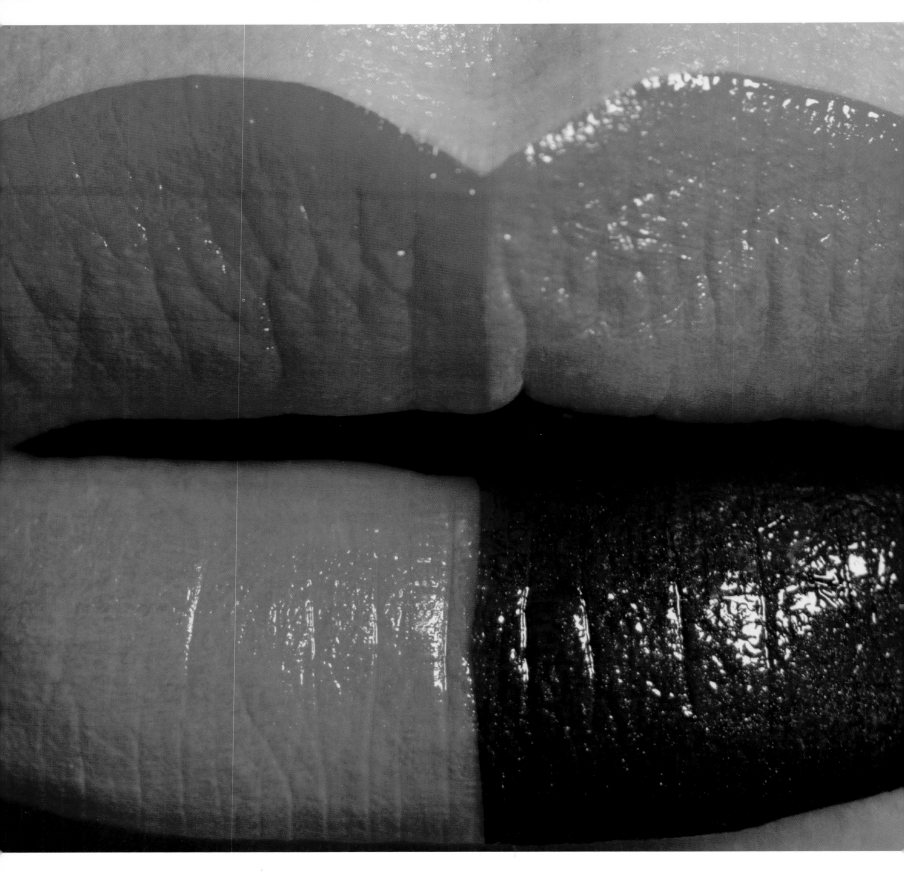

Left and below:
A Celebration of Color
Published in *Vogue* Nippon,
April 2003. (With makeup
artist Val Garland.)
When you do makeup you can
isolate the lips or the eyes or
other parts of the face.

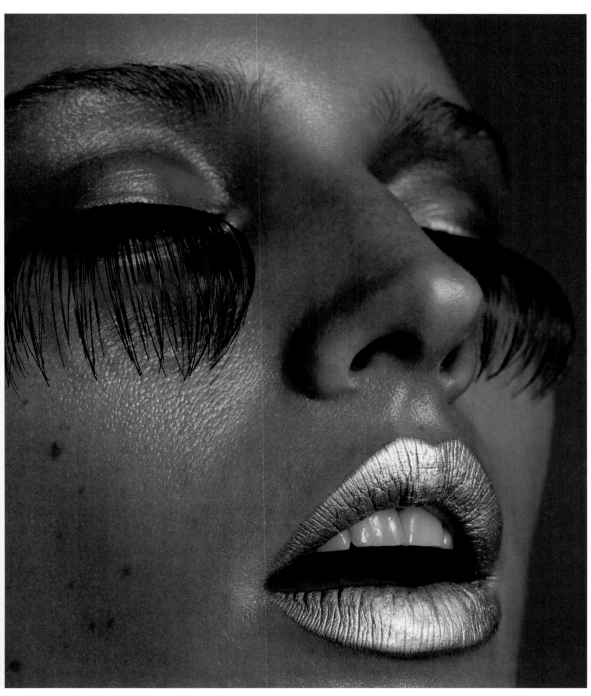

MK: The lips are pretty amazing in *Schizo Rainbow* [far left].

RB: Yeah. I always thought they would look good over a double page. I think this image is super abstract. There is a lot of post-production work on this one. Getting in this close you could see the makeup bleed on the side of the lips and we needed to clean them up and divide the colors without removing texture from the lips. Val's makeup looks great to the natural eye, but then when you get in on a 10 x 8 negative … I seem to remember there was quite a lot of separation with the colors and blending that we had to do in post. I think postproduction is one of the most crucial stages now for photographers working with beauty. What you can achieve and how you enhance your style and your vision is quite amazing. I like a certain naturalism or rawness to be left, so you work with a retoucher and they gain an understanding of that. I don't like it to look like it has been brutalized. I don't blitz the skin. It's important to know what you like about a picture, where it is living for you and where it is not. I don't see retouching as so correctional anymore. That goes without saying. I see it as a way to explore color, to move the image to where you visualized it preshoot, preprocessing. It's an area in which many photographers have really defined their style of late.

MK: You describe having found yourself in photography by accident. How does it feel seeing your images in magazines?

RB: Often I just can't wait to do the next shoot! Sometimes I don't see them for months after they have been published. British *Vogue* is amazing for repro because Robin Derrick understands and is so into it. But sometimes you can get upset with the repro. It all takes a lot of time and money so you have to be in control of that as much as you can. You have to work hard at all aspects of the image: picture taking, postproduction, reproduction. It's too competitive not to be. There is an application and passion that is necessary to make it how you want it to be. It is also a lot of fun.

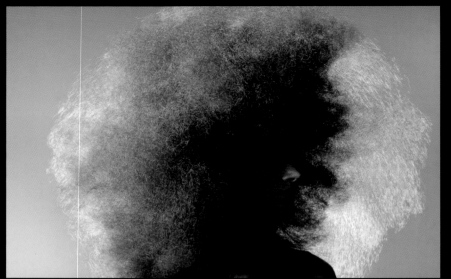

With simple, basic setups, effective lighting is vital. The silhouette in this image was created using lighting behind and around the model, with fill-in flash directed at her face. In a setup like this, with such a soft element as the hair, using hard, directional lighting will produce more dramatic results.

Bush's essentials

The equipment I need depends on which system I am using. For example, if I were working with Mamiya then I would take a compatible Polaroid back, a selection of lenses and film backs, and three or four bodies.

Specification

CAMERA: Sinar 10 x 8 with Zeiss lenses, typically 300–360mm

LIGHT: Mix of Broncolor and Briese lights, and a honeycomb attachment for the Eugene Souleiman story to give more direction

FILM: Kodak Portra 160NC and Ilford FP4 PLUS 125

EXPOSURE: 1/125 sec between f/32 and f/45

Suggested reading

A Gun for Hire, HELMUT NEWTON, Taschen, 2005

Observations, RICHARD AVEDON, Simon & Schuster, 1959

O Rio de Janeiro, BRUCE WEBER, Knopf, 1986

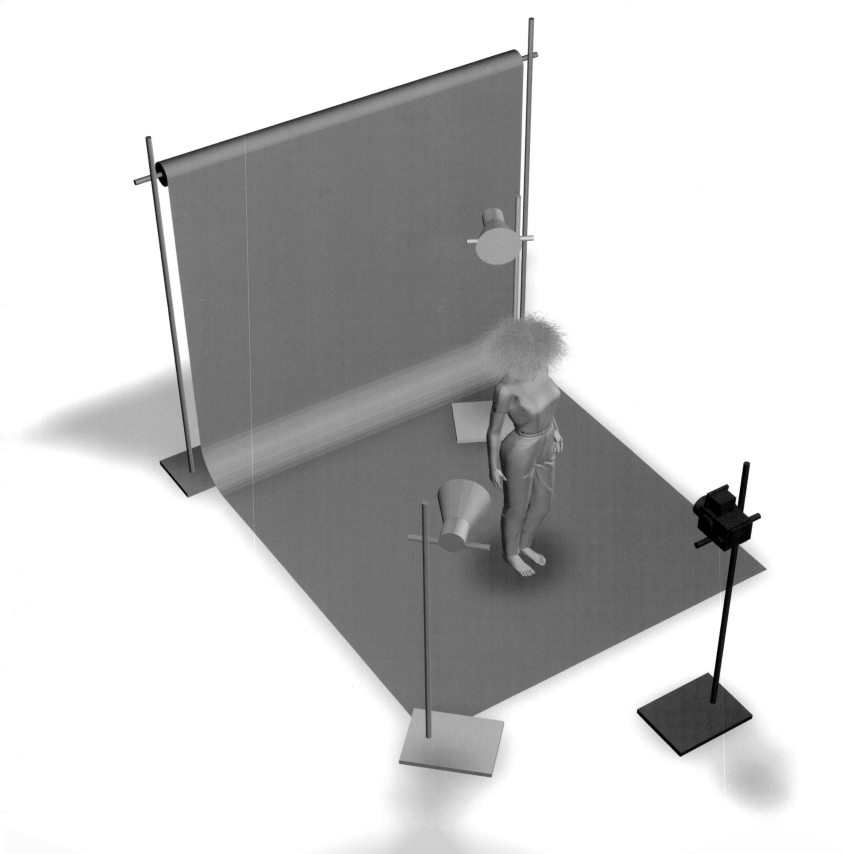

Elaine
Constantine

Composition

Elaine Constantine obtained a City & Guilds qualification in photography at South Manchester Community College in the UK, and began making documentary photographs of friends around Manchester's music scene in the 1990s. After moving to London and assisting Nick Knight, she was initially picked up by *The Face* and soon became one of the defining image-makers of the magazine. She subsequently produced work for *Arena Homme Plus*, *Sleazenation*, and American and Italian *Vogue*; and advertising for Levi's, Nike, GAP, and Katharine Hamnett. Constantine has continued to produce regular seasonal campaigns for the American Eagle label. She has also concentrated her efforts on projects outside the commercial and editorial industry—including commissioned series Tea Dance (2002) for Castlefield Gallery—and more recently, on directing and writing film projects. In 2005 she was awarded the Royal Photographic Society's Terence Donovan Award.

Elaine Constantine is one of only a handful of photographers who have managed to break through and sustain an alternative visual aesthetic within mainstream fashion and advertising since the mid-1990s. Her still imagery from that time is a jubilant, but not squeaky-clean celebration and expression of youthful energy inspired by music and youth culture. In these colorful, dynamic frames, young individuals incorporate fashion into lifestyle. They are often shot as narrative sequences documenting friends closeup at gigs, parties, or spending the day at the seaside. At a time when the look de rigueur was a statuesque supermodel posing in the studio, Constantine irreverently flaunted the classical rules of good fashion in terms of models, composition, light, pose, and styling.

After a period spent not producing fashion editorial, Elson Street was commissioned by *Pop* magazine, but never run. The story is a multifaceted sequel: a planned return to the magazine story format; a return to her hometown of Manchester and to working with art director Lee Swillingham; a re-evaluation of the style that she had instigated, but which, as it became more popular and frequently copied, ultimately became less interesting for her to pursue.

Constantine's originality and influence make her an important inclusion in this publication. Her example is a valuable one for aspiring fashion photographers. The basis of her success is partly intuitive—a compelling sense of color and composition; a particular understanding and expression of the energy and sensibility of youth—but is combined with the technical, production, and editing prowess required to translate her vision onto film and into the pages of magazines.

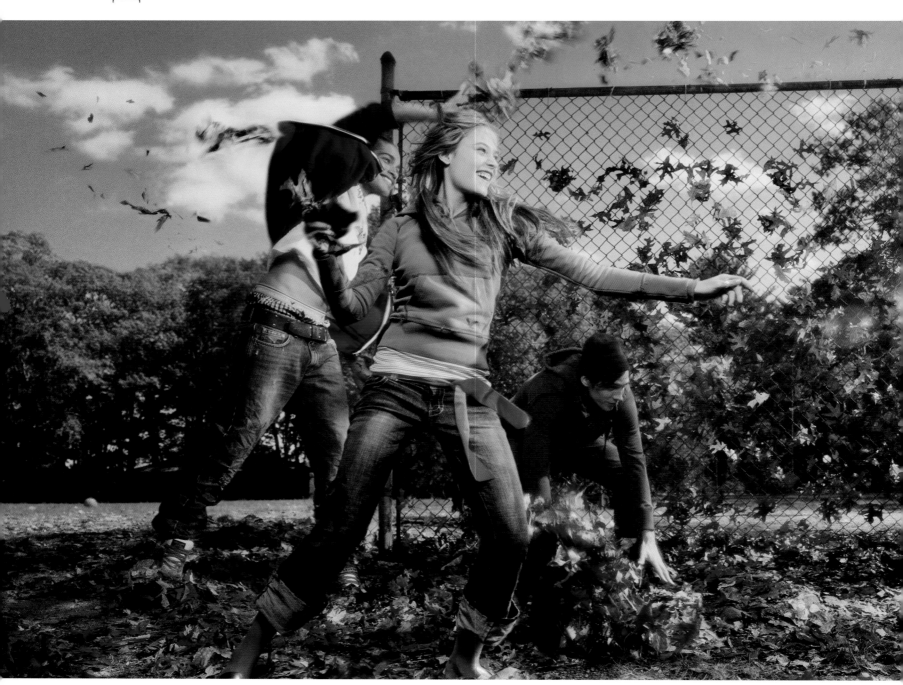

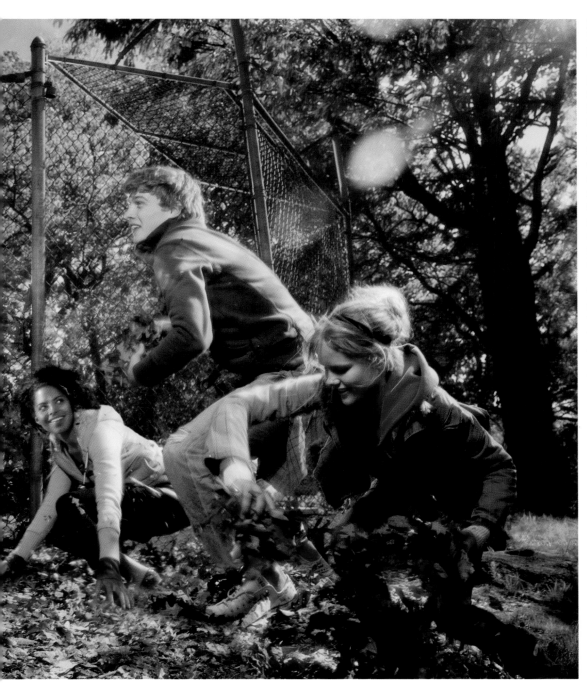

MK: You are one of the most well-established photographers I have interviewed. Can you tell me about your background and how you think of yourself within the industry?

EC: When I was getting interested in photography I saw the work of Chris Killip [documentary photographer famous for his images of the north-east of England] and that really inspired me. I didn't go to college and I wasn't a photographer as such. It was the '80s and I was unemployed. I did a photography workshop for people on the dole and the teacher brought in a book of his work. The subject matter was from my background and I could relate to it. I started taking pictures of my friends. We were all really into Northern Soul [there was a strong black soul music scene in the north of England in the 1970s] and scooters and stuff, so I started doing documentary pictures and printing them. Fashion happened as a happy accident. I became a fashion photographer after assisting Nick Knight. I only worked with him for about six months, but it was hard-core training. When I came out of that I just went for it and made a portfolio in two weeks, and went to *i-D* and *The Face* and started getting portraits. I'm now concentrating on a film project, but I still work for a company called American Eagle Outfitters. They hired me to start shooting their campaigns. It is an idealized version of the style I'm known for, which is a good discipline. It's an aesthetic linked to the way I shoot compositionally and in color, mixed with quite a particular idea of what an American teenager should look like. It's created a brand look.

Advertising campaign
Published in American Eagle Outfitters catalog, spring 2006. I shoot compositionally and in color, and I mixed this with quite a particular idea of what an American teenager should look like.

Elaine Constantine: Composition

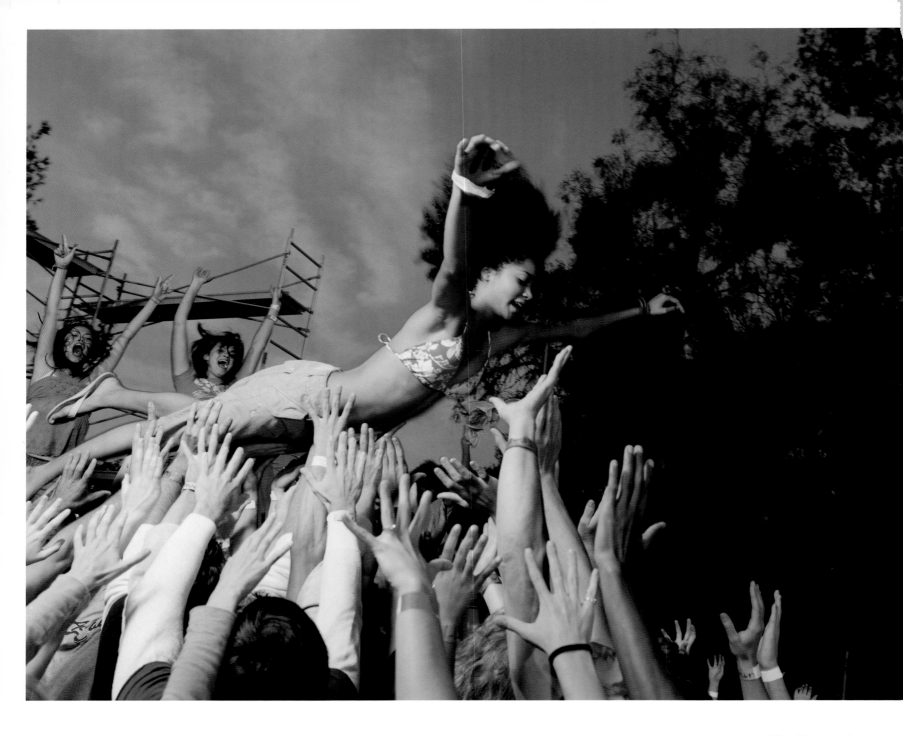

Advertising campaign
Published in American Eagle
Outfitters catalog, spring 2006.
This is an idealized version
of the style I'm known for.
It created a brand look.

46

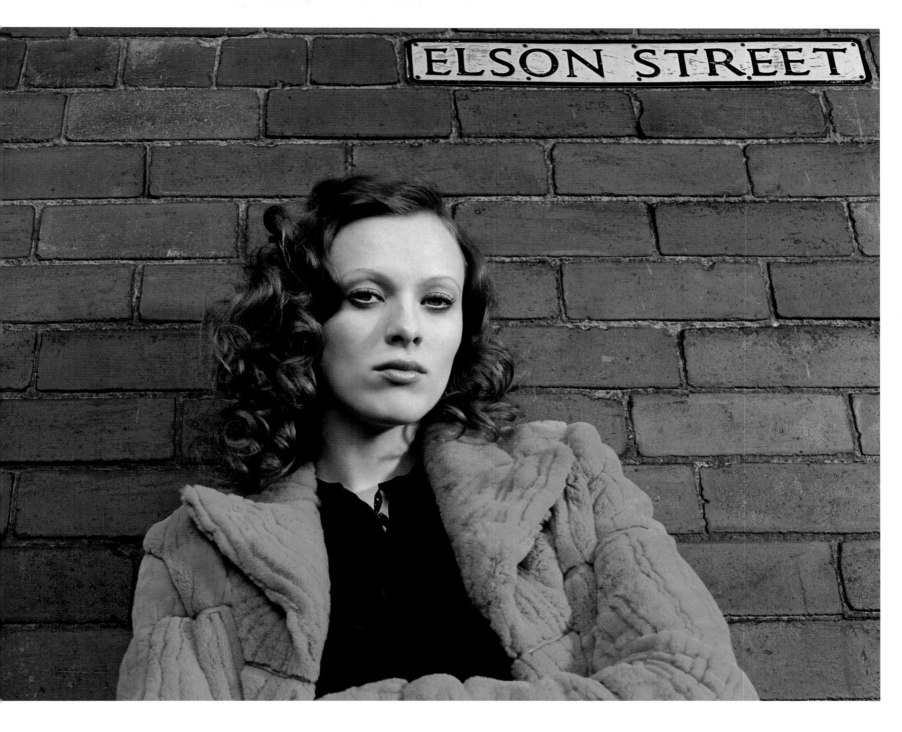

MK: There are a couple of things in the story we are talking about that I'd like to start with. Firstly, your collaboration with an art director. The second thing I'm interested in is the way you set up and compose your pictures, particularly the groupings of figures, which really come across with such energy and spontaneity.

EC: This story is kind of going back to my photographic roots and the influences that made me do fashion in the first place. When I started doing fashion for *The Face* it was a reaction against the typical girl in a studio looking off into the middle distance, pouting and trying to look interesting. It seemed like the total antithesis of everything I felt at that age. I wanted to represent the excitement of things I'd done or experienced when I was 16. That meant the models couldn't be celebrities or big girls. Supermodels were out. It stopped me from working for certain magazines for a while, but it didn't really matter because I managed to get my aesthetic through.

Elson Street
Commissioned for *Pop*, 2005.
This story goes back to my photographic roots and the influences that made me do fashion in the first place.

Elaine Constantine: Composition

MK: The story was suggested to you by the Art Director at *Pop* magazine, Lee Swillingham?

EC: I'd done a story on Giselle for *BIG* which was like a reportage set of images of her with her family. It wasn't a fashion shoot as such and it worked so well that people often asked me to repeat that, but it never felt right. When Lee asked me to do Karen Elson at home with her family I'd had a big break from fashion and I was interested in doing something on my own terms, about someone coming back and seeing how things are. It's almost like a metaphor for my own feelings about photography.

MK: Perhaps because you are in a different position you are approaching the ideas differently too?

EC: Lee had always said he wanted to do a story about Karen Elson going back up North, but he had never had the right publication. Lee and I came from the same town, but we didn't know each other. We met at *The Face*. It was different from the Giselle story because it was a fashion story for *Pop*. So one challenge was how to incorporate the labels and designers we needed to, but to retain the reality feel.

MK: There is a mix of portraits of Elson, pictures of her with groups of kids, and pictures of her with her family. The pictures with the kids seem to have a resonance with a particular style that you are known for.

EC: I had an image I used for inspiration, which was a Weegee photograph, *Welcome Home Jimmy*. I'll often have a whole scrapbook full of images to keep my mind focused on what I'm trying to make, what the sentiment is that I'm trying to bring together. The idea was that the town should be excited that Karen is coming home. What we wanted to project wasn't necessarily the reality, because while Karen is well known in the industry she isn't instantly recognizable, so we had to work to build up the anticipation of her being there.

Welcome Home Jimmy
Photograph by Weegee. From the Hulton Archive collection, courtesy of Getty Images.
I used this image for inspiration. The idea was that the town should be excited that Karen is coming home.

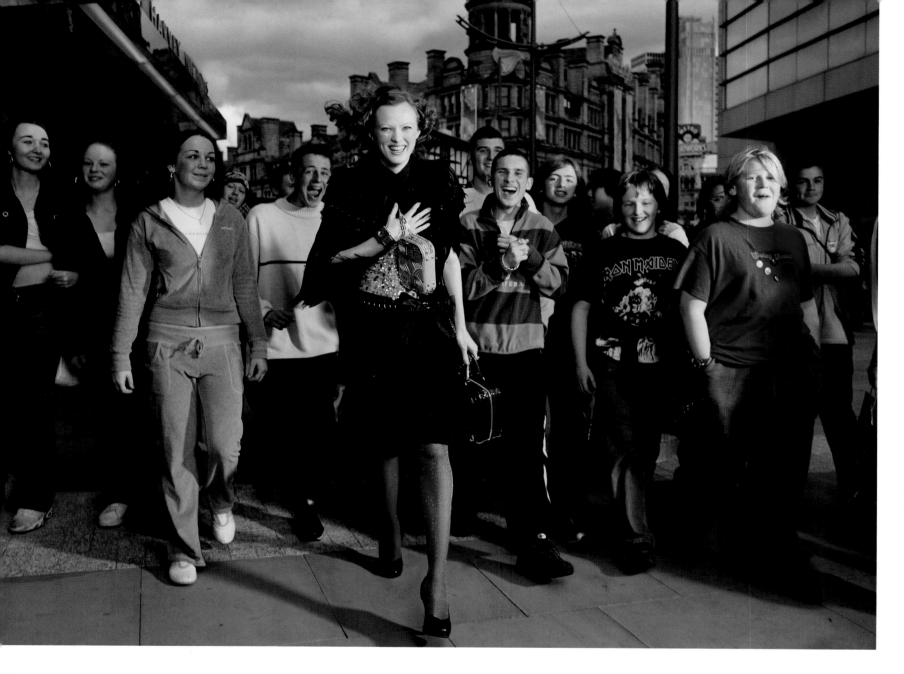

MK: We've talked a bit about a realism or naturalism that is associated with your work and I think that this comes across really strongly in the group shots in this story. There is a quality of people having fun in a convincing way. How do you start to construct that in a picture? How do you get that to happen?

EC: In the image where she is walking down the main street in Manchester we didn't know, when we set up the camera and the lights, that we were going to get all those people around. It was the image I envisaged before I shot it, but I didn't have a clue how I was going to make that happen. We started by getting Karen walking up and down in the main street. I was running

backward with a camera with someone making sure I didn't bang into anyone. I've got an assistant with one light running to the side and then another assistant running another on rollers, I've got a big boom behind me facing her and then I've got a side light. And we are all running. There are four of us running and she is walking. So that's a bit of a performance in itself. Then you start getting kids asking "What are you doing?" and I started shouting "Come on, get behind her" and it just happened like that. We'd go back and run again and back and run again, and as we did that more and more kids joined. It was completely spontaneous. None of those kids knew five minutes before that they were going to end up doing it. That was a unique experience.

Elson Street
Commissioned for *Pop*, 2005.
I was interested in doing
something on my own terms,
about someone coming back
and seeing how things are.

Elaine Constantine: Composition

MK: Was it similar when she was in the school yard?

EC: Ahead of time we contacted her old school and told them what we wanted to do. We said we wanted to bring Karen to the school and see if it was possible to get the kids involved. We sent a folder of her work to show the kids, and then on the day we had head cards so she could sign autographs. That was the job done. They were so excited to see what someone from their school had achieved. It doesn't always work like that. Most often I hire models and extras. What I often do is have a shoot setup that looks like it's a bit of a party, maybe with a DJ playing. I've got four assistants and we test the lights with them jumping around in front of the flashes to find out if the movement is freezing. Generally you get people in front of the camera and give them very specific instructions about how to behave, and they go for it, especially if it is in a group. I might say something like "Your eye line is this corner of the softbox, you are going to run 10 paces, and when you hit the line you are going to look and scream." So you start doing that on Polaroid and then you've got some energy up. You can start to move it around so that not all the eye lines are in the same place, but you need to give everyone a direction or motivation of some sort at the start. It seems spontaneous when you look at the image, but it's not. It's very tightly disciplined. We normally shoot in sunlight complemented with a lot of flash, which means you can get detail on product. Sometimes you have to fill it in from lots of different angles, which is why I have so many assistants.

MK: I think the angles you shoot from are interesting, coming in close, from below, not just from the front. The frames are quite crowded and colorful. This is true of the Elson story in the playground. How do you determine the angles?

EC: It often comes from clients wanting blue sky. I quite like the idea that if you are building up that energy you need to get in close to feel like you are actually there. I think the energy factor holds it together. It's not always purely spontaneous. The composition in a Diesel campaign I worked on was very carefully constructed. We did a lot of frame grabs from musicals like *West Side Story* and *Hair*, so we had very specific dance moves that we wanted to put together in each different treatment. It wasn't only me directing all of that, because we had a choreographer, so it was a collaboration between us.

MK: For a complex story like that, would you use diagrams and storyboards?

EC: I think the main starting point for me is an image. You start there, you might repeat it in your Polaroids, but then you push it a step further and a step further until it becomes something else that is specific to the mood you're after and what you're shooting.

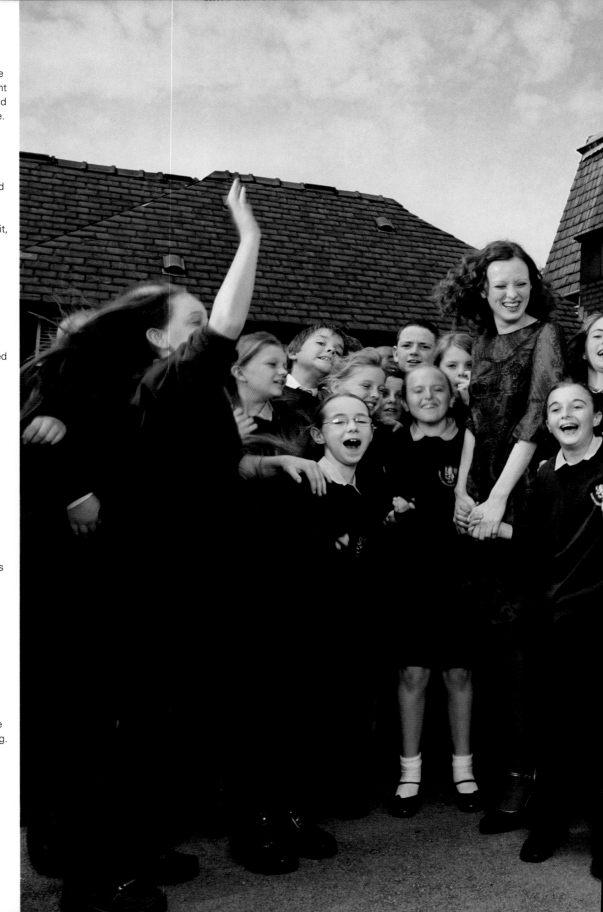

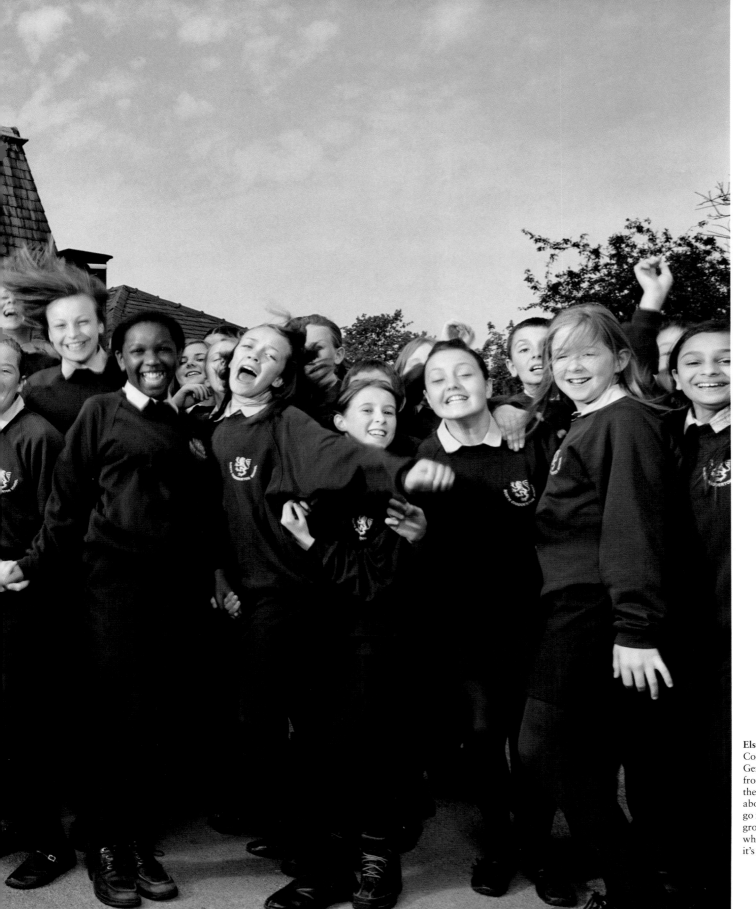

Elson Street
Commissioned for *Pop, 2005*.
Generally you get people in
front of the camera and give
them very specific instructions
about how to behave, and they
go for it, especially if it is in a
group. It seems spontaneous
when you look at the image, but
it's not. It's tightly disciplined.

MK: Is location important to you? How did you figure out the locations in the Elson story?

EC: We just knew. We all lived in Manchester. Everyone was very helpful.

MK: How many days did it take to shoot?

EC: Two.

MK: There are a couple of portraits in there as well, but there is still an energy. They are not really reflective.

EC: I think it was Karen's attitude. She is challenging. She's not someone looking off into the middle distance. I was giving a bit of direction in pose, because there was an unreal element to what we were doing. It was more about the idea of going home and revisiting old haunts than in the Giselle story, which was much more documentary.

MK: Did you shoot a lot? Working with kids and groups, is the edit important to finding the right picture?

EC: We shot about 10 or 11 setups and used about six. You know what you want when you are on the shoot because you've got Polaroids that you keep referring to. Also, the crop can be important. You know roughly which image is going to work when you edit. Sometimes you can be surprised, but I normally just try to edit nearest to the best Polaroid. When I start shooting film it doesn't look that different from when I stop shooting, even though people might be moving around. You are looking for a nuance of a face turning or an arm going up. After I set it up, the camera doesn't normally move, it will be locked off on a tripod and the cast will be in the same positions throughout. It's almost like taking a studio outside in that way.

MK: Was there anything that surprised you in this shoot?

EC: The final images were photographically what we wanted. Style-wise the content, with the contrast of ordinary, unstyled people, gave us a bit of a surprise. I think that is because we didn't necessarily want to work with big labels, but it developed its own wonderful look. We were thrilled with that. There was only one setup I didn't like; where she was dancing in an Irish Club. It felt too alienating. It felt wrong.

MK: You are currently involved in a film project. How do you see your engagement with fashion photography continuing?

EC: Coming back to fashion photography after having some time away from it is nice. I don't want to work it in the same way as when I was shooting back-to-back editorial. I don't have the interest because I feel I was able to break from the cliché that I hated. It comes down to finding projects that I'm interested in. I've agreed to do a cover of Scarlett Johansson for *InStyle* magazine. I really liked her, and they've wanted me to do something with them for a long time. I'm up for the right editorial commission, where I don't have to repeat the things I've done.

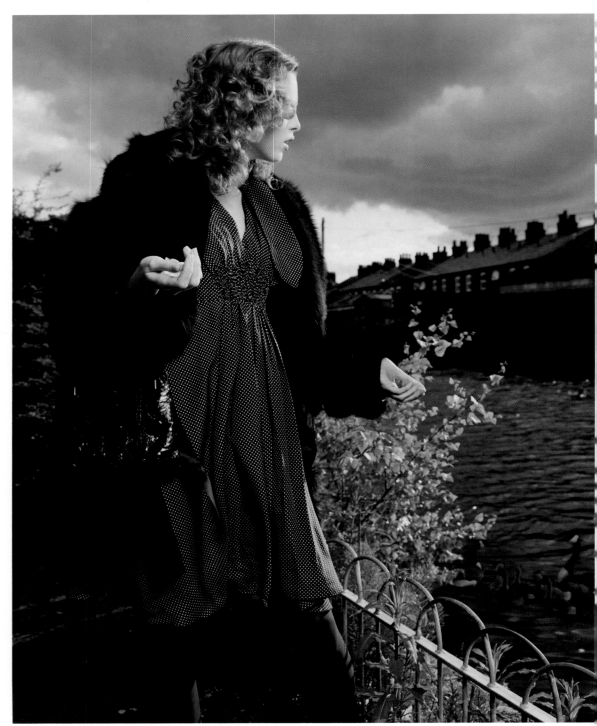

Left and right:
Elson Street
Commissioned for *Pop*, 2005.
When I start shooting it doesn't
look that different from when
I stop shooting, even though
people might be moving around.
You look for a nuance of a face
turning or an arm going up.

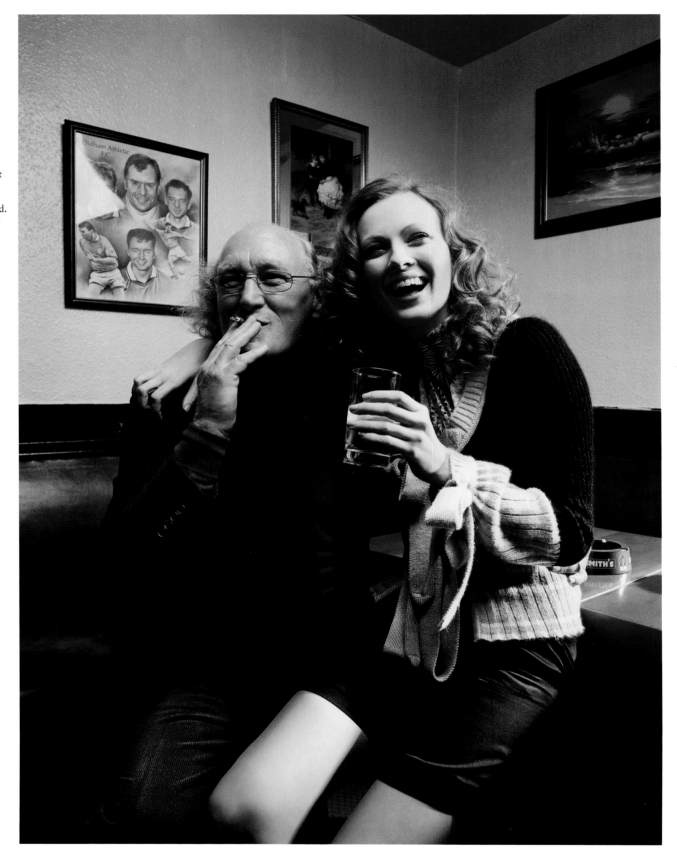

Elaine Constantine: Composition

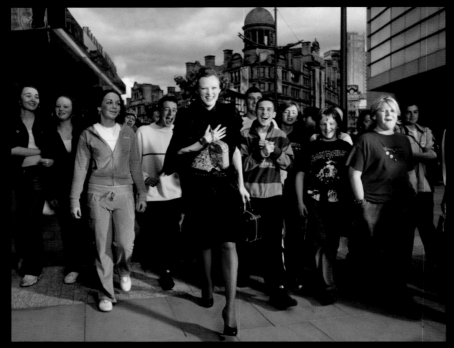

Workshop

This lighting setup illustrates a walk-and-shoot technique, with the photographer walking or running backwards with the camera and flash heads held on boom poles by lighting assistants. For this image, Constantine had two assistants to help with sidelighting: one ran alongside her carrying a flash head, while the other ran another flash head along rollers. A third assistant held a big boom light behind Constantine, to face the model.

Constantine's essentials

• Loupe

• Peppermint tea bags

• Sleeping pills

Specification

CAMERAS: Mamiya RZ67, Fuji 6 x 7

LIGHT: Profoto 7As

FILM: Kodak Portra 160NC

EXPOSURE: Details not available

Suggested reading

American Prospects, JOEL STERNFIELD, Steidl Publishing, 2004

Family Business, MITCH EPSTEIN, Steidl Publishing, 2003

Imperfect Beauty, CHARLOTTE COTTON, V&A Publishing, 2000

In Flagrante, CHRIS KILLIP (photographer) with texts by JOHN BERGER and SYLVIA GRANT, Secker & Warburg, 1988

Martin Parr: Photographic Works, VAL WILLIAMS, Phaidon Press, 2002

The New Color Photography, SALLY EAUCLAIRE, Abbeville Press, 1981

Unknown Weegee, LUC SANTE AND CYNTHIA YOUNG, Steidl Publishing, 2006

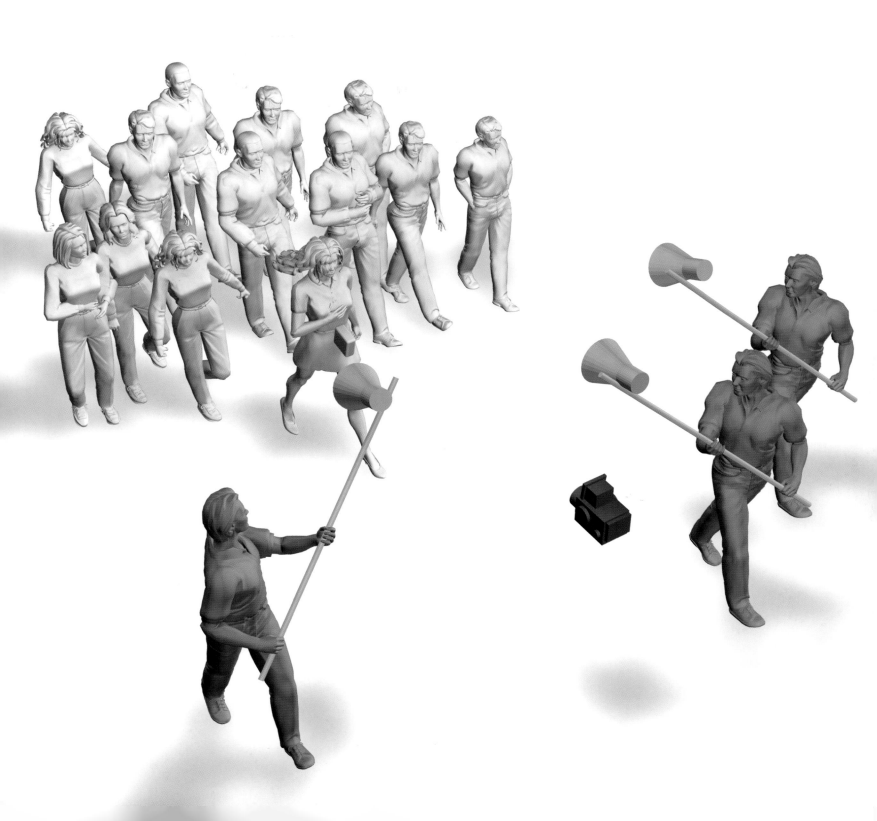

Du Preez and
Thornton Jones

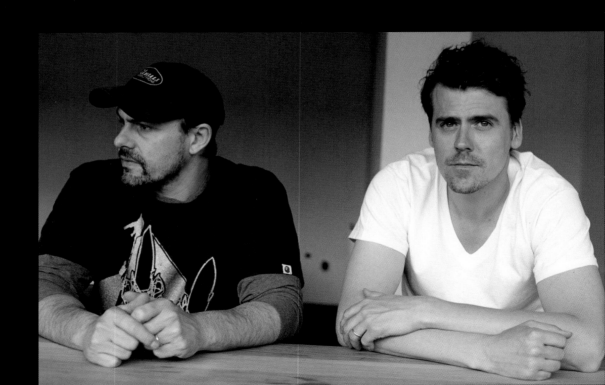

Digital platforms

Warren Du Preez and Nick Thornton Jones have been working jointly as image-makers since 1998. Their creative collaboration is the result of a shared commitment to the development of aesthetic ideas that push the boundaries of analogue photography, illustration, film, and digital platforms applied primarily within fashion, design, and music contexts. Thornton Jones, with his illustration/art direction/design background, and Du Preez, self-taught as a photographer, continue to deconstruct, mix up, reinvent, refine, and hone their skills with precision and depth through a rigorous working process. Combining digital expertise with seamless elegance, very often pushing imaging applications far beyond any known potential, or creating new applications themselves, their work might be considered a symbiosis of scientific inquiry and high art.

Du Preez and Thornton Jones have undertaken many groundbreaking projects with clients including Björk, Issey Miyake, Levi's, Hamish Morrow, Cartier, and Massive Attack. For Morrow and Massive Attack, these took the form of cross-media presentations utilizing film as well as still images, and working with leading research and development teams in lighting, software, and image-capture techniques.

Their work has been the subject of a Gas Book monograph (Gas Book 14), and the pair have also collaborated as image-makers with experimental fashion designer Suzanne Lee on the publication *Fashioning the Future: Tomorrow's Wardrobe* (Thames & Hudson, 2005), which was also presented as a film, *Fashioning The Future: Mutation*, at the Institute of Contemporary Art, London, in 2005.

Aria, shot for *Big* magazine's Air issue (no. 61) and featured on its cover, marks a much-anticipated return to editorial contribution after a well-considered break from the arena. Though the 2000s saw an explosion of photographers using slick digital effects in their layouts, Du Preez and Thornton Jones' practice stands apart on almost every level, from their personal creative drive and their approach to collaboration as a team and with clients, to their deep conceptualization and contribution to a brief, and their sophisticated understanding of image-making. They are, without doubt, leaders and innovators in the field, applying, but also questioning digital platforms to achieve new, more potent visual expression and language.

As discussed in the Introduction, the application of digital technology across almost all parts of the photographic process has radically altered the way fashion and advertising images are produced. This includes the way the shoot is conducted, in editing and postproduction; the presentation and handover of images to a magazine or client; the role and input of the client; and the final appearance of the photograph in a layout or advertisement. In the best-case scenario, digital technology facilitates creative options that are not possible with an analogue process and, theoretically, promotes a quicker and cheaper way of working.

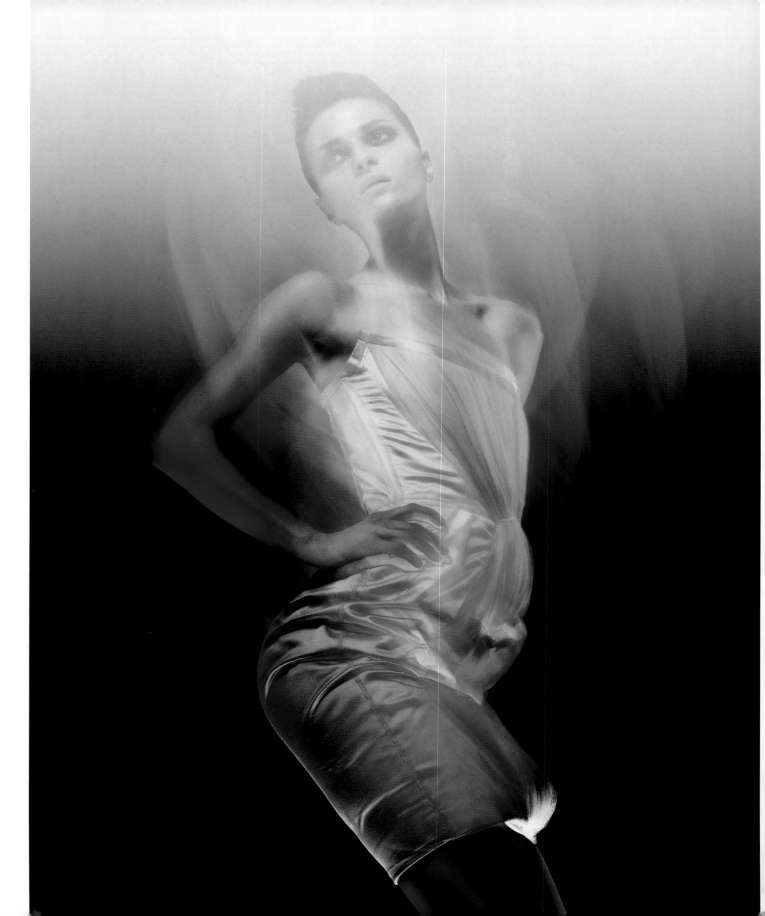

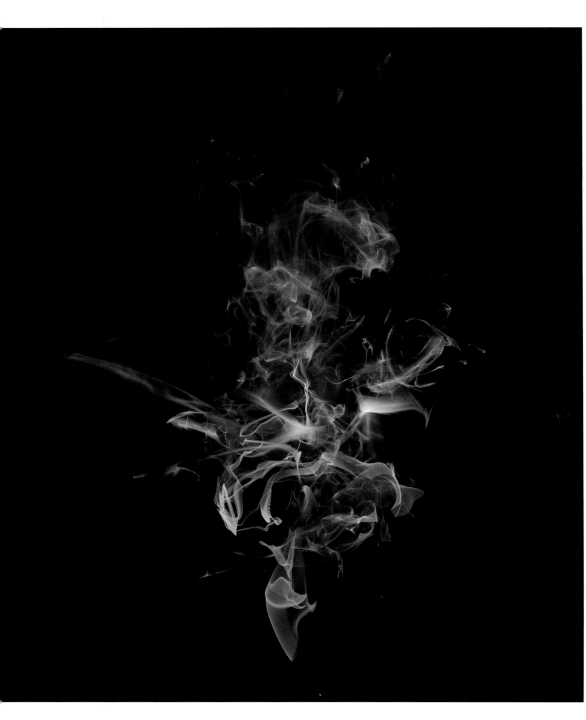

MK: You guys are the only image-making pair in the book. I'd like you to tell me a bit about your background and how you came to work together.

WDP: I started assisting a photographer called Thomas Krygier who was quite left-field and nonconformist. He had no formal training and neither did I. We were doing lots of cover jobs for *The Face*. What I learnt from him was the concept of capturing images and imagination. It gave me the faith to pursue what I believed, in the sense of making images. Thomas didn't want to get bogged down in the technical side which allowed me to grow very quickly. My assisting helped open some doors and get momentum. *The Face* gave me my first job, in 1991, which was an eight-page portrait story, and I was signed by an agency called Hamilton's who looked after people like Helmut Newton. After that it was about formulating a career and applying myself. You realize that it's not getting an agent that will change your life, it's your relationships that will change your professional life: your relationships with art directors, magazines, and clients. I established an important relationship with *The Sunday Times* and I was working with portraits a lot at that stage. That's how I met Nick. Through *The Sunday Times*.

Left and far left:
Aria
Published in *BIG* magazine's Air issue, 2006. The important thing is that there really aren't any rules. It's just getting on and doing things on an ideas basis.

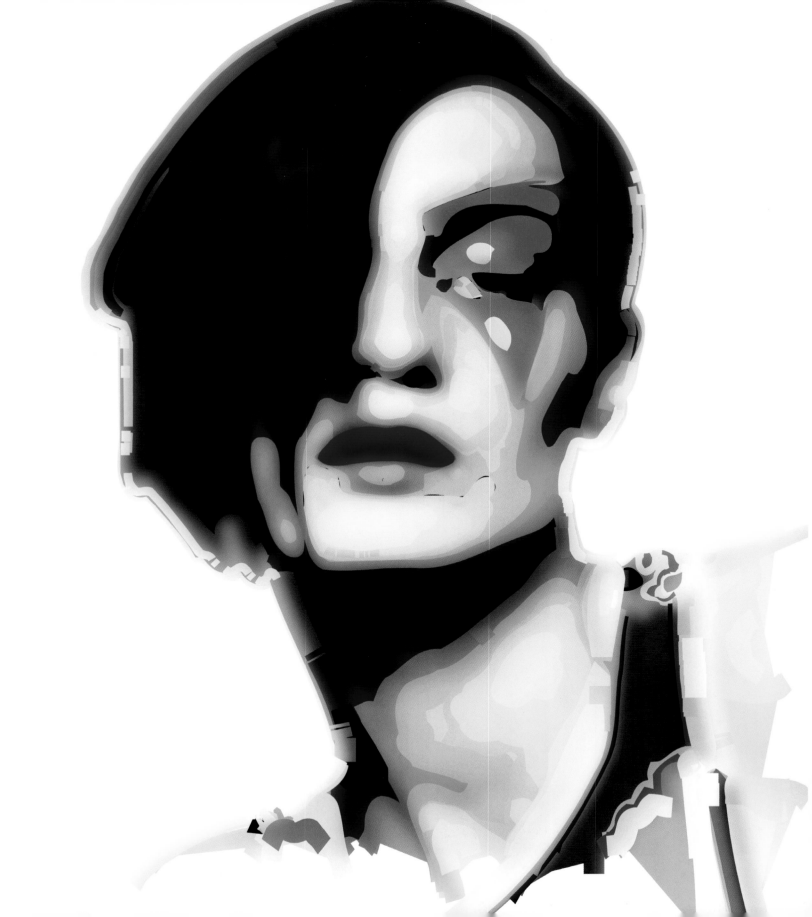

Erin O'Connor
Cover of *Dazed &
Confused*, October 2000.
Nick's and my premise is to try
and invent things and to try and
find things that haven't been
seen before, with photography
and illustration combined.

NTJ: I studied graphic design at college. When I left I got work at a corporate design company, but wasn't into it. A friend had set up a magazine at *The Times*. We had worked together on it and when he left I got his job. My office was next door to the office of *The Sunday Times Magazine* and I developed a relationship with the art directors there. I was very interested in what they were doing. I spent months going back through the archives from the '60s and I really got to understand why they were so respected in the industry and how important the magazine was. I showed them my work and they were into what I was doing, so when a vacancy came up I became their Senior Designer, and then the Art Editor. They let me have control of the fashion issues. I met Warren through the previous art editor. I was losing interest in design and graphics, the fundamentals of it, and was getting back to the appreciation of images and shape and form. Warren was a whirlwind of a guy on a push-bike. I remember him vividly. We did an issue on the moon and commissioned him to do the main fashion. His story was amazing. It was new and innovative and the best thing that had happened that year in any magazine. We did the retouching on the piece together and we got talking about making images.

WDP: There was openness to experiment between us and we thought, "Why don't we give it a go?"

NTJ: For the first year or so Warren did what he did and I did what I did. We didn't let those things interfere with our collaboration. It was just a platform for thought process. I still had my job at *The Times*, but we knew something interesting was going on. We started breaking images down on system. We talked about imagery and what we thought was missing. So conversations started. We'd meet up before and after work to talk and develop ideas. Then I bought my first computer, a Macintosh G3.

WDP: Buying a computer was pretty much unaffordable at that point, to most contemporaries, so it was a major thing. It was like buying a car!

NTJ: We spent a lot of time playing and pushed and pulled and worked and worked with images on the computer.

WDP: There was a flux, and things were starting to change. I remember beginning to formulate what we were doing.

I'd gone to Paris for a meeting in 1999. I'd said to Nick I thought we were ready to start showing some of our work. I had no idea where or how it fitted. People like you to have a consistency and are confused if you show portraits and fashion and still life together in your book. I showed the work and everyone was really excited by it. Nick's and my premise is to try and invent things and to try and find things that haven't been seen before, with photography and illustration combined. As we were learning and absorbing things, we realized that a really important part of making successful images was the way they'd been lit. The laser and alternatively lighted stuff that rendered images in an illustrative form really struck a chord.

NTJ: I think it was because they were hard to figure out. People couldn't understand the way the image departed from its original capture because we were using such a unique light source, and it had been taken somewhere else after the photographic process. It brought something graphically to an image, from a line point of view, that was original and interesting. One of our first commissions as a team was to do a cover for *Dazed & Confused*.

WDP: Before that *Creative Review* did an eight-page feature on us which was a really big thing. All of a sudden there were Nick and I doing work that was hypervisual, which only belonged to one or two other people in the industry at that point. That made it seem real, not just something we were consuming ourselves with.

NTJ: The important thing we want to get across is that there really aren't any rules. A lot of people don't necessarily understand what we are trying to do, as someone from an art direction and illustration background and someone from a photography background. There are no rules to that. It's just getting on and doing things on an ideas basis.

WDP: I do things because I want to, because I think they are interesting. You don't have to be conformist. You don't have to apply a formula. You should do what you feel. Our first commercial commission was for the fragrance Cacherel. It was a big print and TV campaign. It gave us a sense of how to survive as a team, and it gave us financial security and allowed us to gain some creative momentum. It went well, but I thought, "Anyone can fluke something," so it became our preoccupation and challenge to do it again and again and again.

MK: When I was thinking about people who use digital platforms and push things inside and outside of camera, it struck me that you guys approach the medium not as a one-off trick or gimmickry. I like the way digital manipulation is a part of a complex process of image-making for you. And you've sustained that over a really long time.

NTJ: It has to begin as a personal thing. It has to be your process if you are going to repeat and develop it. In our preparatory work early on, we got into the mind-set of creating our own terms. It was about thinking, "Let's try this. Let's see if it works." We were also fortunate to get commissions with people who allowed us to continue that philosophy. One of the most poignant examples is when we were commissioned by Björk that year to do her worldwide press. A big part of the commission was that she didn't place any restrictions on us and the way we worked. We spent over six weeks in postproduction and did over 40 images for her. It strengthened our belief that you can have a successful and important process outside what is captured on the day.

WDP: We have a natural desire to keep creating and moving. Sometimes you need to slow the process down, so it becomes a balancing act, but you also need to keep excited about what you are doing.

MK: Often you don't use stock techniques; you work with people who help you create new techniques and technology and apply them to your images.

NTJ: Even when we were doing very graphically based work on Illustrator, an important aim was not using available filtering systems. Or if we wanted to work with the tools available, to take them somewhere they hadn't gone before. Like pushing the wrong button for the right reason. We would spend weeks on computers just doing that, which in a sense amounted to nothing, but sometimes little gems appeared.

MK: Is there any particular tool that you think led to or is most important within the massive technological advancement of the past decade?

NTJ: I think Photoshop. It changed the face of image-making and photography.

WDP: It enabled a digital interpretation of an analogue process. When I consider the period 1996 to 2000, when the changes really started to kick in and alter the process of how we were working as photographers and image-makers, it became an affordable entity outside of big corporations and retouching houses. It could become part of your own process if you wanted it to be.

NTJ: Now I think what is important to remember is that, unless you have that process, you are out of the game. It's expected of you.

WDP: You won't get a look-in to the 1% work factor.

NTJ: The demands of big campaigns, with the timescales, the people involved, the work between the studio and postproduction schedule, mean they aren't achievable off the shelf. Working with a retoucher on a personal level is the norm, and unless you spend the time working with the medium day in and day out, and experimenting, you can't get a good knowledge.

MK: Some of your imagery shows the work of an extreme technical virtuoso, like the work you've been doing for the new Massive Attack video which looks complex and digital. But I like it when you back away from that a bit and turn it down.

NTJ: We do too. We like to work at the extremes. There is a lot of subtlety in our work at the moment because we think it is harder to find: it's pure and fine. But we'll still scream. At first special effects were all about what you could see and what was new. Now it's more built on what you can't see. That's ultimately where a lot of our work has gone: to something that you don't necessarily know has been done on a computer.

Worldwide press campaign
Rolled out for the launch of *Björk: Greatest Hits*, 2003. A big part of the commission was that Björk didn't place any restrictions on us and the way we worked. We spent over six weeks in postproduction and did over 40 images for her.

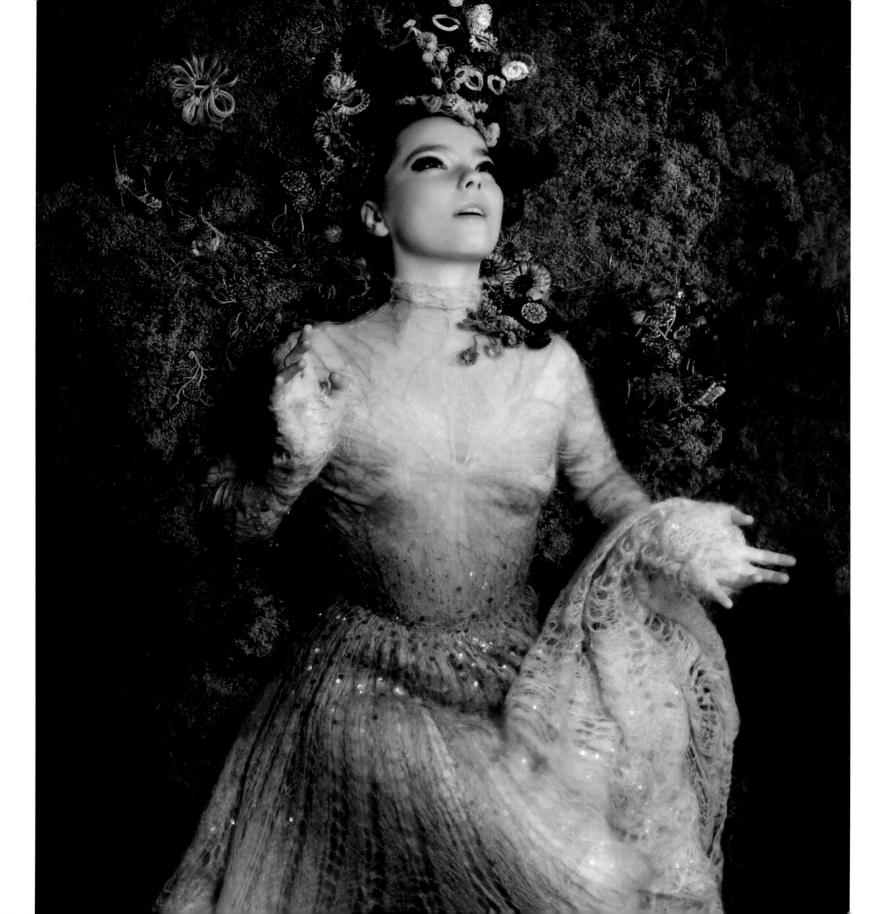

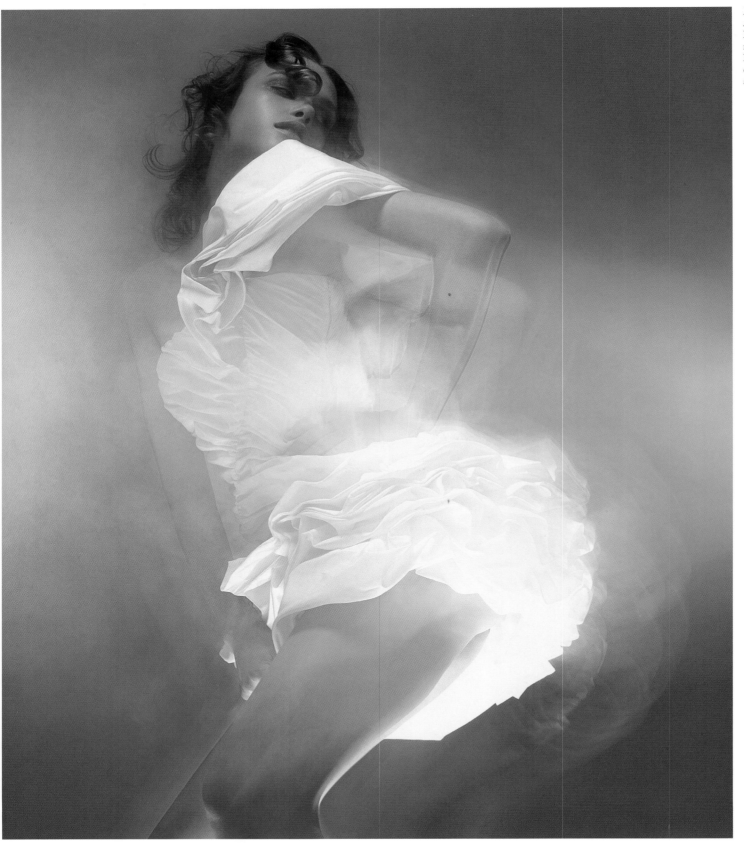

Left and right:
Aria
Published in *BIG*
magazine's Air issue, 2006.
If you are going to repeat and
develop a process, it has to be
a personal thing.

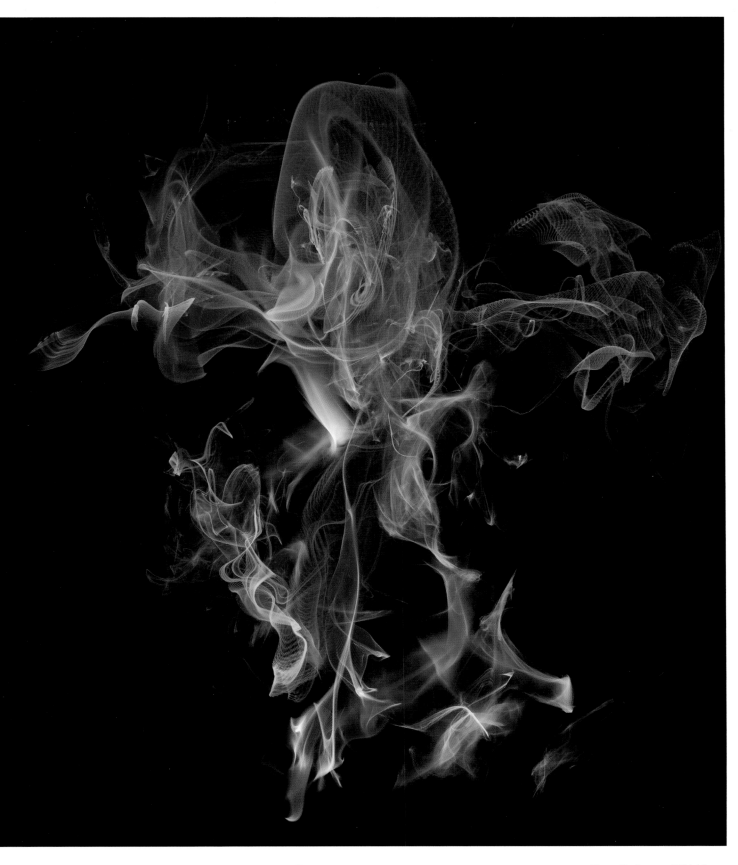

Warren Du Preez and Nick Thornton Jones: Digital platforms

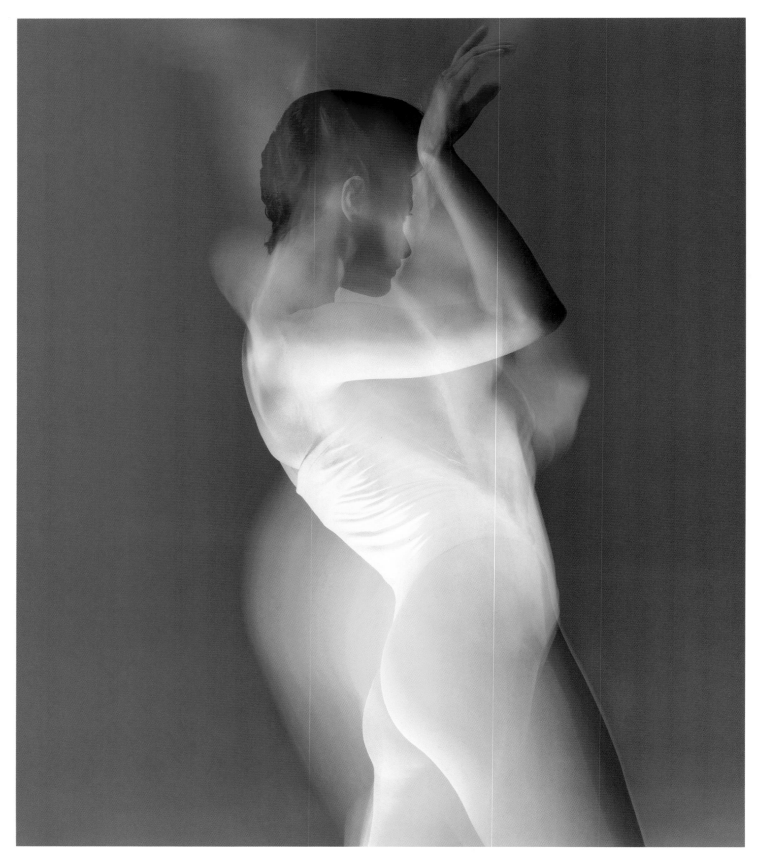

WDP: There's a lot of refinement involved. In the period from 1998 to 2001 our work was considered to be "hypervisual." We became known for those images, but it was also a product of the time because people hadn't necessarily seen things like that. We wanted to do that because it was pushing things.

NTJ: Another thing that has really changed the way we've worked recently is doing more movie-based projects because within that are massive digital applications that you do not see. We work technically with some of the real cutting-edge innovators in the digital world. They have allowed us to take some of that into our still image-making. We are moving more toward 3-D. So we might work on a beauty image and make the skin believable, but to a really high standard so there is an ambiguity between is it real or isn't it real? What have they done? What haven't they done? I think that if one could bring the concept of 3-D into a still capacity, in one frame, in high resolution, then it would be seamless and alive. That's where I believe we are headed; how we can implant the unseen in reality as opposed to the unseen in an overtly futuristic or fantasy world.

MK: Can you tell me a bit about the commission for *BIG* magazine?

WDP: Each issue is put together by a different art director and based on a different subject or theme, so there is an independent construction to each issue.

MK: How did they explain the concept for the "Air" issue to you, and how did you translate that abstract idea into a photo shoot and development of a sequence of images?

NTJ: The Creative Director of the magazine, Toni Torres, who knew us, suggested to the Creative Director of the issue, Monica Paganucci Wolfington, that our work was appropriate to a subject matter like air.

WDP: I think they were interested in our take on the vaporous or visceral elements in a more abstract way rather than a literal level. I think they wanted some poetry. The rest of the issue is quite natural.

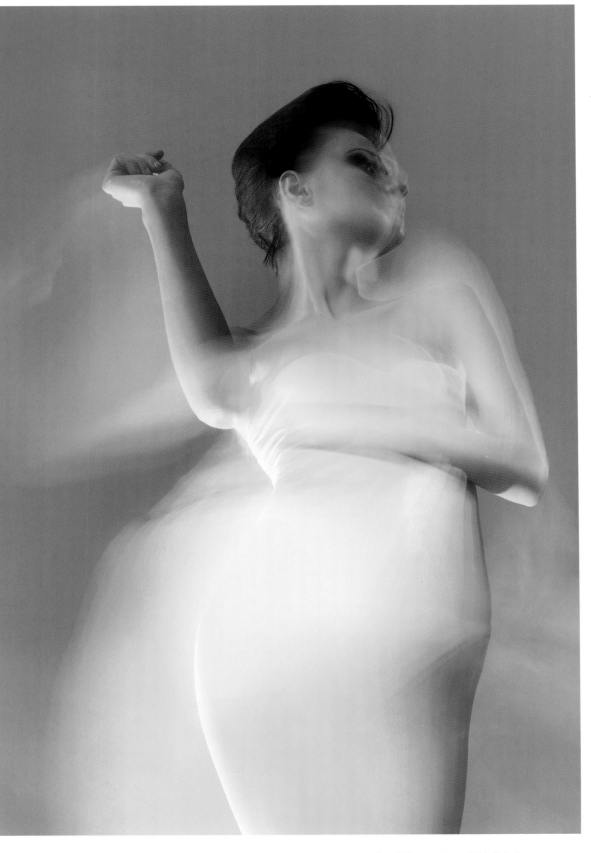

Left and right:
Aria
Published in *BIG* magazine's Air issue, 2006. We might work on a beauty image and make the skin believable, but to a really high standard, so there is an ambiguity; is it real or isn't it?

Warren Du Preez and Nick Thornton Jones: Digital platforms

MK: What was your basic starting point? There is a juxtaposition of figurative fashion poses with abstract light compositions.

WDP: They're not light. It is 3-D, but the viewer perceives it as light. There is a hidden geometry in it that you don't get with light, even with our strongest laser work.

NTJ: A lot of our work deals with light. We knew that we could use light as a metaphor for air. The context for it was fragrance. It's something that is fascinating to us because you can't see it. We thought, let's try and perceive what it would be like to try and see fragrance in air.

WDP: We wanted to include other elements. We wanted it to be poetic, but to have a fashion element because that also links to fragrance. We work a lot in fragrance.

NTJ: But when you do work in fashion with fragrance, there are so many restrictions it's difficult to delve into the unconscious or the unseen. We wanted to try to see and feel fragrance without having to focus on a celebrity face staring in a campaign.

MK: How much preparation was involved before the shoot?

WDP: We knew what we wanted to create, but we couldn't quite visualize it 100% beforehand. We went into the studio with the research and development of the abstract imagery. That is what drove us. We'd been working on some motion-based stuff in 3-D. We wanted to bring that to the images. We are quite organic when we work in the studio. It's always relative to the project.

NTJ: The initial research came from film work we've been doing in 3-D. One of our first ideas was, let's just do eight to ten pages of our researched process. It's perceived as light and air. It's very dry underneath, but beautiful on the outside. In the time available it wasn't possible to make enough variations we were happy with, so it pushed us to come back to the human element. We hadn't created the abstract stills before we went to the studio, but we'd seen it in motion and knew we could arrest it. The challenge in the studio was how to create that with a human being and retain a sense of motion. In air it is all about movement. That was our goal. We didn't have sketches, but we knew we could get there if we explored it.

WDP: We had a snapshot of a motion piece we liked, but the colors were wrong. We'd been working on the commercial and in one small film it felt like an essence of a fragrance in light. Sometimes we have this blind conviction to just go and do it.

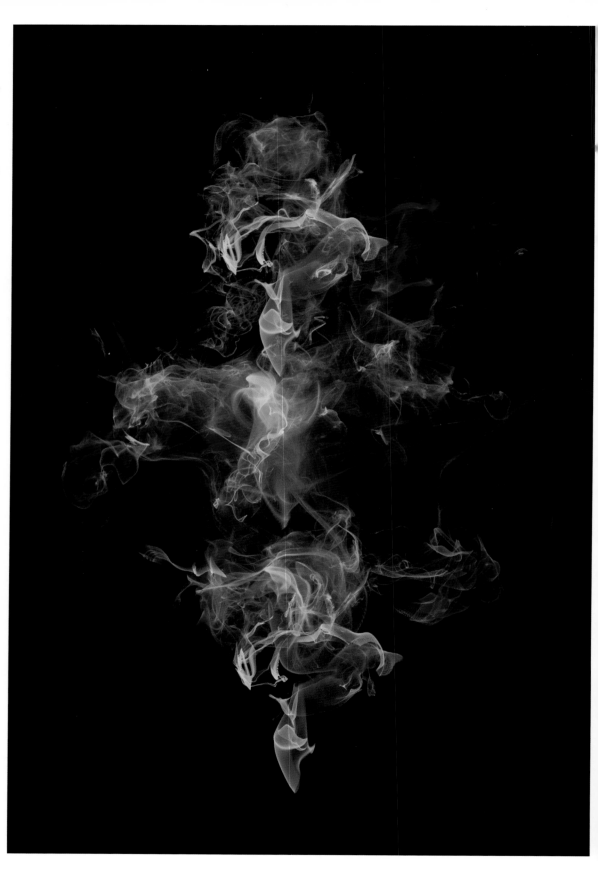

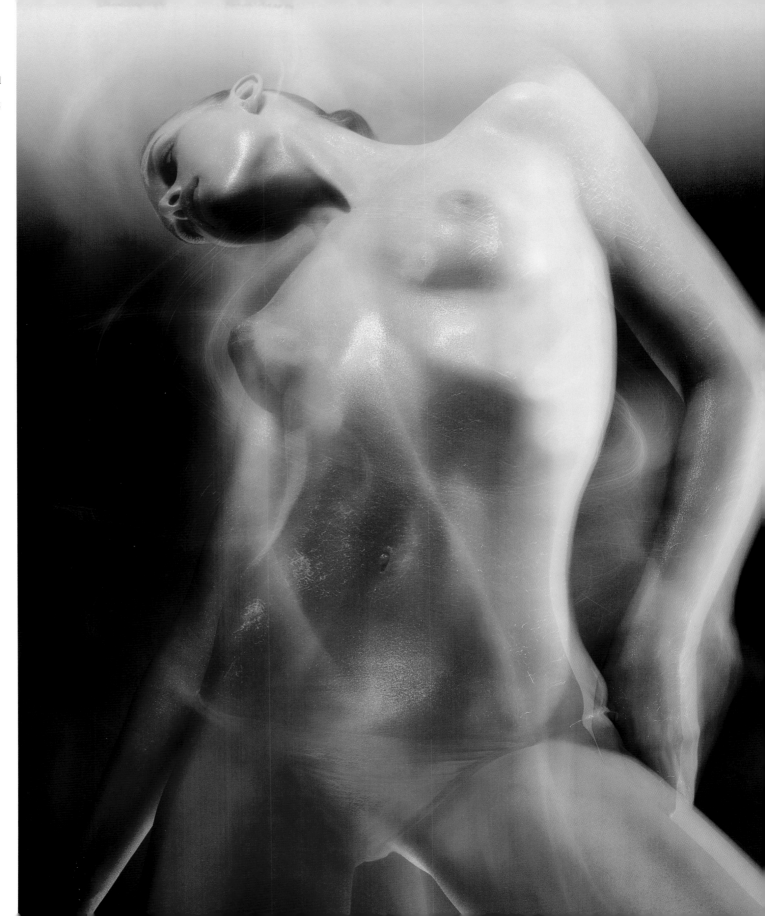

Left and right:
Aria
Published in *BIG*
magazine's Air issue, 2006.
We wanted to try to see and feel
fragrance without having to
focus on a celebrity face staring
in a campaign.

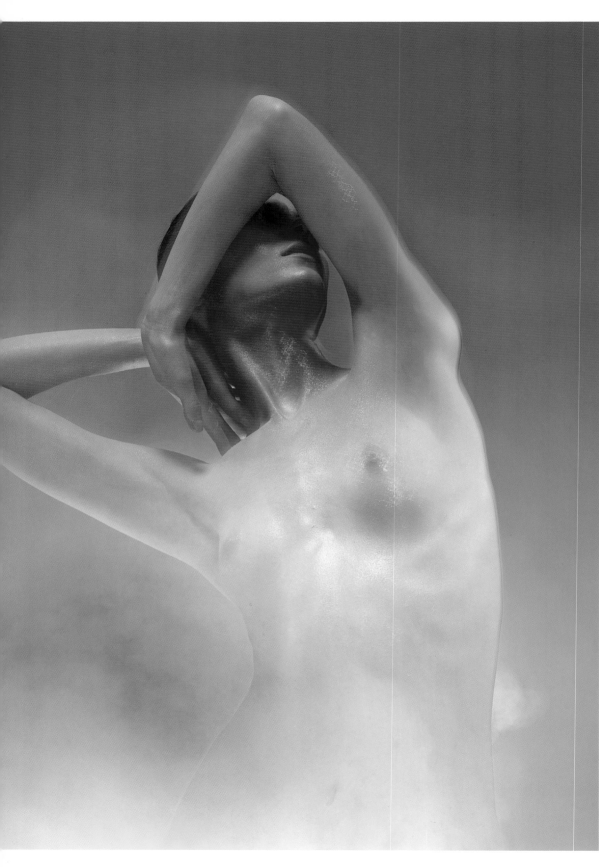

MK: Let's run through the shoot in the studio.

NTJ: The idea for us was coming from being clothed to an undressing. We wanted to use colored light to represent this and break apart around the girl. There isn't a lot of postproduction in the figurative images, so all of the light is done in camera, which is important.

WDP: We wanted some playfulness rather than it being overt and steamy and about sex. I think that is what the light does.

MK: Can you describe something of how you achieve the sense of movement through the lighting?

WDP: It's a combination of mixing two media. It is electronic (flash) and alternative light (tungsten), or specialist light that was built specifically for the art direction and shoot; the movement comes from playing with the relationships between the shutter and exposure.

NTJ: If you want to show emotion it has to happen over time, but if you have the shutter open for a length of time, you have no clarity because you are essentially creating a blur. You have to put two forms of capture together in one. There are a lot of things going on in those images to make the light bite into the skin and into the surroundings in different ways. Partly that was done using different viscosities in the air.

WDP: We had rotation tables so the models didn't have to move. The rotation rig is moving and they were on it so we could find compositions we were happy with without it being forced.

NTJ: Different sheens and glitters were also applied to the model's skin, which gives the light something to interact with.

WDP: It's very difficult to describe what we've done as there are so many nuances within it. It's years of refinement and observation and study. It's not one trick or a single device.

Left and right:
Aria
Published in *BIG*
magazine's Air issue, 2006.
Hundreds of frames go to make
one image, and they are all just
a series of dots coming together
to make one pattern or form.

MK: Let's move to the abstractions now.

NTJ: We worked with a small, but really top film postproduction house and spoke to them about trying to bring some of the moments from the film we'd been experimenting with to a printed still-image resolution. Film resolution is small and doesn't translate to a page. We've done a lot of light-based capture so we know the clarity and texture we can get back, but we needed to develop the gradation and ranges and the size. Particle work takes a long time even at a film state, which might be 1 meg, and then you are asking for around 100 meg. You are asking someone to crunch a lot of numbers. It takes a lot of time to achieve this render. Hundreds of frames go to make one image, and they are all just a series of dots coming together to make one pattern or shape or form. We had to work with low-resolution film and choose the end point of what we would like to render to. We then took the high-res frames and from those frames generated the images.

WDP: It was rendered as components and then put together in our studio. It had to go through our creative process. We got a whole bunch of files and placed them together for a complex image. We chose specific colorways and patterns, shapes and forms from our frames.

MK: Did the way the studio shoot worked out end up affecting the colors and shapes in the abstractions?

NTJ: We knew the palette in the films. The levels of primary weren't too high. They were slightly desaturated, slightly smoky, because they are always in flux and motion so it is never a solid color. I suppose when we went to light in the studio, the vapors in the air all aided the fact that the colors weren't going to be full-on or solid. The light takes on a pastel quality. We were trying to create images that were figurative, but that felt like the light-based films in motion. There is no greater feeling than knowing you are getting it, that you've found something you haven't made before and are creating it.

MK: You've managed to take something incredibly technical and make it look organic. It's amazing.

WDP: There are a lot of brilliant technicians, but at the end of the day a great image also has to have vision and poetry. That is a great mantra of ours: to try and find the organic beauty within technology and the digital revolution.

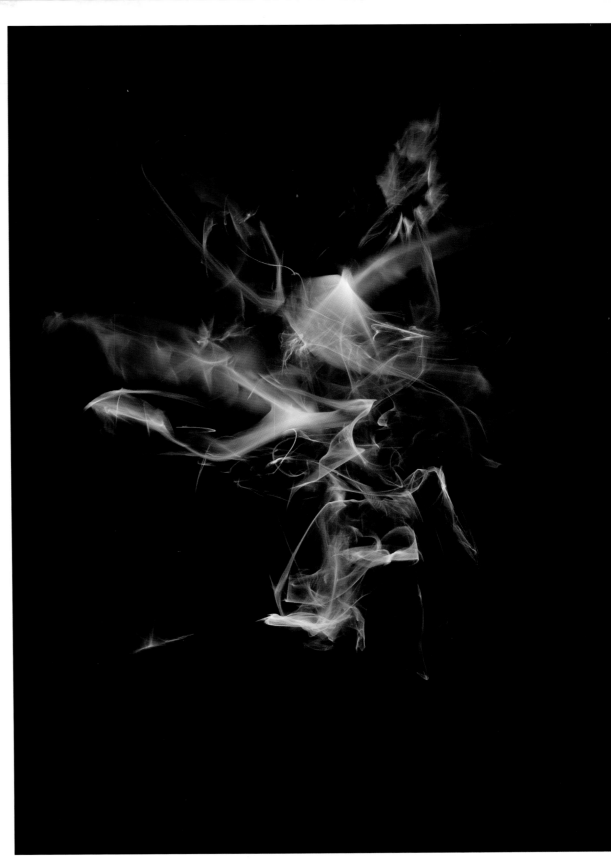

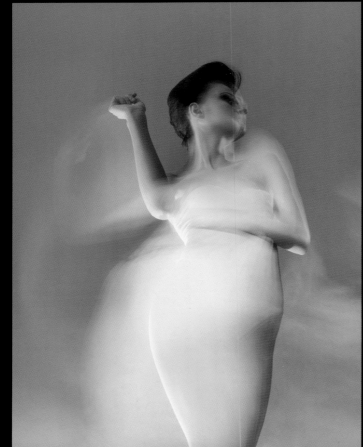

The visual effects achieved by Warren Du Preez and Nick Thornton Jones are the result of a living creative process and not describable in a single lighting diagram as utilized for other chapters in this book. In relation to their work, it is more beneficial to show the potential for the growth of an idea and the next step in image-making. The aim of this workshop is to inspire experimentation and ownership of the methodology and application of digital and analogue techniques. Du Preez and Thornton Jones believe this is the only way to achieve originality, and the level of professionalism and skill required to work successfully in the editorial and commercial arena. This still (right), produced roughly one year after the original story (sample image left) was published, illustrates the importance of continued research into the evolution of the image.

Du Preez' and Jones' essentials

The imagination and conviction to create or realize an idea or execute a vision. You should use equipment and a process that are relative to your own experimentation and nurtured process. It is hard to prescribe essentials when it is all relative to one's own ebb and flow. Making mistakes allows you to grow and develop your craft as opposed to just reappropriating someone else's process.

Specification

CAMERA: **Mamiya 645AFD II with Leaf Aptus 75 back**

LIGHT: **Broncolor flash and custom alternative light**

EXPOSURE: **Exposures and process not provided**

Suggested reading

Fashioning the Future: Tomorrow's Wardrobe, SUZANNE LEE, images by WARREN DU PREEZ and NICK THORNTON JONES, Thames & Hudson, 2005

Gas Book 14: Warren Du Preez & Nick Thornton Jones, DANIEL MASON, Design Exchange Co. Ltd., 2003

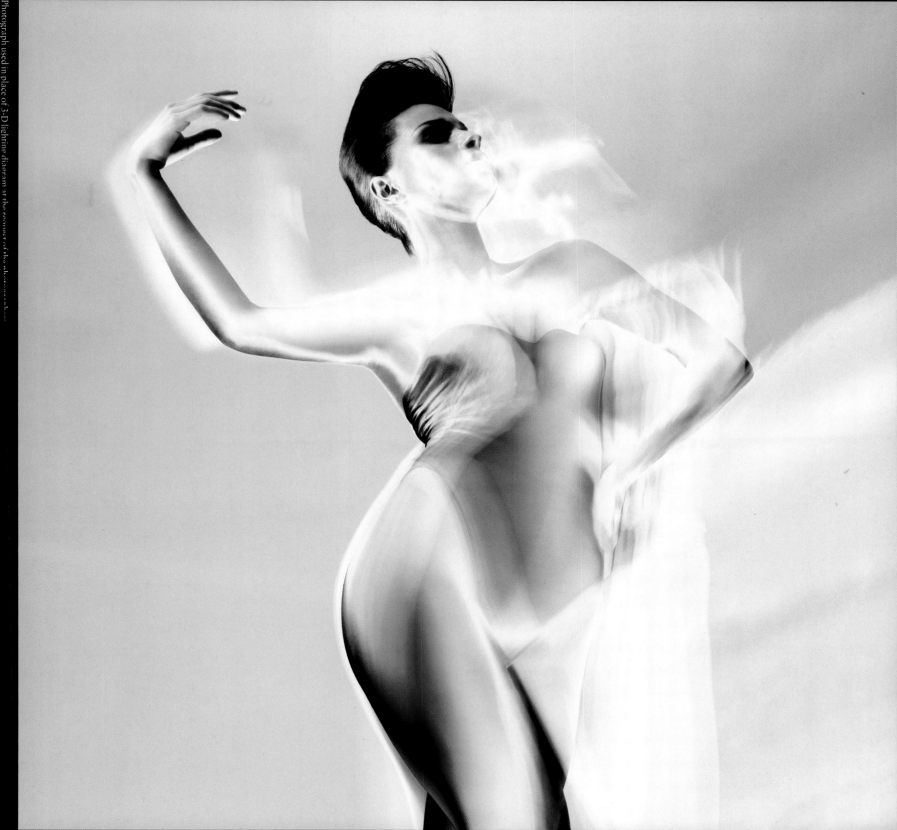

Jason Evans
and Adam Howe

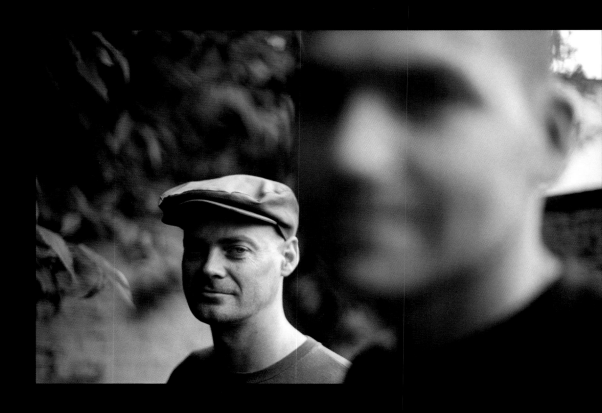

Photographer and stylist

[J]ason Evans studied fine art at university. [In] 1991 he started photographing for [i-]D magazine, and since then has [m]aintained an uncompromisingly original [an]d interesting approach to working as [a] photographer for both personal and [c]ommercial practice. His fashion images [h]ave a strong conceptual basis yet remain [st]riking, often amusing and unexpected [vi]sual explorations of color, structure, [an]d environment. Evans has been a major [c]ontributor to *i-D* magazine, shooting [fa]shion, portraits, and music photography. [C]ollaborations with stylist Simon Foxton [h]ave been commissioned as album covers [fo]r Four Tet, and he has also worked [e]xtensively with Radiohead. His distinctive, [d]ouble-exposed portraits display an [o]ngoing interest with in camera, analogue ["]special effects" alongside his commitment [t]o traditional techniques and formats. [E]vans has exhibited widely. His work is [r]epresented in collections including those [o]f the Tate Modern and the Victoria and [A]lbert Museum, both in London. He has [a]lso established the photoblog website [w]ww.thedailynice.com, and lectures at [t]he university College for the Creative [A]rts at Farnham, UK.

Adam Howe, who graduated with a fashion textiles degree, is a stylist. Since assisting 1980s design/style icon Judy Blame, he has established a hugely influential career. Howe has contributed to magazines including *032c*, *i-D*, *Arena Homme Plus*, *L'Uomo Vogue*, *Vogue Italia*, and *The Face*, working with photographers including David Sims, Glen Luchford, David Hughes, and Elaine Constantine. He has also styled for music, video, film, and album covers, including the effortlessly cool image of Róisín Murphy used for Moloko's album *Statues* (photographed by Constantine), now regarded as a classic. He has worked as a design consultant for Nike, among other clients, and is a partner in the menswear label Six Eight Seven Six.

Though in most cases paid less and given minimal credit for the overall authorship of the photograph, the stylist has a crucial part to play in creating what you see in front of the camera. A stylist makes real the sometimes abstract ideas of a photographer or client (or both). How a model or set looks—what the model is wearing and how, the effects and juxtaposition of color and texture, the overall composition of the image—is fundamentally affected by the stylist's advice. A stylist is often the first of the photography team to be sought by fashion designers or brands, so they can be influential in the choice of photographer. A stylist's contacts are crucial to the photographer's access to exclusive collections and designs. A stylist ensures that a photographer has the necessary clothing and accessories in budget and according to the brief.

In the best scenarios, as in the case of Adam Howe's working relationship with Jason Evans, photographer and stylist are collaborators, plotting the original idea and concept, contributing to casting, working together in the studio, and editing the photographs. Adam's ideas often determine Jason's approach to the photography. This interview highlights the importance of developing ongoing relationships based on trust, a shared sensibility, and the ability to recognize when the time to work together is right.

Adam Howe's work as a stylist has been highly influential over how fashion and clothes are worn, and also on photography itself. Both he and Jason (himself previously a stylist) were key protagonists of the gritty, low-budget, street-style fashion and photography in the UK in the early 1990s. This was as much about the originality of the clothes as the shoot itself. In keeping with this, young photographers moved away from the over-the-top production values of a traditional fashion shoot to more low-key, documentary imagery. Ironically, this aesthetic quickly became integrated into the mainstream.

There are many other such examples of stylists and fashion editors whose work has led and shaped rather than followed the direction of fashion photography: Joe McKenna, Katie Grand, Grace Cobb, Anna Cockburn, Simon Foxton, Venetia Scott, Melanie Ward, Nancy Rhode, and Olivier Rizzo. All work as creative equals to the photographers with whom they have produced some of the most innovative and captivating commercial imagery of this turn of the century.

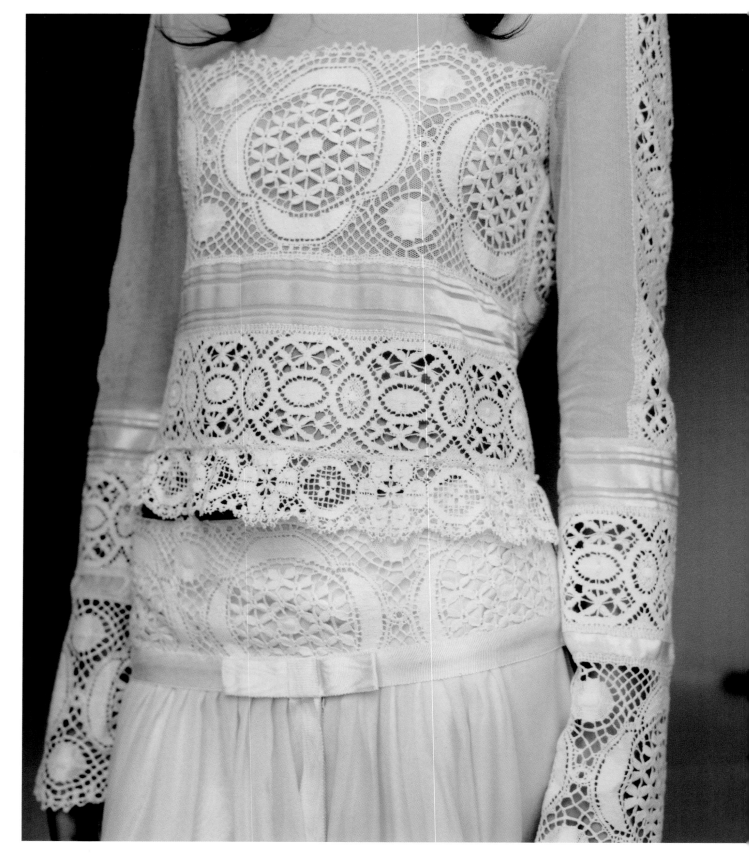

Right and far right:
Grace Abounds
Published in *i-D*,
September 2005.
We are applying the concept
of stripping everything away,
making something that is
unpretentious, unreferenced,
and straightforward.

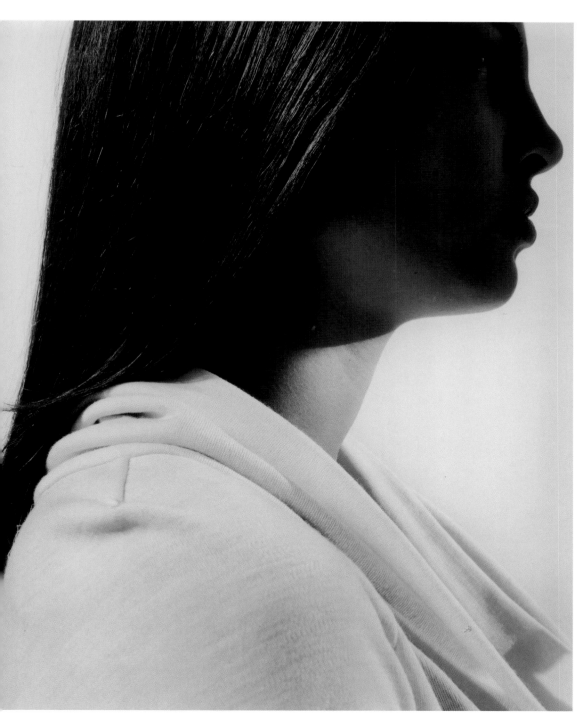

MK: I'd like to focus on your working relationship as a way of exploring the nature and possibilities of the collaboration between a stylist and a photographer. In many ways this collaboration is at the heart of the fashion and advertising photography business. Would either of you like to talk about how you come together and what is the nature of your work?

AH: We'd known each other for a long time before we started working together—about 15 years. It came at the right time for me as a stylist: I wanted to simplify things and started talking to Jason, and his ideas fitted perfectly. We both wanted the same thing to a certain extent. Previously my work was more complicated and narrative. I wanted to get away from that. Generally, I didn't think fashion photography was being done properly. It was being done as a pastiche and wasn't honest. I wanted to really start looking at clothes again; looking at cuts, looking at fabrics, looking at texture. I liked Jason's simple, honest approach.

JE: When I first met Adam it was the early '90s, when there was a change in attitude to editorial photography. I think there is a lot of very referential work being made now that isn't interesting to those of us who have been around a couple of generations. We have no interest in recreating things we've already seen. We are applying the concept of stripping everything away and making something that is unpretentious and unreferenced, and as straightforward as possible. It's not a new idea, it has happened a lot of times, but it's just an appropriate time to apply that idea. That made it an appropriate time to be working together because we both had similar frustrations about what was being presented, and we felt we could do something else.

MK: So for both of you there can be something in this collaborative relationship which pushes your work practices forward?

JE: It's about a shared interest in style and culture. Neither of us is particularly enamored with the fashion industry, but both of us are fond of cultural style ideas. That's what motivates us. It is very much about the context of the images and the fact that they are going into editorial circulation. Both of us are excited that we are at a point in editorial history where you can do something quite unremarkable, conservative and plain; something that appears to have minimal effort, but that actually is the most avant-garde thing you could possibly do because everyone else is going berserk with historical references and overdressing of sets and ideas. We've just taken everything away and come up with something that is surprising because there is nothing there. There is nothing to look at apart from the person and the clothes, and sometimes not even the person.

Jason Evans and Adam Howe: Photographer and stylist

MK: How would a young photographer and stylist begin to forge a relationship together?

JE: Like any relationship it should be about trust and integrity and honesty. If you are going to forge a relationship based on back-scratching, you are going to come unstuck at some point. In the world of commerce there are a lot of relationships that are motivated by cynicism. I have to trust Adam completely. I'm investing a lot of time and money in a studio and my reputation and the rest of it.

AH: There is a traditional road involved in working with an agency where they make appointments. Out of most of the appointments I've had with people I didn't know, I've never worked with them again. The people I've worked with in the past—people like Jason, David Sims, and Glen Luchford—when we started out they were assisting and I was assisting. We got on and were friends and we'd bounce ideas off each other. It was never about going to see someone with your book.

MK: Obviously it's not just one relationship you have with a particular stylist or photographer. You've both had many different relationships that are interesting and significant. Would you like to comment on this?

JE: A certain conceptual framework would apply to one stylist and not another. It was relevant to talk to Adam at this point about these projects because that's exactly what he is interested in right now, and at another time it may not have been appropriate. We've known each other for 15 years and now is a good point for us to work together. It's the right time to do what we are doing. We'll probably go at this until we are not interested in the idea anymore, and then we'll work with other people.

AH: There are people I've worked with commercially who I think are very good photographers, quite clean photographers, and we've tried to shoot fashion together and it just hasn't worked. As a result, the tearsheets are lying in the drawer getting dusty and I'd never put them in my book.

Right and far right:
Grace Abounds
Published in *i-D*,
September 2005.
You are really looking at a
garment from the tucks to the
hem to the belt to the cut to
the texture.

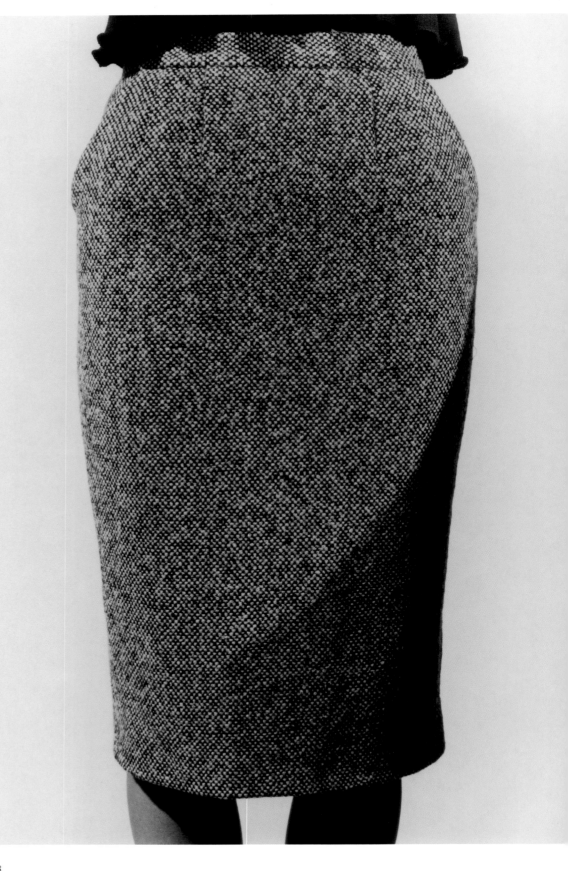

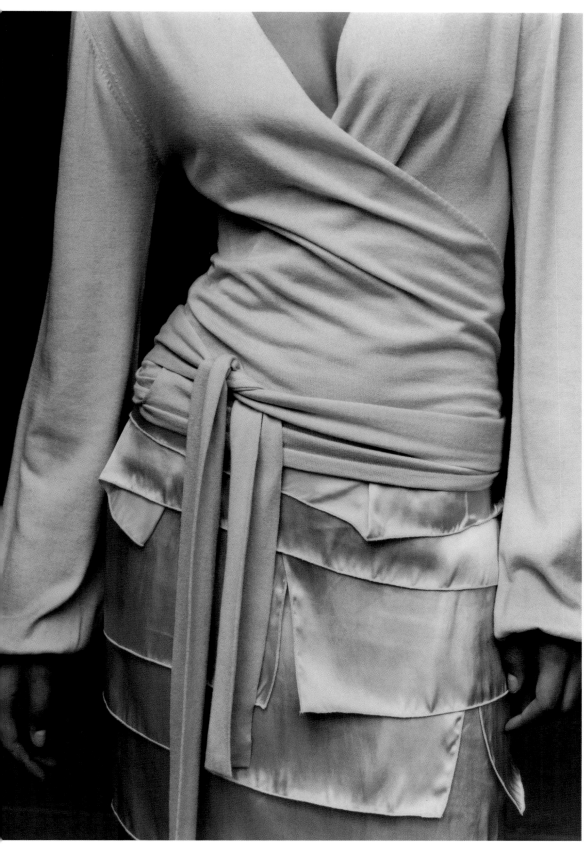

MK: Let's take the *i-D* womenswear story as an example. Would you mind going through the process of putting together the shoot and working together during the shoot, and then through postproduction and editing the images?

AH: For the first story we started with the clothes.

JE: There was one photograph I saw of a tennis skirt that wasn't a fashion photograph, and the photograph was very much about the garment and its construction. The photograph was screaming "pleats" at you. It was strangely alluring. Visually it was quite a claustrophobic image, but that was particularly attractive and refreshing. I showed that photograph to Adam and then the dialogue grew out of that and how it would be to make a project that was simply about the objects that Adam liked. Adam had to find things that had that explicit quality. The Miu Miu image [far left] for example, it is just the most "tweedy" tweed skirt.

AH: You are really looking at the garment from the tucks to the hem to the belt to the cut to the texture. It was about examining a garment to an almost worrying degree. I needed to start looking at clothes again because clothes are always the last thing. It's often like, "I've got the idea, I've got the casting, I've got the person, but now what are they going to wear?".

JE: It was trying to get away from the idea of the photography being particularly explicit. I don't think it is in these images.

AH: Everything that was superfluous was stripped back. There was no narrative, going right back to as basic as you can.

Jason Evans and Adam Howe: Photographer and stylist

MK: So let's talk about the casting and the models.

JE: It's two girls. I was in New York and Adam was in London most of the time, and Japan, so there was a dialogue. We e-mailed references backward and forward and a selection of women came to the agency. I knew that it wasn't going to be so much about their faces, though we had to include one headshot or the model agencies would not have let us use the girls. I was looking for women who had bodies shaped like women. Neither Adam nor myself were interested in photographing androgynous, skinny girls. We wanted women who were going to fill the clothes and bring the clothes to life. So we found two women who had curves. I e-mailed the casting to Adam and he was happy with it.

MK: OK, so you've selected the clothes that are the basis of the concept for the shoot and you have the girls you'd like to work with. Did you shoot in a studio?

JE: Yes. It was about finding a studio that was cheap enough for editorial rates and had an outdoor area, because it is shot using sunlight and mirrors. The light would be coming in from the left, with the mirror on the right bouncing the sunlight back into the right-hand side.

AH: If anyone is thinking about testing or doing something on a total shoestring, then obviously this wasn't a shoestring. We had a studio, but in theory it could be shot in someone's apartment with a white wall or something. A lot of fashion photography you associate with lavish productions, overdressed sets, and this kind of thing. I flew to New York on Air Miles.

JE: That's something that we share. We cut our teeth at a time when not only was there a visual minimalism, but just doing things on a shoestring, like shooting stuff in people's apartments and on people's roofs, was de rigueur. It was a massive rejection of traditional production values, trying to make everything low-key, low-budget, and I guess Adam and I are still comfortable with that. We don't need a chauffeur and someone to bring us a cappuccino to make good fashion photographs!

Right and far right:
Grace Abounds
Published in *i-D*,
September 2005.
The idea was to try to get away from photography being particularly explicit. I don't think it is in these images.

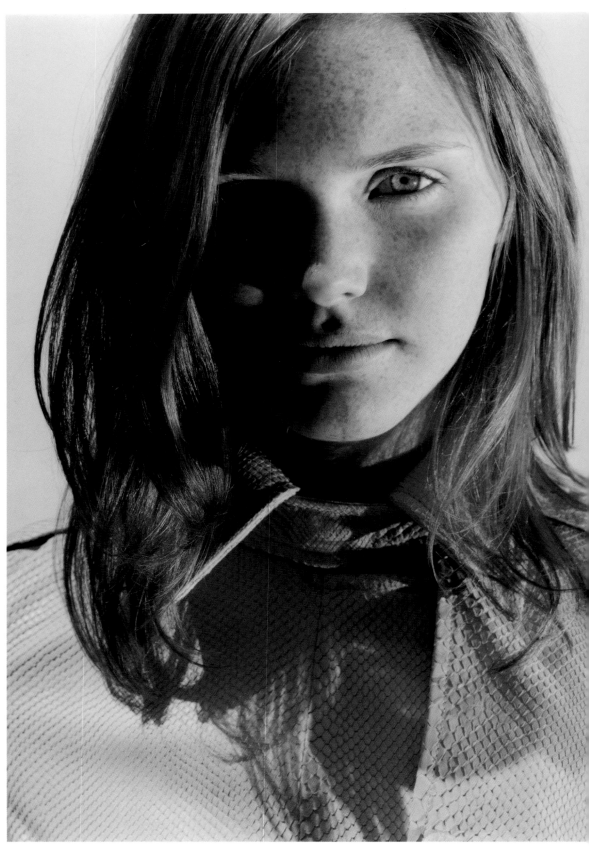

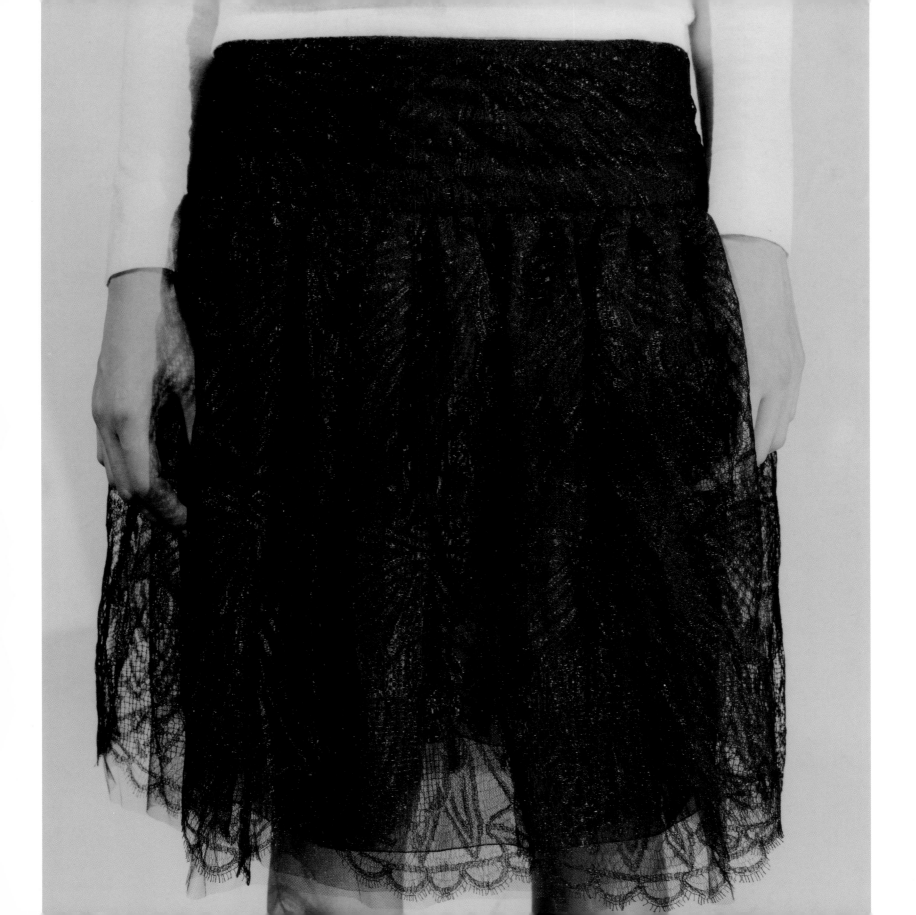

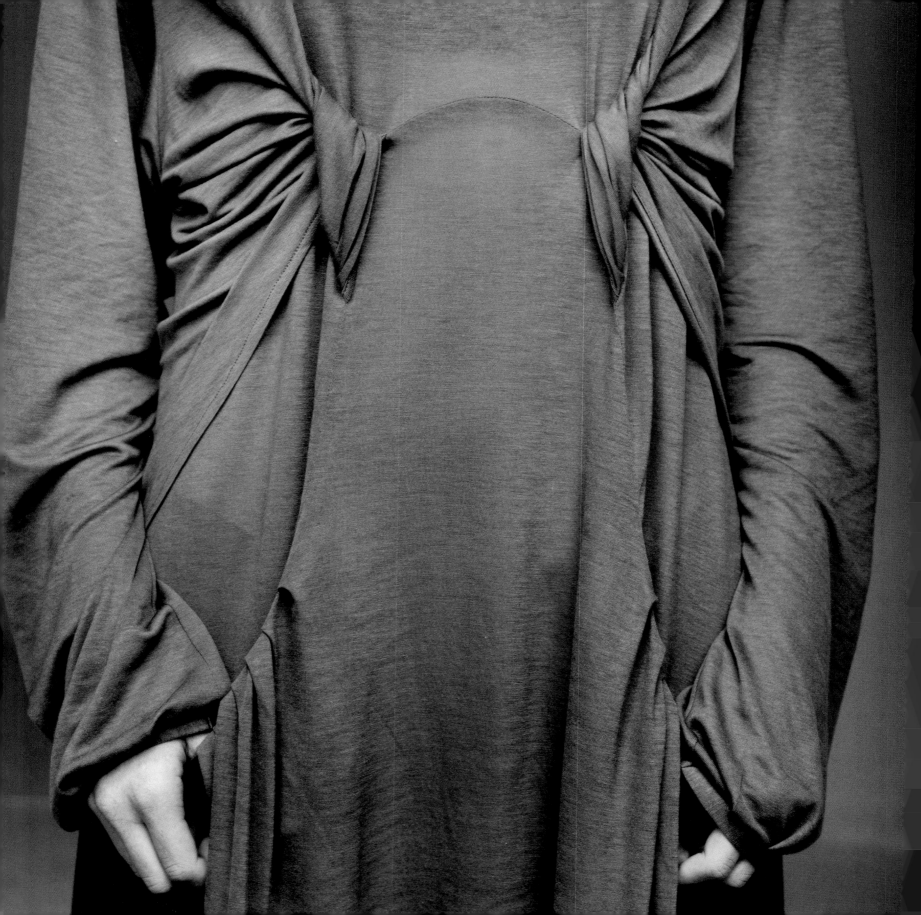

MK: Adam, can you talk about your role during the shoot?

AH: It was really about fitting. We needed two girls to make it work; they were slightly different shapes.

JE: One of them had a bust and one had hips.

AH: I didn't have a specific outfit for a specific girl. It was seeing what each girl looked like, for example in the backless dress with the freckles, which I think is a beautiful shot. Nothing was planned before the day. Also, flying to New York without an assistant, I had to carry everything myself so I had to be very selective before I went out there, and then it was down to fitting.

JE: Because of the element of trust in our working relationship we can do that. We can be spontaneous and we can improvise. We know each other's parameters enough to be able to carry the right things to play with without me having to have a large range of lenses and Adam 1,000 outfits. That awareness of each other's parameters allows us to work quite light.

MK: So that leaves the way the pictures have been run in the magazine, which is not consecutively like a normal fashion story. The images are divided up and operate as a sequence within a group of four or five stories, each by a different photographer.

AH: I didn't know they were going to do that. That was a total surprise to me. Did you know about that Jason?

JE: They did tell me, but after I'd submitted the prints. I immediately thought that would work to our advantage. We were trying to be contentious. To scatter our stuff against the kind of stuff that we're working against is really lucky. It heightens the sense of contrast. Some people need their hits of eight-page runs. Going back to our age, I think we are quite egoless about what we do. Maybe not entirely egoless, but perhaps we're more likely to let things go and be pragmatic. It was shot to run as a sequence and we had one planned, however, as it turned out it was fine. When you work with different magazines you expect different scenarios to arise. Different art directors and different editors throw different things at you.

Left and right:
Grace Abounds
Published in *i-D*,
September 2005.
I didn't have a specific outfit for
a specific girl. We worked with
what each girl looked like, for
example, the backless dress with
the freckles, which I think is a
beautiful shot.

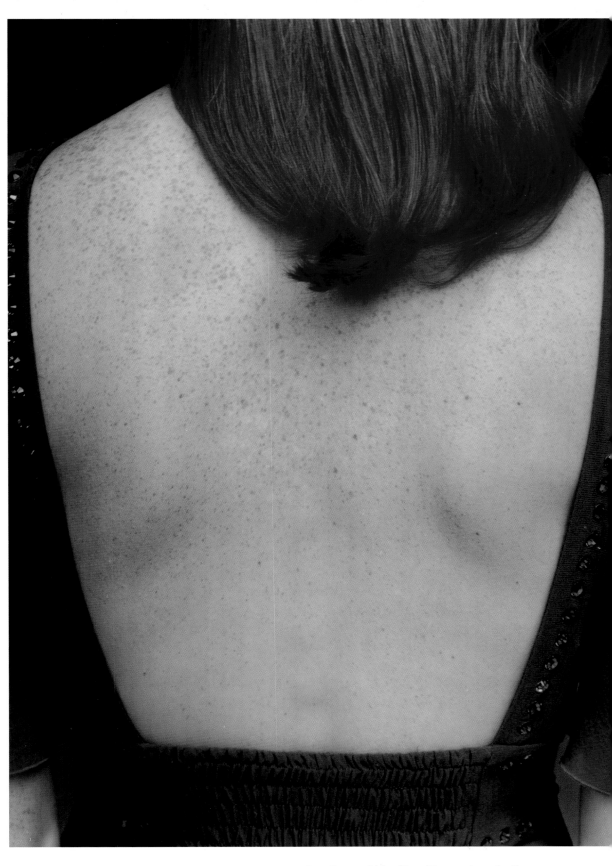

Jason Evans and Adam Howe: Photographer and stylist

MK: You mentioned that you did come up with an edit. How does that work? Did you do it together?

JE: We were back on different continents after the shoot and I had the contact sheets in New York. I scanned them and I e-mailed them to Adam with my choices, and he e-mailed me back with his thoughts. It's something that is negotiated. I think traditionally the photographer had the last word, and I think often stylists didn't get a look at the contact sheets. It depends on the working relationship. I'm respectful of Adam's decisions at all stages of the working process. Some stylists are drafted in and then drafted out, but the way we want to work is something that is ongoing. We've done another project using a similar conceptual aesthetic remit and we're planning more. We're both finding things out. Nothing ever works out exactly how you expect it. We have to take on board what we learn in each project and reject it or integrate that into the next project.

MK: So the second project was a menswear story, also for *i-D* magazine. How did you push the concept further?

AH: The menswear story became more about the actual model. He worked really well and fitted in as part of the team.

JE: He was an interesting bit of casting because he wasn't a trendy fashion model. He's actually a catalog model in Germany. He's good-looking in a slightly cheesy way, and there's something quite stiff and uncool about him, which is what made him such an attractive prospect. He's just there. You could put whatever you wanted on him so the clothing really bears scrutiny. I think it is a lot about odd understatement and very natural collisions that happen in people's wardrobes.

AH: He had this amazing silhouette with his different head. The fashion was about silhouette.

JE: It was a very formal project. I was trying to take the photography out of the equation. With the camera, I'm trying to let it be. I didn't shoot lots of film, I didn't give lots of direction. The point was to make sure Adam was happy with the way the clothes were sitting. If you look at the story there's not a lot of smothering. There are creases in the garment. It is off the hook, it's not steamed to hell and tweaked and styled and pinned. It is as it is.

AH: I forgot to bring pins!! More so on this day, I was in the corner getting on with dressing the model. Jason was shooting another story at the same time. It was a really enjoyable day working with another stylist on set as well.

JE: To save money I'd hired a studio and was doing two editorial projects simultaneously.

AH: One with Simon [Foxton, a stylist] and one with me at the same time.

MK: Adam, where do you source clothes? How do you present ideas to clients and photographers?

AH: It's actually very easy now because of the Internet. You can cover all of the runway shows in one day just by going to catwalking.com. Regarding interesting garments, a good stylist should be a magpie collecting stuff. You should always archive these things. But magazines are tightening their belts. They don't like it if you put "stylist's own." They want you to use advertisers. Even magazines that promoted DIY in the past.

JE: It's hard to make generalizations about issues in the fashion editorial process because even in the time we've been involved it has changed so radically. There has been a massive reorganization of the way that commissioning fashion companies work and the way that magazines work. I can remember doing entire fashion stories where everything was vintage, but that could not happen now. The fashion industry shifts all the time. There is a lot of luck and chain reactions that lead you to funny places. It's how much you want it more than anything.

AH: I think I'm really lucky to have survived this long.

JE: How do you think that you have survived this long?

AH: I think probably by finding an alternative route in this career.

JE: I think people can be surprised at how much hard work you have to put in.

AH: You can't teach people what an original idea is. You can direct them, but there is never a straight line, never a straight road. It's all tangents.

Grace Abounds
Published in *i-D*,
September 2005.
Everything that was superfluous
was stripped back. There was
no narrative.

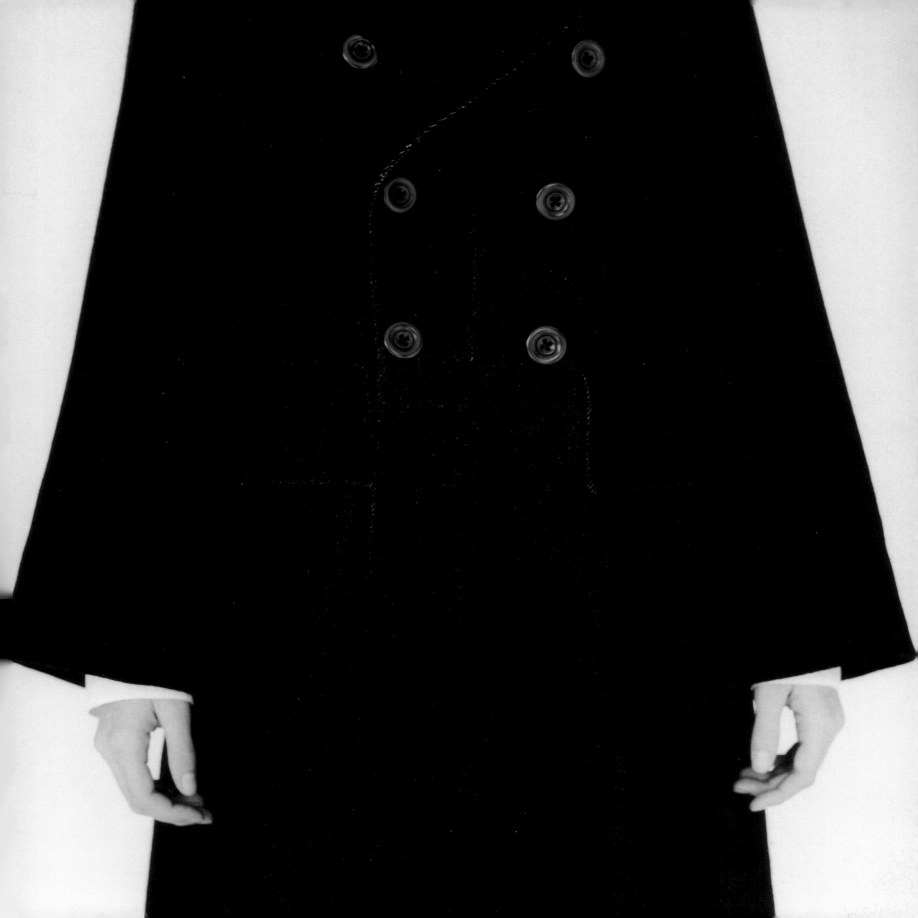

While this image was created in a studio, the setup could be used in anyone's apartment. It was shot using sunlight and three mirrors. The model and mirrors were positioned so that the light came in through the window from the left and was bounced back from the right.

Howe's essentials

- Lint remover

- Bulldog clips

- Scissors

- Needle and assorted thread

- Antistatic spray

- Jewelry box (chains, leather thongs, rings etc.)

- Gaffer tape

- Pins

Evans' essentials

I don't have a standard kit because what I need varies from job to job, but I always have:

- Spare batteries

- Gaffer tape

- Permanent maker pen

Specification

CAMERA: Mamiya RZ67 with standard lens

LIGHT: Available light (sunshine) and up to three mirrors to redirect the light

FILM: Ilford Delta ISO 100, pushed a stop in developing

EXPOSURE: 1/125 sec at f/22 (NB: Some shots were done inside the studio, some on the terrace. The details supplied relate to the brighter, outdoor

Suggested reading

Der Mensch–Mein Bruder, HELMAR LERSKI, VEB Verlag der Kunst, 1958

The Ecstasy of Things, THOMAS SEELIG AND URS STAHEL, Steidl Publishing, 2005

Photography in Industry, NIKOLAUS KARPF, ed. JOACHIM GIEBELHAUSEN, Verlag Grossbild-Technik, 1967

Still Life, IRVING PENN, Thames & Hudson, 2001

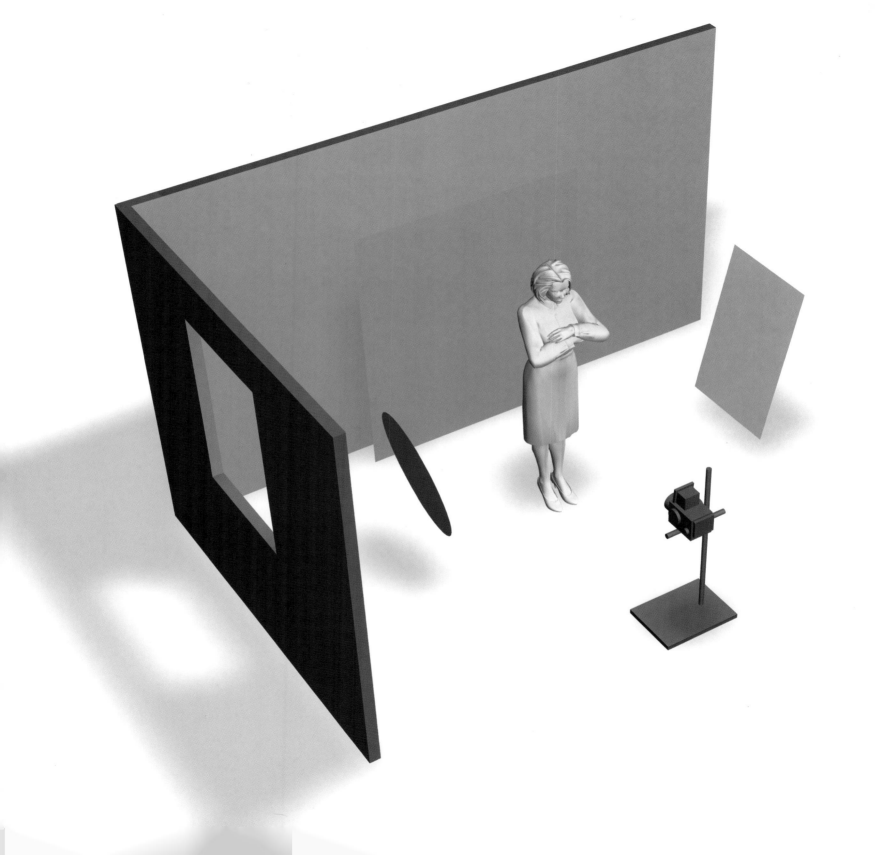

Landscape

An internationally acclaimed photographer, Dan Holdsworth works primarily with landscape. His images, most often seen as large-scale exhibition prints in galleries and art books, often explore the extreme edges of human, scientific, industrial, and natural habitats. His commercial clients include Orange, Nurofen, Adidas for Euro 2000, and advertising and design agency Emery Frost (Australia). He has held numerous group and solo exhibitions, including *Photography 2005* at Victoria Miro Gallery, London (2005) and *At the Edge of Space, Parts 1–3* at the National Maritime Museum, London (2006/7). Holdsworth's work is held by the Victoria and Albert Museum and the Tate Gallery, both in London, and in public and private collections worldwide. *Dan Holdsworth* was published by PhotoWorks in 2005.

Photographing landscape has its own formal, compositional, and practical challenges and disciplines, many of which Holdsworth illuminates in this discussion. Landscape can be used as an important compositional element of a fashion photograph and has a myriad of applications within advertising, most obviously including cars and travel.

In comparison with the majority of photographers featured in this book, Holdsworth's commercial practice is distinct from his personal projects. Though represented by an agent, he does not work regularly as a fashion or advertising photographer, but dips into the industry on a specific commission-by-commission basis. The work discussed in this chapter was undertaken for Middlesbrough Institute of Modern Art and is a relatively unusual example of the client allowing the parameters and presentation of a brief to be almost totally determined by the photographer. This amount of creative freedom is seldom allowed, and is only ever given when the client or commissioning body is looking for something associated uniquely with the established vision or working methods of a particular photographer. Indeed, Holdsworth's authorship, together with that of writer Paul Shepheard, contributes to the desirability and prestige of this campaign and is given prominence in its distribution. Designed by Yes studio as a sequence of text and images in a magazine format, and used on billboards and in the arts press, both Shepheard's text and Yes studio's layout are fundamental to the impact of Holdsworth's images. As a project it highlights, yet again, the importance of collaboration and art direction to the successful delivery of and maximum impact for an advertorial or promotional message.

Interview

MK: This body of work, commissioned by MIMA, is slightly different from the other commercial photographic projects I've focused on, and you as a photographer embody a slightly different way of working. I wondered if you could comment on this in terms of someone who has an agent and works commercially from time to time, but is led by a very strong, art-based practice.

DH: In commercial practice it's about how you can make a living from photography alongside making personal work. I came to London and started working as an assistant to a portrait photographer. I worked for *i-D* and *Interview* magazines. I am now with M.A.P. who work with both fashion and art photographers. I was always trying to make landscapes, but initially I thought I'd endeavor to make a living working commercially. It's brilliant to be able to use what you are passionate about to support other projects. You are always trying to get to a position where you can make your ideas possible.

MK: If you met your agent through assisting, it was obviously good for contacts too, beside paying the rent.

DH: It was useful to meet specific and good people. I think I was lucky to have such good contacts immediately. My agent Julie Brown was the first person to encourage me to be a commercial photographer in London, at the age of 19. Through a photographer, John Spinks, who was assisting Juergen Teller at the time, I started assisting. Some of the clients I met I ended up working with later. You meet lots of interesting people as an assistant. I learnt a lot about photography technically, and about the interactions of business.

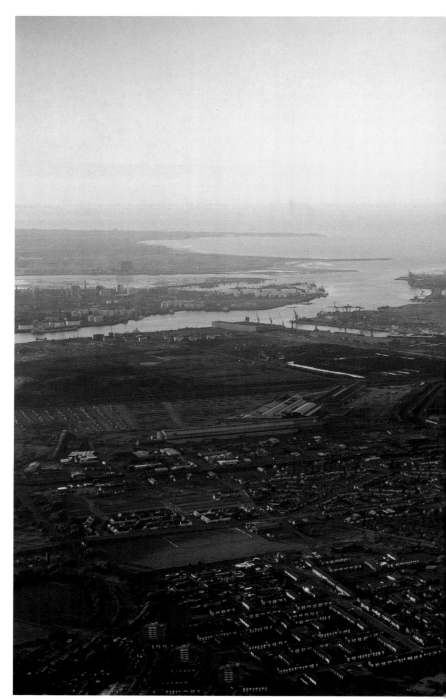

Geographics
A project for Middlesbrough Institute of Modern Art. Published in 2005.
I use long exposures. I'm not trying to capture a moment; it's more constructing a scene that gets the idea of the brief across.

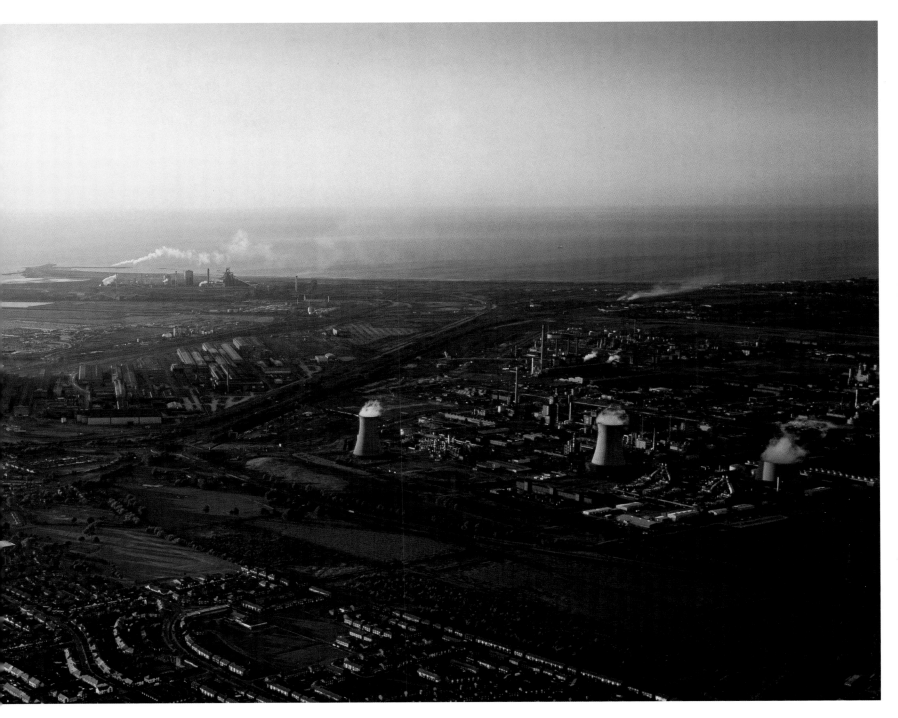

Dan Holdsworth: Landscape

Geographics
A project for Middlesbrough Institute of Modern Art. Published in 2005.
I thought it would be interesting to make a piece that played on the idea of the kind of survey *National Geographic* might make of a region; an iconic, photographic exploration.

GEOGRAPHICS
DAN HOLDSWORTH & PAUL SHEPHEARD
A PROJECT FOR MIMA, MIDDLESBROUGH INSTITUTE OF MODERN ART

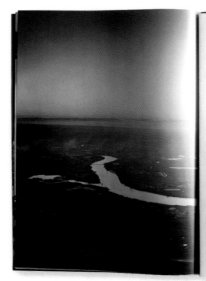

THE RIVER ROLLING THROUGH ITS BUSY HINTERLAND EXPORTING NEW WORLDS

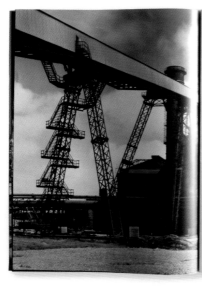

VAPOURS WREATH THE BLAST

THE SOFTEST EVER FIREWORK BILLOWING

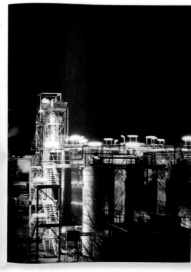

AN AREA OF OUTSTANDING ARTIFICIAL BEAUTY

HERE IS EVERYTHING

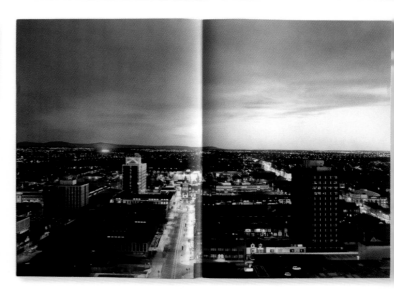

MK: You are a landscape photographer, which is the focus of this chapter, but you've also had to photograph people from time to time as part of a brief for a job. Is that a challenge for you?

DH: I never really made portraits, but I have photographed people in landscapes. I guess they become elements to work with in the image. I use long exposures so I'm not trying to capture a moment; it's more like constructing a scene that gets the idea of the brief across.

MK: Lets take *Geographics* as an example of a brief you were presented with. Tell me about how you got the job, and the scope of the project.

DH: The curator of MIMA, Judith Winter, approached me. MIMA was having a new building designed and built. They knew my work and wanted to commission me to photograph the development of the building. Middlesbrough is my hometown so I've got a particular relationship with the place and with the gallery. I thought it would be interesting to make

a piece that played on the idea of the kind of survey *National Geographic* might make of a region; an iconic, photographic exploration. I also wanted it to have a quality that would help to advertise the gallery and give people a sense of the geography of Middlesbrough and the surrounding areas. People think of it as pure industry, which is important, but I wanted to put that in context.

MK: The presentation of the commission is as a magazine publication.

DH: It's kind of a piece of public media art. As a piece of public art it had to satisfy the gallery, but it also had to satisfy the council who fund the gallery, and the sponsors. In the same way a commercial project is mediated by a client, I had a client to please.

MK: The final piece is a collaboration between you, the writer Paul Shepheard, and the graphic design studio YES. Was the Gallery also part of the collaboration?

DH: Absolutely. We worked with the curator very closely. She was really open to the whole project. I wanted to make a positive piece of work, something that would be intriguing for an audience who didn't know what Middlesbrough was. The idea was to make an abstract poetic survey. It's not in any way literal or trying to illustrate the area, but I was trying to introduce some ideas about place.

MK: Can we talk about how you and Paul worked together? The text is very poetic as you say, but so is the layout of the words. The text relates directly to the landscape image it juxtaposes.

DH: We were thinking about the way advertising copy works and the way the bylines under *National Geographic* photos summarize everything in a caption. The collaboration worked both ways. We traveled to Middlesbrough together, and we both also went up independently. Making photographs, I obviously had to be there more to get the light and the conditions and locations. From my side there was a lot of time trying to get access to locations that I thought were iconic to the area, or revealed something.

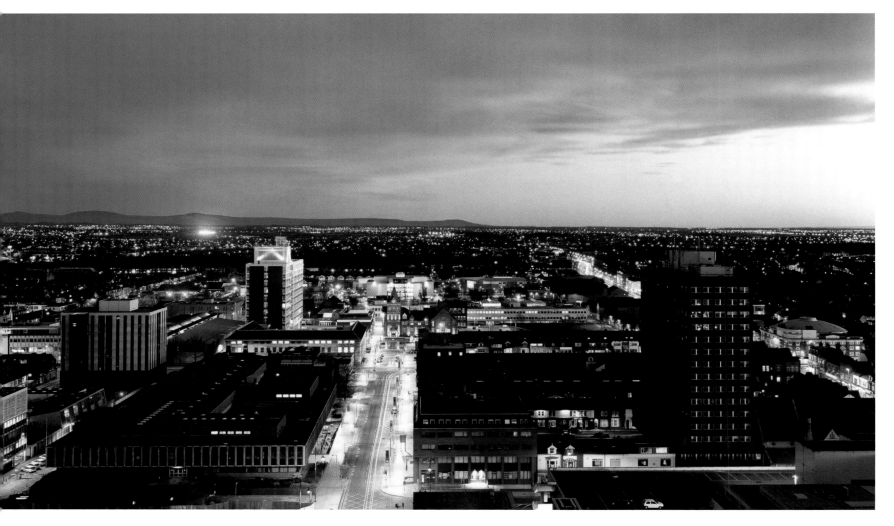

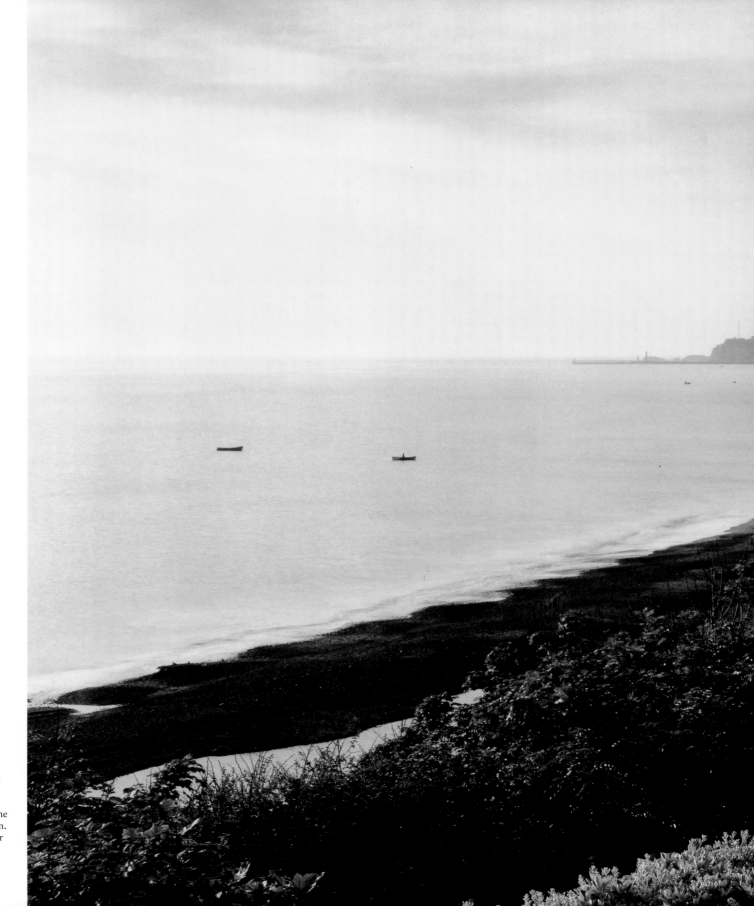

Geographics
A project for Middlesbrough
Institute of Modern Art.
Published in 2005.
It's really important to find the
right perspective and position.
It involves a lot of looking for
the right location.

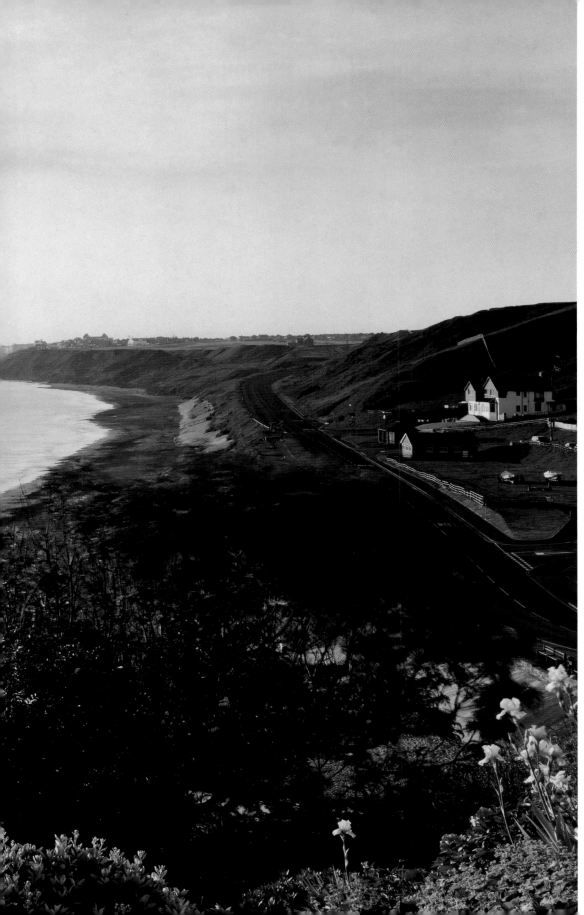

MK: Did Paul write the text after he had seen the photographs? Or did the text stand alone?

DH: It was very circular; it went backwards and forwards a lot. It was a very nice process. I think it was the idea of trying to get more out of something through a collaboration. He is a writer I've always been really inspired by and I had read his books years before I met him. His intuition and feeling about landscape is very similar to my own. As a landscape photographer, most often I'm working on my own, so it was really nice to have someone to bounce ideas off. Paul had ideas about which landscapes he thought were important. It was interesting to create a relationship between different kinds of landscapes. Some of them are pastoral, some are industrial, and some postindustrial.

MK: When and how did YES get involved?

DH: I'd talked to them about the project and wanted to get them involved to bring the image and text together. It was great to work with YES. In some ways they acted as mediators between us and the gallery. They helped to conceptualize the project. They designed the layout with the image and text really coming up against one another. It wouldn't have been as successful a project without them.

MK: Let's talk about some of the images, starting with the center spread [left]. It feels like one of the more straightforward pictures, but I think that is deceptive because there is a lot going on with the light and subtle visual effects. Would you mind going through taking the photo?

DH: I wanted to present something slightly different from what I normally do in my work. It's quite a pastoral image. It was shot on a large-format camera really early in the morning, about 4.30am in the summer. I just wanted to get early morning light after the sun had just come up, and to get some movement in the water and in the plants. Technically it is quite straightforward. It's really important to find the right perspective and position. It's a lot of looking for the right location. I wanted to have high viewpoints as much as I could. It was taken from the garden of a house sitting high on a hill above the beach.

MK: How long did you spend finding a given location?

DH: It takes a long time. I was in Norway just after Christmas, looking for locations for a particular project, and I drove 620 miles (1,000km) in three days. That's a lot of searching around.

MK: Do you make test shots or do you observe the light?

DH: Yes I make test shots. I'll keep going back to test it on different days. In advertising you often work with location scouts. You need to make sure you have all the right elements for a given brief, and also to ensure that you can get into a position to photograph those elements, otherwise it is useless. It's really important for a landscape photographer.

Dan Holdsworth: Landscape

MK: Were you only using available light?

DH: That photograph was taken with a deep depth of field. It is probably like an eight-second exposure. I work with exposure a lot. I rarely introduce my own lighting. All of the work in *Geographics* is lit with available light. I like taking pictures really slowly. I like working with long exposures because it gives me time to work out what is going on. It is part of the way I work naturally. Considering and looking at the light carefully, and where it is falling, is important because it determines how the surface of the negative is going to be. Sometimes I push the film in processing to get more contrast. I like the organic nature of the chemical process that you get with film. You can change so much just using exposure. You can shoot day for night and all kinds of things.

MK: Is there much manipulation in postproduction?

DH: Pretty much what you see is what it was. My printer sees color really well. We have a very good relationship so he knows what I want to get from a print.

MK: Let's move to an image you shot at night [right].

DH: Basically, again, it is finding the right location. This is an industrial complex in the center of the town. It is the kind of landscape that has really influenced me and that I've explored a lot in my practice. It is taken from a motorway flyover that I wasn't really meant to be standing on, but it provided a platform that I could get the view from. I set my 5 x 4 camera up on a tripod, and made about a 10-minute exposure. Because it is a long exposure you can see there is a bit of movement: wind is blowing the gas coming out of the towers. I'll often use daylight film, then slightly overexpose it and readjust the colors in printing. It is a straight print without digital manipulation. You get green from fluorescent lights and the orange is from tungsten light, and then I play around in the printing to strip out color and fine-tune it. I wanted the sky to be very black so I made sure the exposure was short enough that it didn't capture too much of the ambient light or color in the sky. I wanted the structures to sit against black, rather than the sky being bright, so there is sharpness to the edge of the industry. Through experience I know what I want to get as an end result, and then I work backwards so I know the kind of location I want to find, and I know the kind of exposure I need to give to get the quality of print that I'm after, which then might match to a given brief for a project.

Geographics
A project for Middlesbrough Institute of Modern Art. Published in 2005.
You need to make sure you have all the right elements for a given brief, and also to ensure that you can get into a position to photograph those elements, otherwise it is useless.

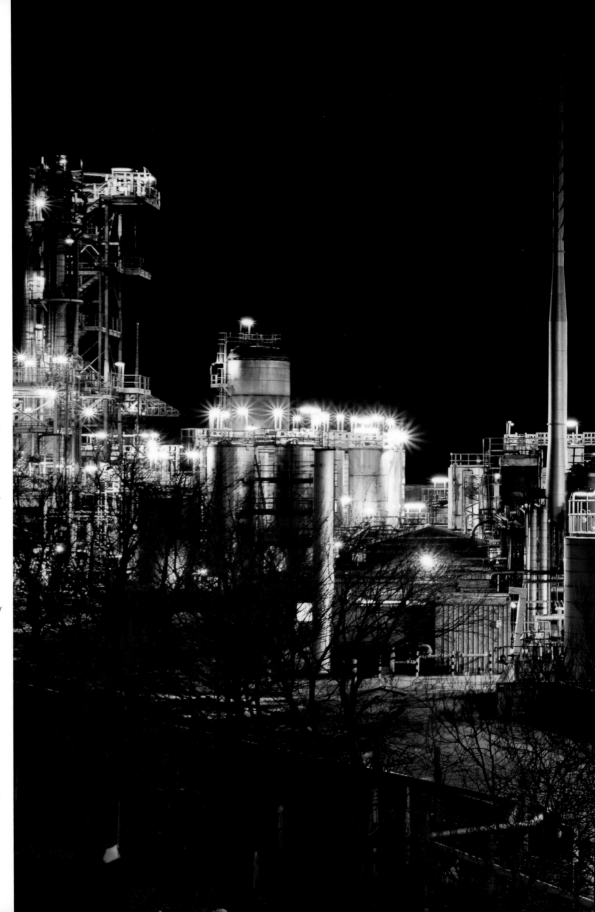

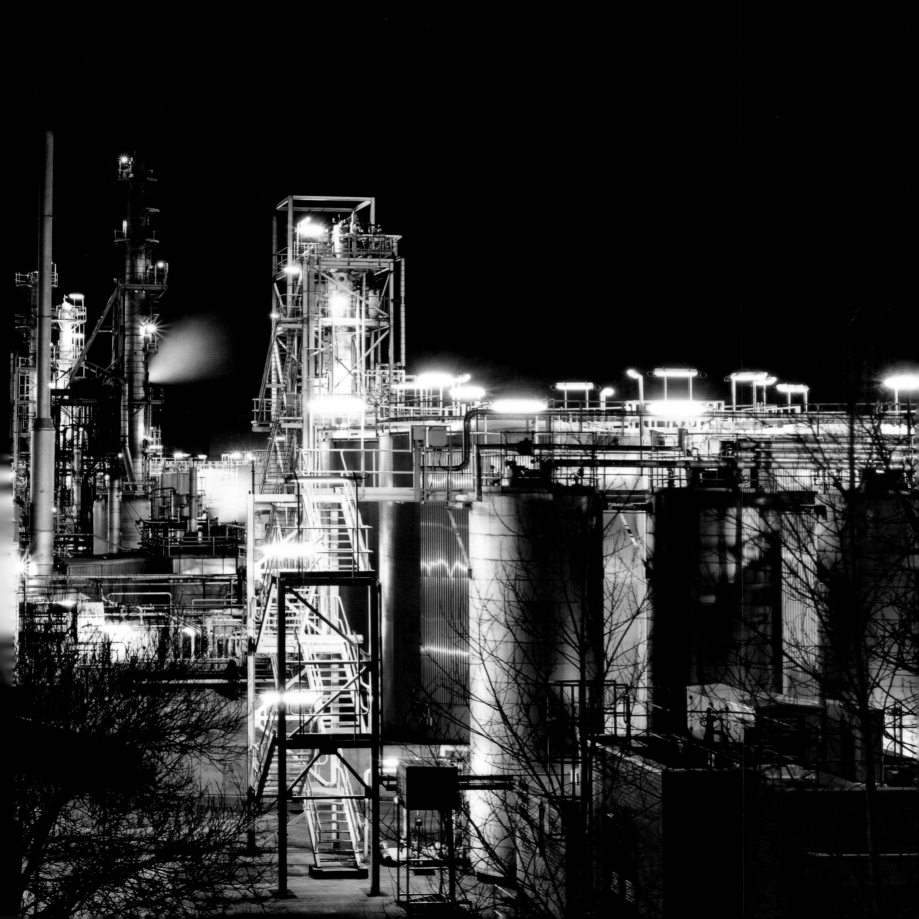

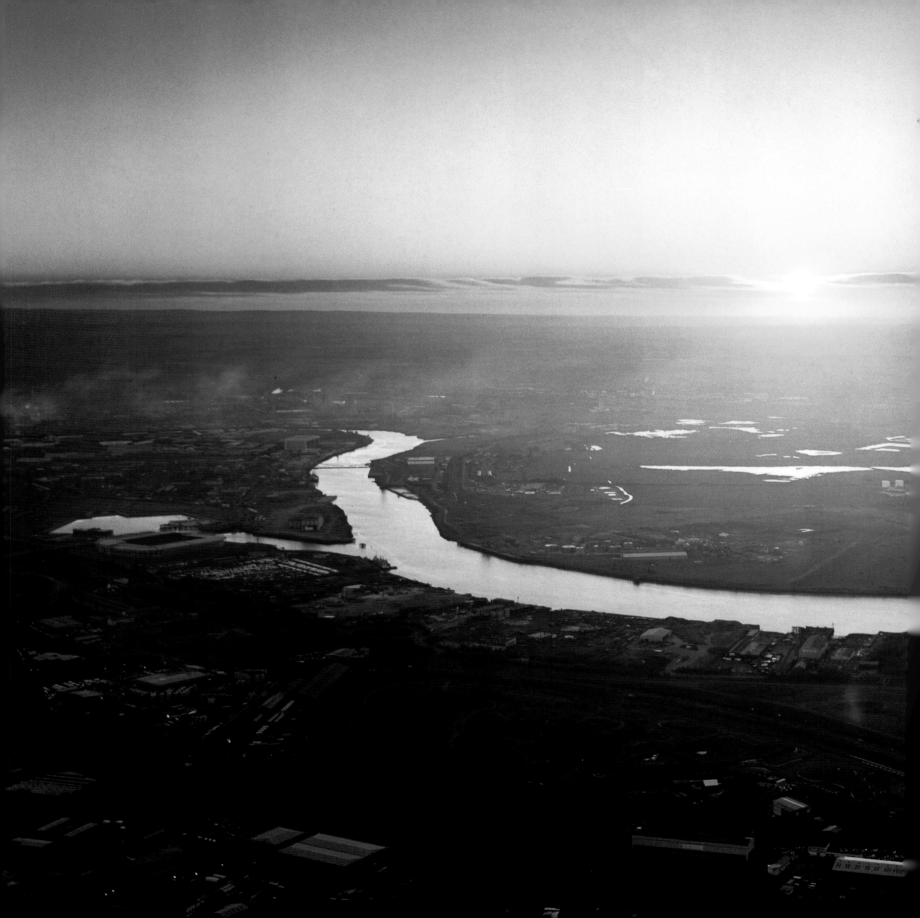

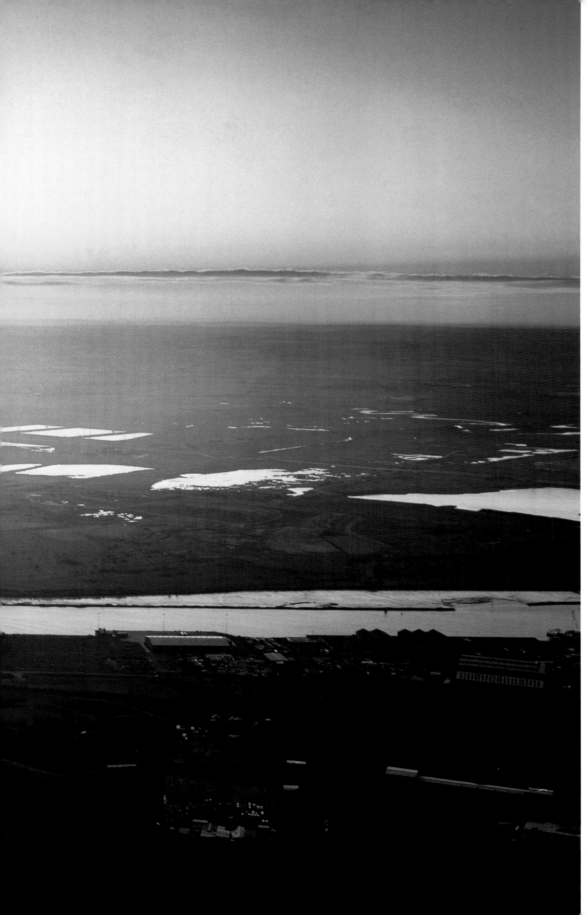

MK: Shall we talk about an aerial photograph?

DH: This is a photograph of a sunset over the River Tees and the city. I ended up waiting at the airport to get a plane. It was a beautiful evening and the pilot was really late, so we set off an hour or so later than I'd wanted to and the light was really low. In the end it worked well because you have the sun breaking just before it went behind the horizon. You have to work with a quick shutter speed. I think it was about 1/60 sec, using a handheld medium-format camera, a Mamiya 7, with a standard wide lens. It's a really good camera for landscape because it has a fantastically sharp lens and you can make really good enlargements from the negatives. I exposed it for the ground which really overexposed the areas of water, but I think that manages to hold with the sunset. I've also taken pictures in a helicopter, which is more stable and easier, and you don't have wings in the way. You can take the door off and just lean out—you are strapped in. In either case it's best to be set up before you have to take the picture. There's not much room and it is difficult to get the right position! In a plane there is a really small window, just like in a car. You have to push the window up, and the wing is above you, so it is awkward. I'd always go for a helicopter, but it is a lot more expensive.

MK: Do you enjoy seeing your work on billboards and in magazines, not just on a gallery wall?

DH: It's great to think your work is being seen by so many people. It is very satisfying.

Geographics
A project for Middlesbrough Institute of Modern Art. Published in 2005.
The idea was to make an abstract poetic survey. It's not in any way literal or trying to illustrate the area, but I was trying to introduce some ideas about place.

Dan Holdsworth: Landscape

Workshop

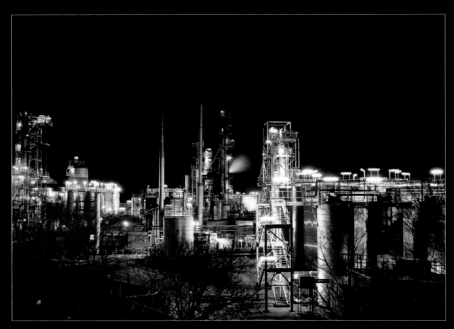

This image was shot using ambient light only. A motorway flyover provided the viewing platform, and setting up the camera on a tripod allowed the long exposure required (10 minutes) to capture the movement in the scene.

Holdsworth's essentials

- **Lowepro camera bag, packed**

- **4 x 5in camera with two lenses (standard and standard wide)**

- **6 x 7in camera with two lenses (standard and standard wide)**

- **Cable release**

- **Tripod**

- **Light meter**

- **Torch**

- **Spare batteries**

- **Film**

- **Dark slides**

- **Changing bag**

Specification

CAMERA: Wista (metal) 4 x 5in, Mamiya 7

LIGHT: Daylight and ambient artificial light

FILM: Kodak Portra 160VC

EXPOSURE: Various lengths of exposure from 1/60 sec to 10 mins

Suggested reading

Fahren Drive, JOACHIM BROHM, Schaden Verlag, 2005

John Riddy, DAVID RYAN, Lawrence Markey, 2000

Mexas: Photographs by Esko Mannikko, MAARETTA JAUKKURI AND GARY MICHAEL DAULT, self-published, 1999

Titanic's Wake, ALLAN SEKULA, Camera Austria, 2003

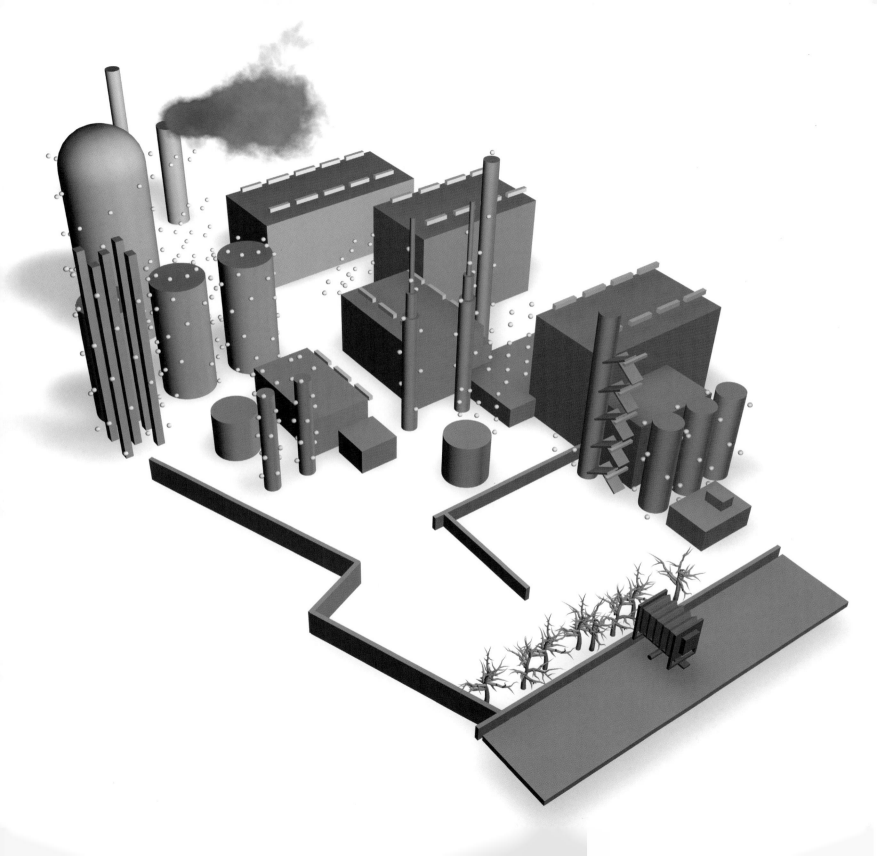

Working with celebrities

Alexi Lubomirski obtained a degree in photography before assisting Mario Testino for four years. Currently based in New York, he regularly shoots for *Harper's Bazaar*, notably producing celebrity fashion including covers of Gwen Stefani, Jennifer Aniston, Demi Moore, Cate Blanchett, Teri Hatcher, Renée Zellweger, and recently, a nude and pregnant Britney Spears. Frequently collaborating with leading stylists, including Grace Cobb and Brana Wolf, he has shot editorial fashion for *Pop*, *Wonderland*, *The Face*, *V* magazine, *L'Uomo Vogue*, *L'Officiel*, and Russian *Vogue*; and advertising for Valentino, L'Oréal, Lancôme, and Ellen Tracy. Lubomirski's celebrity stories cleverly draw out the qualities in his subjects that have made them stars. At the same time, his images often reveal an unexpected, spontaneous humor or sensitivity in his sitters. His editorial fashion unashamedly celebrates beauty and glamor, referencing a wide range of photographers and images depending on the assignment. He has an inherent understanding of how to make clothes and models look their best.

Shooting fashion on celebrities who may or may not be professional models poses many unique challenges. It is also worth noting, as Lubomirski does here, that working with a famous sitter within the structure of a fashion story differs from a straight editorial portrait (also a feature of contemporary magazines).

The logistics of the celebrity fashion shoot can be complex, depending on the stature of both the photographer and the subject. It is often an early discussion between the magazine, a stylist, and the sitter's agent that determines the parameters of a story. A photographer may not know the subject prior to the day of the shoot, and will probably only have a short time to work together with them. There may be limitations imposed on how the celebrity is represented, and there will almost certainly be a celebrity support team present on set. Contemporary magazines need to fill fashion credits which means there is a good chance the subject will be wearing clothes that differ from their personal style. In this chapter, Lubomirski brilliantly outlines his working methods for dealing with these situations, and explains how he got Demi Moore to smile on one of the last shots of a cover story for *Harper's Bazaar*.

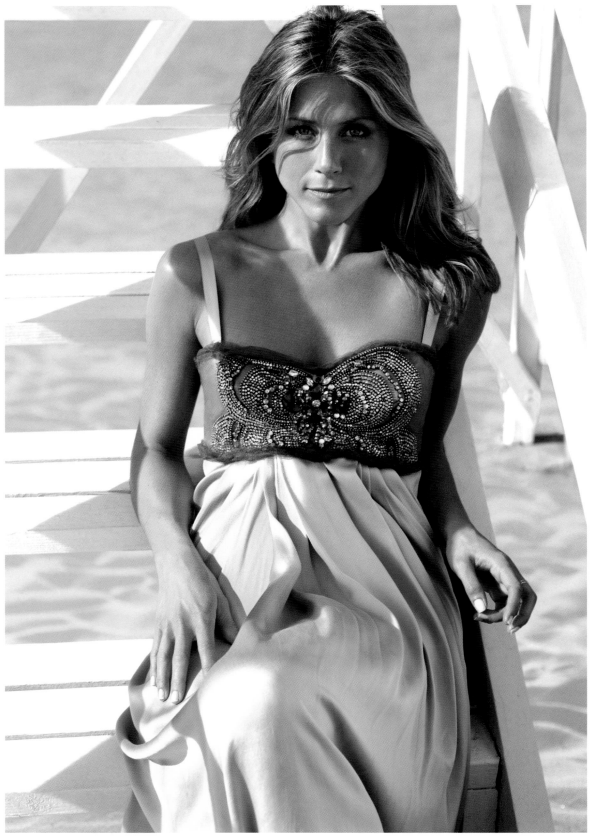

Left:
Jennifer Aniston's
New Life
Published in *Harper's Bazaar*,
September 2006.
In the first five minutes you
have to immediately work out
who a person is and how they
want you to act around them.
It's the first five minutes that
are so important.

Right:
Demi Moore's Next Act
Published in *Harper's Bazaar*,
September 2005.
I realized every time we talked
about Ashton Kutcher her eyes
lit up. I said to my assistant, "Go
and print out an A4 picture of
him." When she came back into
the studio I had it taped to my
forehead. She laughed and we
got the cover.

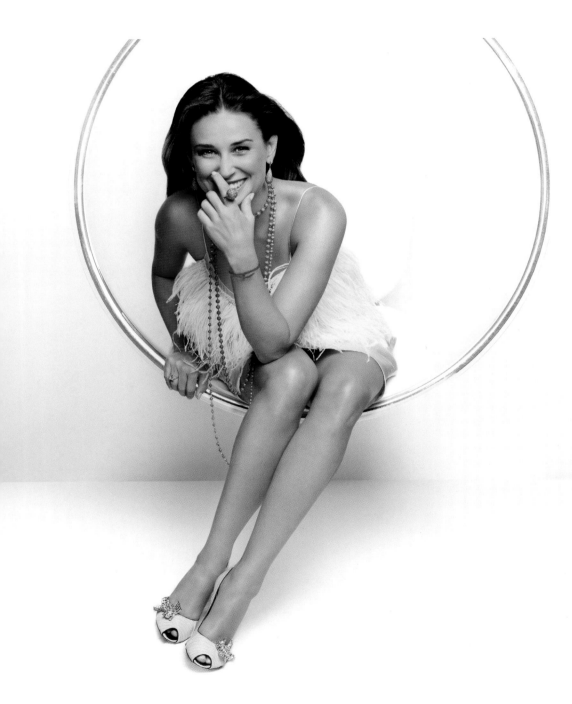

MK: Hi Alexi. I've been starting by asking everyone how they got into the industry. I'm also specifically interested in how the experience of assisting Mario Testino was important for you?

AL: I studied photography in Brighton for three years. Six months before it was over, I went around to everybody I could get the number of and told them I wanted to show them what I had been doing so far, and ask what I might change in my work if they were going to hire me.

MK: That's great, I think that is something that I'd want to do.

AL: I had a small portfolio with color photocopies of all the things I'd done at college. Out of the hundreds of people I went to see, Camilla Lowther was the one who said don't change a thing about your style of work. She said I should come and see her when I finished, which I did. She asked me if I wanted to assist because Mario Testino was looking for someone and she thought I would be good. I got the job.

MK: For how long did you work with him, and what kind of things did you do?

AL: Four years. It was invaluable. To see how he had conquered the photography world was very inspiring. It was a 24-hour job, seven days a week. We did everything. Loading equipment and cameras, doing lighting, editing, ordering prints, helping edit books, helping edit stories, etc.

MK: How did you make the break into your own work?

AL: I started doing tests, but it was hard with Mario because you worked so much. I was lucky to have Jacquetta [Wheeler, a model] as a girlfriend, so we did things together. All the assistants—the assistant stylists, hairdressers, makeup— would get together and talk about doing stuff. We ended up doing a shoot in Jacquetta's bathroom. I didn't have money for lights so we did really long exposures with torch light and did about eight pages. I showed Katie Grand the pictures, and she liked them and got them placed in *The Face*. That was three years ago. After that I did another test shoot, which was run in Russian *Vogue*, and Katie Grand asked me to do some more portraits for *Pop*. It got to the stage where I had to do one thing or the other, so I decided to move on and that was it.

Alexi Lubomirski: Working with celebrities

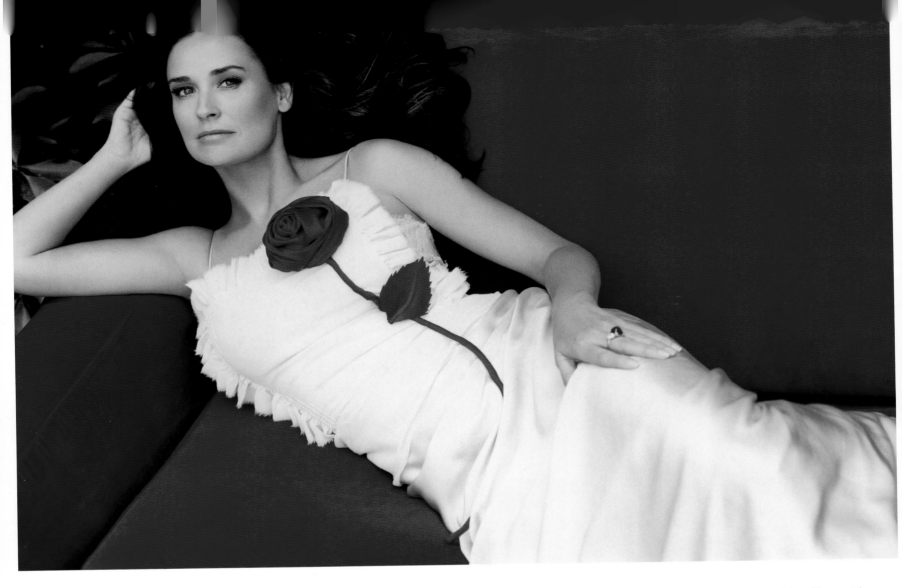

Demi Moore's Next Act
Published in *Harper's Bazaar*,
September 2005.
When actors do a still shoot
that isn't necessarily their craft.
But this is my craft, so I'm the
person who needs to do the
magic and make sure that
everything is right.

MK: Mario worked a lot with very high-profile celebrities, and even royalty. Did you learn a lot from him about how to work in those kinds of situations?

AL: Definitely. A lot of actors love playing characters, but when it comes to shooting still it's a whole other world for them. Some of them love it and some of them hate it. Passionately! One of the things I learnt from Mario was how to make them comfortable. He showed that he was confident, which I noticed made them confident because they felt they were in safe hands. He wasn't worried, so why should they be? Now whenever I go into a shoot with a celebrity I do the same thing every time. When they come in I say hello, but I let them go straight in to hair and makeup. When they are just finishing that they start to feel better about themselves because they look great. That's when I go in and talk to them. And you ask them anything. In the first five minutes you have to immediately work out who that person

is and how they want you to act around them. You want them to trust you. You need to be able to read body language. But it's the first five minutes that are so important.

MK: The first five minutes? I like it! Moving on from that, how do you get an actor to be a model in a fashion story? How did you work with Cate Blanchett for *Harper's Bazaar*?

AL: The stylist at the magazine is important. They need to have formed an idea about what they think the actor would like to wear in advance, and that needs to fit in with the story line. If you look at stories in *Vanity Fair* or *Harper's* or *Vogue*, it's very rarely about a star in a studio. With Cate Blanchett, she had such a statuesque look that I wanted to shoot her in a statuesque place. I wouldn't necessarily say it is a fashion story, but it has more fashion direction and ideas going on than a celebrity profile. With Cate Blanchett it was about a role or theme.

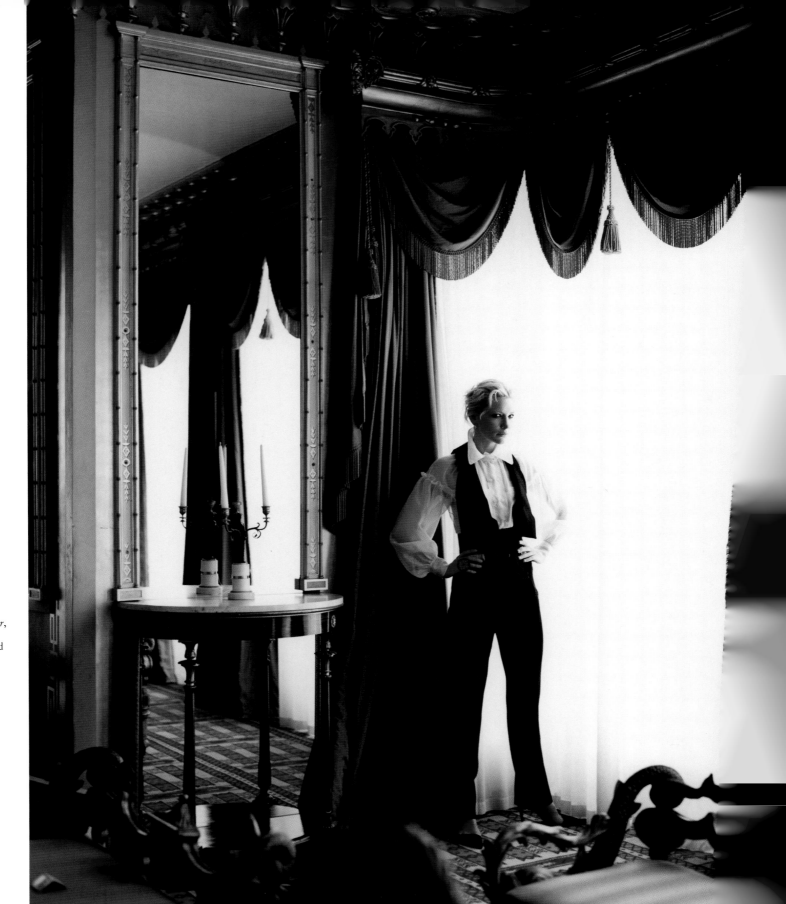

Cate Shines
Published in *Harper's Bazaar*,
August 2005.
With Cate Blanchett, she had
such a statuesque look that
I wanted to shoot her in a
statuesque place. The story
was about a role or theme.

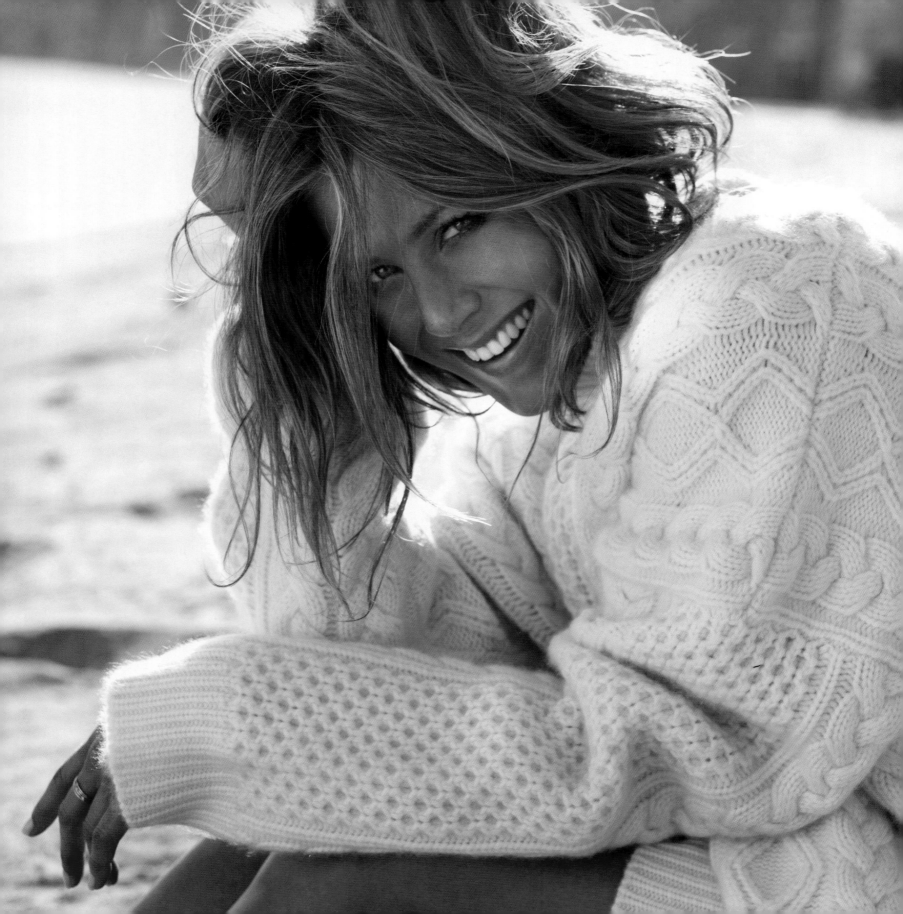

MK: Do you think actors generally make good models? Do you think it is something that comes naturally to them?

AL: It depends, but there are things you do to make it easier. In some aspects they can be great. Another thing I always do is try to find a character. So when I shot Jennifer Aniston on the beach I said "I want you to be Marilyn Monroe." It was all about big jumpers and being comfortable. With Demi Moore it was different because there was less of a theme, but I really needed to get her to smile for the cover. It was a two-day shoot and I realized every time we talked about Ashton Kutcher her eyes lit up. So at the end of the second day I said to my assistant, "Go and print out an A4 picture of him." When she came back into the studio I had it taped to my forehead, so it was my body and his face. She laughed and we got the cover (see page 105). When I shot digital for the first time it was more difficult. When you shoot film you take the first Polaroid and you look at it and it ends up in your pocket because the light might not be right yet and you're just testing. On a film set, using monitors works well for actors because that is their craft. They can look at themselves and what they are doing and analyze how they move and react. When they do a still shoot that isn't necessarily their craft. But this is my craft, so I'm the person who needs to do the magic and make sure everything is right.

Jennifer Aniston's New Life
Published in *Harper's Bazaar*, September 2006.
One thing I always do is try to find a character. So when I shot Jennifer Aniston on the beach I said "I want you to be Marilyn Monroe." It was all about big jumpers and being comfortable.

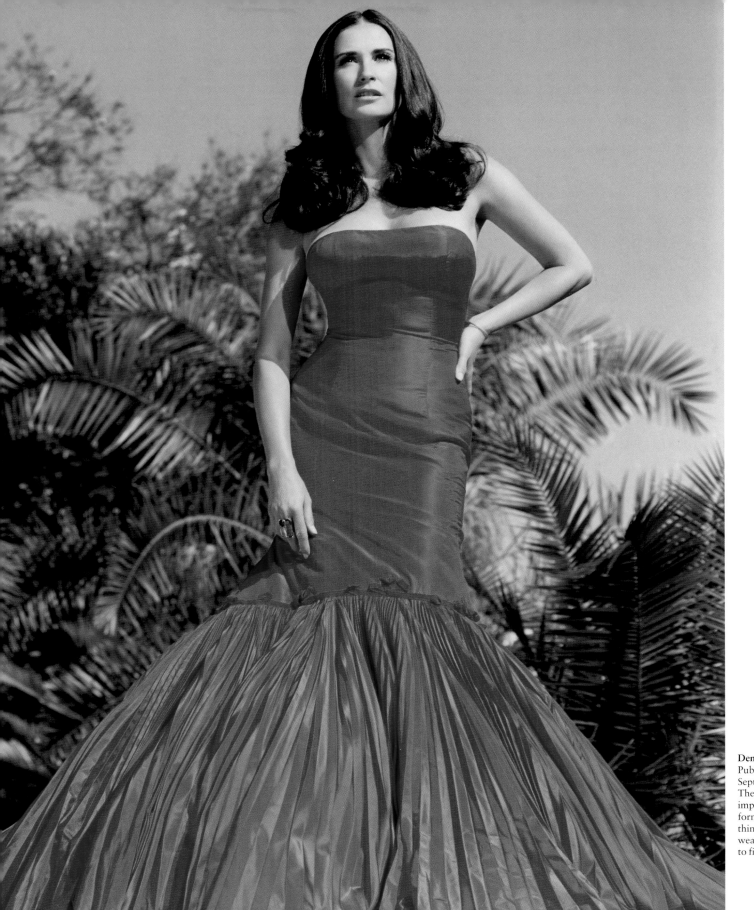

Demi Moore's Next Act
Published in *Harper's Bazaar*,
September 2005.
The stylist at the magazine is
important. They need to have
formed an idea about what they
think the actor would like to
wear in advance, and that needs
to fit in with the story line.

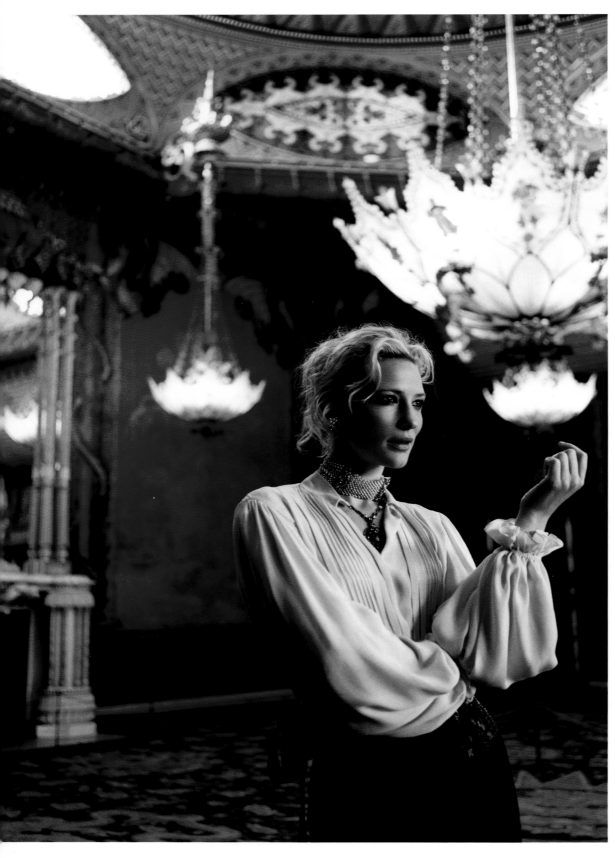

MK: Do you get to meet the subject before you shoot them, and if you don't get to meet them, how do you formulate and express the idea or theme or character?

AL: The magazine and I come up with an idea beforehand. With Cate Blanchett it was already decided that it had to be done near London because of her schedule. She was based in Brighton, so I thought of Brighton Pavilion. The idea kind of formed itself from the location and from how I thought of her. I hadn't spoken to her before the day, but I think the magazine must talk to the publicist about the idea beforehand. Also, they knew that it was for *Harper's* so it was going to be classic dresses and about her looking great. I have a big collection of photography books, and files and files of images. Before every shoot I'll show them images I'm thinking about to help them get into character. For example, it was the Monroe pictures for Aniston, for Cate Blanchett it was Grace Kelly and Audrey Hepburn. It was all about being elegant and sophisticated. It might be for a particular photo or pose or it might be about the mood. It helps because at the end of the day you are trying to describe to someone what is in your brain and you need to use every tool possible to explain it. Sometimes though, as prepared as you could have been, it doesn't make any difference and it jumps all over the place.

MK: What do you do if you start working and it is jumping all over the place, or if the subject isn't comfortable with the clothes?

AL: You work round it. There is no point trying to force an idea on someone who doesn't want to do it. I want them to enjoy it. Maybe if someone doesn't like an idea it is a sign that there is something better to be done. I try to have a back-up plan, but sometimes you just have to improvise, which can lead to you getting something you weren't expecting at all.

MK: When you shoot a portrait for a magazine, how is that different? If you were going to shoot a straight portrait of Cate Blanchett, say for *Pop*, how would that be different?

AL: I think it depends on the magazine you are shooting it for. If you don't have to worry about credits for clothes, or hair and makeup, then I suppose you are freer to get to something of the essence of that person. When you shoot for *Harper's* you are trying to get that, but you are also trying to say things that will help sell a magazine. I love the portraits of Arnold Newman. He was amazing. He could take one element from anybody's world and incorporate it into the photograph. That's portraiture for me. If you're shooting a young actor for a magazine like *Wonderland*, you can push it a bit more. You can make it more edgy and also push the hair or the makeup or the fashion more. But even when I'm doing that I still like to make people look beautiful—even in black eye makeup and crazy outfits!

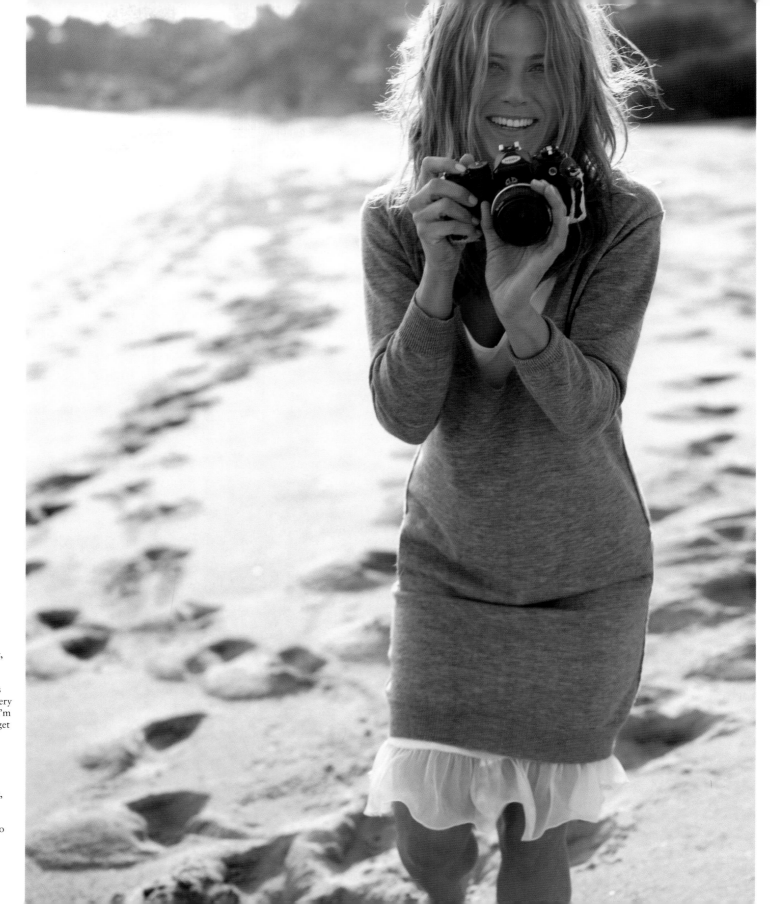

Left:
Cate Shines
Published in *Harper's Bazaar*,
August 2005.
I have a big collection of
photography books, and files
and files of images. Before every
shoot I'll show them images I'm
thinking about to help them get
into character.

Right:
**Jennifer Aniston's
New Life**
Published in *Harper's Bazaar*,
September 2006.
There is no point trying to
force an idea on someone who
doesn't want to do it. I want
them to enjoy it.

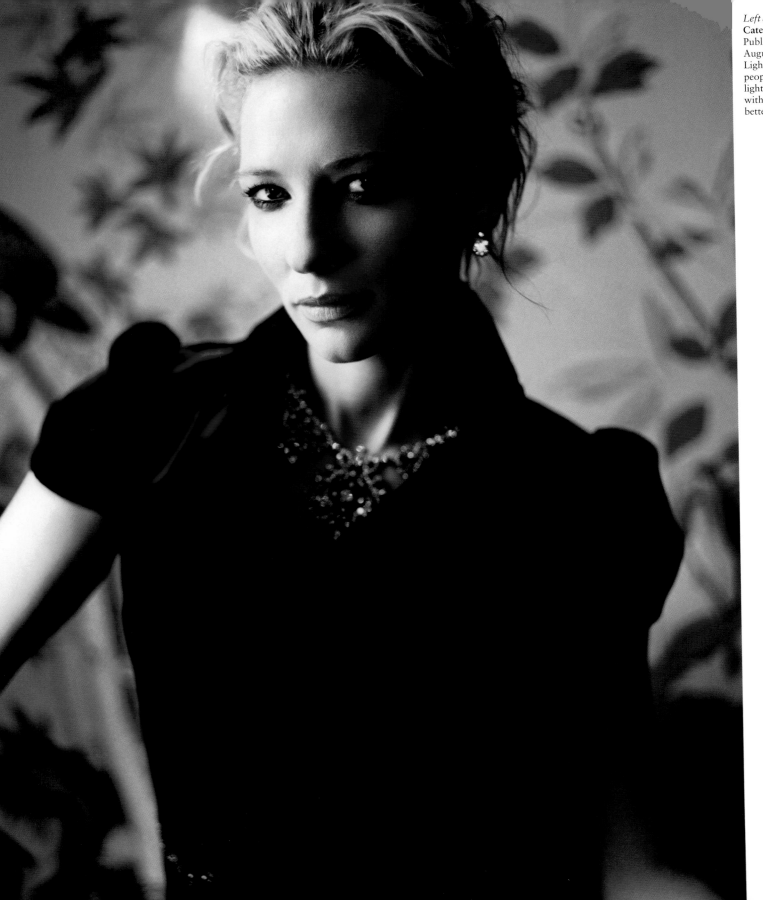

Left and right:
Cate Shines
Published in *Harper's Bazaar*,
August 2005.
Light is so important. Some
people look better with straight
light, some people look better
with sidelight, some people look
better from slightly below.

MK: Are there any technical things, or tricks if you like, that you can use to help achieve this?

AL: There are loads of tricks, but there are no tricks that work every time. Light is so important. Some people look better with straight light, some people look better with sidelight, some people look better from slightly below. You just pick it up as you go, and I'm sure I learnt a lot about that from Mario, though he never sat down and taught me things.

MK: What about with the Cate Blanchett story?

AL: That was different. She looked gorgeous no matter what I did! She was the nicest person to shoot and she is very naturally elegant. It was shot in a room with beautiful light coming through big windows. Now Cate Blanchett aside, most people look good if you put them next to a window! It's soft and you can move around in it. You can make it sidelight or front light, whichever works…

MK: Did you use any other lights in that story?

AL: No. It was all natural light. It was a big, long room and there were maybe six huge windows running down it. You don't see them, but I just made sure she was in line with one of them. You can't see the window, just the light coming through it. The window that was closest to her lit her up, and then the next window in the room lit up the table further on, and so on. I just faced her toward the light. The other thing about daylight is that you can see what you are getting as you are looking and as they are moving, so I'd say in shooting daylight you get to learn what light is best for certain people.

MK: You live in New York now, but you used to be based in London. Are there any differences between working as a fashion photographer in the two cities?

AL: New York is faster at the moment I think. In New York everyone's mission is to work and the feeling is that anything is possible, there is great energy there.

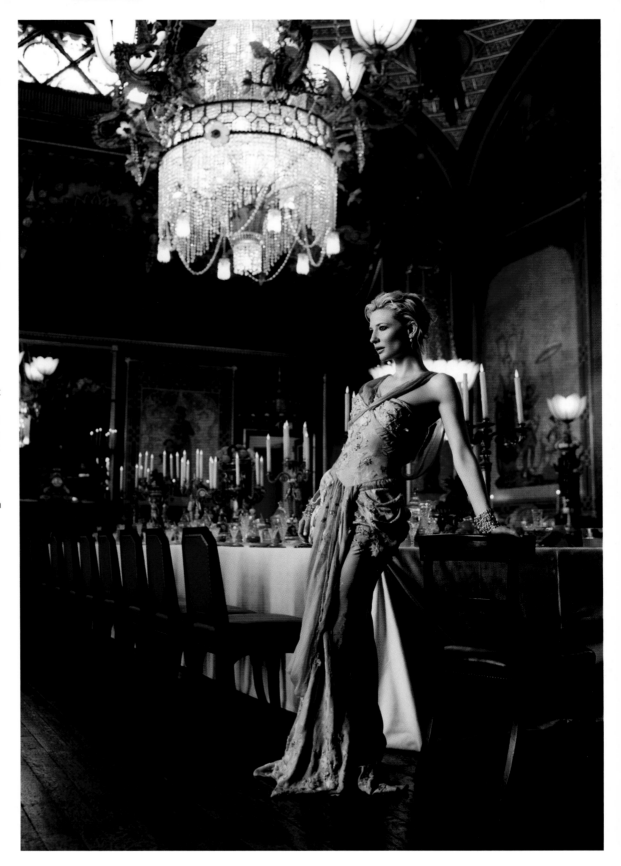

Alexi Lubomirski: Working with celebrities

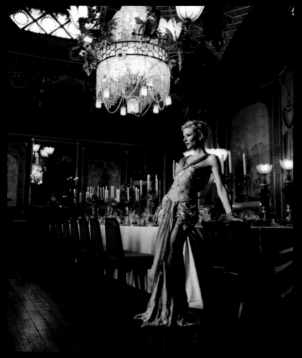

Shooting in natural daylight allows you to learn what light is best for different people. The lighting is soft and you can move your subject around in it and see the different effects as they move. This image was shot in a long room with a wall of floor-to-ceiling windows. The model was placed in line with the light shining in through one of these. Light shining through another window further down the room lit up a section of the table.

Lubomirski's essentials

- Hasselblad H1 digital camera
- Profoto flash
- A personality!

Specification

CAMERA: Pentax 67II

LIGHT: Natural light

FILM: Kodak Portra 160VC

EXPOSURE: 1/60 sec at f/5.6

Suggested reading

The Fashion Makers: An Inside Look at America's Leading Designers, BARBARA WALZ AND BERNADINE MORRIS, Random House, 1978

In Focus: National Geographic Greatest Portraits, National Geographic, 2004

Inside Hollywood: 60 Years of Globe Photos, RICHARD DENEUT, Könemann, 2001

Jeanloup Sieff: 40 Years of Photography, JEANLOUP SIEFF, Benedikt Taschen Verlag, 1996

John Cowan: Through the Light Barrier, PHILIPPE GARNER, Schirmer/Mosel Verlag GmbH, 1999

Once Upon a Time, SLIM AARONS, Harry N. Abrams, 2003

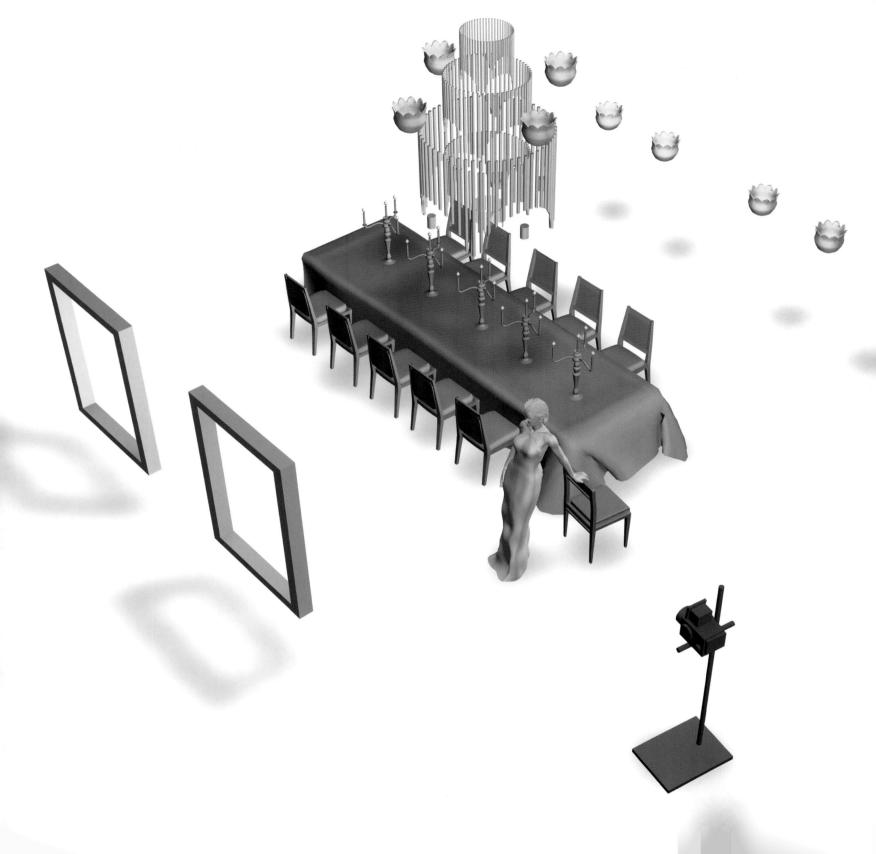

Toby
McFarlan Pond

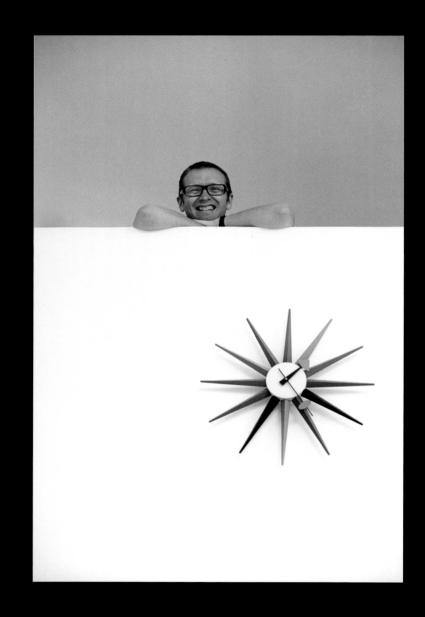

Still life

Toby McFarlan Pond studied design before his interest in music and abstract imagery led to a job assisting Trevor Keys (noted for his work on album covers), and an entry into the commercial arena. McFarlan Pond is one of the most original and creative image-makers in editorial and advertising photography. He maintains personal projects and, at the time of writing, is editing an issue of *Big* magazine. Well known for his playful light drawings, his work is difficult to categorize into a trademark style. He is equally comfortable producing images inspired by Dutch still-life paintings as those inspired by the light and shadow on his studio wall. McFarlan Pond describes his process as akin to problem solving. In his work it is as though light physically registers something of the energy and pleasure of his experimentation and interaction with the objects to which he turns his camera, eye, and mind. He is a regular contributor to *Pop*, *Arena Homme Plus*, and *Big*. His advertising clients include Audi, Absolut Vodka, Prada, Tommy Hilfiger, Calvin Klein fragrance, Ritz Fine Jewellery, and Philippe Starck eyewear.

The focus for this chapter is McFarlan Pond's international advertising campaign for Adidas. Still life is a diverse discipline that includes any kind of object that can be photographed isolated, in detail, or as part of a composition, including fragrance and cosmetic packs; cars; products such as handbags, shoes, watches, cell phones, and jewelry; and even elements of beauty and body work.

In thinking about a pertinent single example to cover such broad ground, McFarlan Pond's work with advertising agency TBWA\Chiat\Day stood out as a great brief conceptualized and executed with flair, deep consideration, and minute attention to detail. McFarlan Pond's work also highlights the potential and sophistication of postproduction techniques, in this case shooting and putting together two objects to create the effect of a reflection. The premise is a juxtaposition of historic, old-school products with their contemporary counterparts. The images effectively market both the new shoes as desirable consumer goods, and the credibility of Adidas as a prestigious historic label. In still-life photography, as with most commercial practice, a balancing act between the greater freedom of editorial image-making and the necessity of fulfilling an advertising client's requirements is essential. Perhaps even more than in other areas of commercial practice, it is important for a still-life photographer to build a portfolio showcasing technical skill and imaginative applications to even the most mundane items. Clients can then visualize a similar treatment applied to their own products, while allowing the photographer they work with to propose and develop unique visual solutions for their needs.

Interview

MK: Toby, I really enjoy the way you interrogate objects and transform them from something mundane into something very beautiful and unexpected. I'm intrigued by your specific interest in still-life photography as opposed to, say, fashion or portraiture or landscape.

TMP: If you work in a commercial environment like I do, you are defined by what you do, but I don't really think of myself as just a still-life photographer. I didn't set out to be a still-life photographer. I did design at Art College. I was really interested in music. I collected record covers and wanted to work in the music industry. Through default I assisted the photographer Trevor Key [1947–1995]. He is a personal hero. In fact, I think he is one of the unsung heroes in twentieth-century photography. He worked with Jamie Reid on The Sex Pistols, he worked with Peter Saville on New Order and Joy Division [album covers]. It wasn't that I chose still life. I was more into abstract imagery for record covers. What I like about still life is it can either be a cast of thousands for the big commercial jobs, or it can just be me on my own in the studio playing music and thinking up pictures. I like the discipline. It is very peaceful. I guess I solve problems.

MK: I think problem solving is a good way to describe it.

TMP: What interests me is not so much the objects themselves. I love ideas. I'm at the stage where I love the process. I think it is important that photography is a joy.

MK: Still life sometimes strikes me as being very controlled.

TMP: Mine always strikes me as a bit messy, which I kind of love. I try not to kill whatever it is I'm photographing. I like the way light reacts with things. I like the way light falls on things. A lot of still life seems to be about making light do what you want. You define an area and create your own universe. But the idea of control doesn't sit comfortably with me. All I'm really doing is creating a place for light to have free reign. I'm not constricting it at all. I'm really just recording results. I work organically. If a reflection is messy I don't really care, I like a bit of chaos. I care a lot about light!

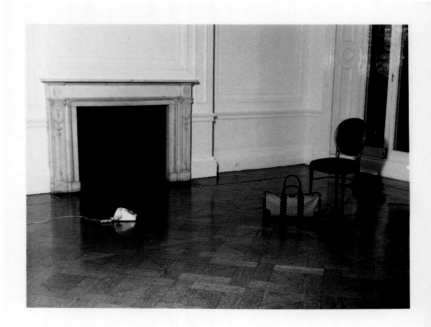

Above and right:
Her Dark Materials
Polaroids for story
published in *Pop*,
spring/summer 2005.
If you think the idea is no
good, you shouldn't do it. It's
really important that you take
responsibility for your work,
even if it is commercial.

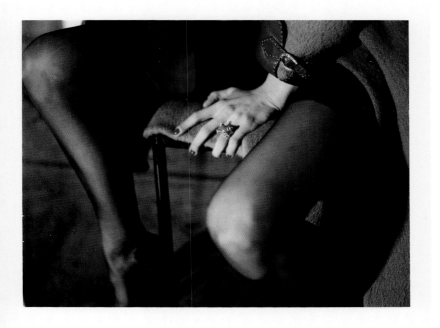 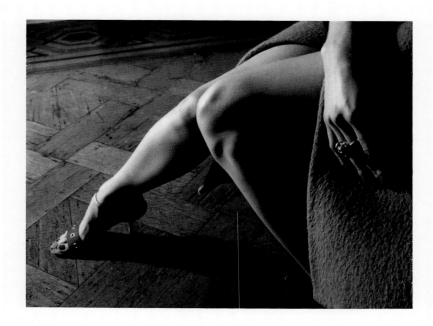

Toby McFarlan Pond: Still life

MK: You don't only shoot luxury products like shoes and cars and perfume bottles, which is perhaps how some people think of still life. You shoot beauty and fashion as part of still life. Do you think there is any difference in these ways of working?

TMP: I've done fashion for *Pop* [magazine].

MK: *Pop* is a good example because you've shot for every issue that they've produced.

TMP: Yes. For five or six years.

MK: When I open an issue there is always something new and different from you. You mentioned that the process is very important to you. How does that process start? Do you start with the objects that an editor might give you to work with?

TMP: I don't think the process ever starts or stops. Editorially you have a freer reign. Generally I leave things lying around which themselves suggest ideas to me. Sometimes Katie [Grand, fashion stylist and Editor of *Pop*] may have a couple of words. At the moment we're doing this thing that started with stainless steel. I've ended up with shadows through trees on my wall in daylight. You explore things. I can't stand seeing the same picture over and over again. I'm constantly looking for new ideas. There are editorial commitments to advertisers, but the thing about Katie and me is that she is one of the few people who just let me get on with it. *Pop* is one of the only things that I can still shoot in my own studio because I work so much in the States. I still have fun with it.

MK: Is there a story you've done for *Pop* that you particularly love?

TMP: There are quite a few. I'm really happy with all of them. The Gucci Polaroids [Her Dark Materials] were interesting because it was the first time I'd actually done a fashion story. I also really like a group of pictures I did based on old Masters paintings. It was something I'd always wanted to do, but not just replicating paintings. We took that as an idea and then got fashion into it. We did an Arcimboldo [Giuseppe Arcimboldo, a sixteenth-century artist who made portraits from fruit and vegetables, pots and pans, etc.] thing where we took Arcimboldo as an idea and we made a fish head with jewelry. It wasn't just copying something.

MK: So an influence can be a book, a painting, a mood …

TMP: It can be the way shadows fall across the wall in my studio, but it's not so clinical. It's not structured.

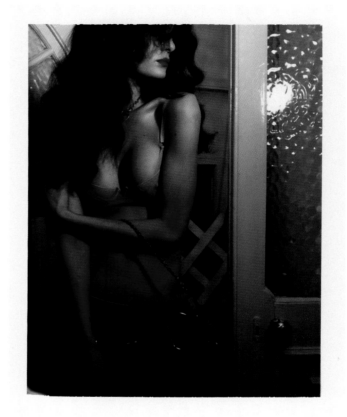

Above and right:
Her Dark Materials
Polaroids for story
published in *Pop*,
spring/summer 2005.
I enjoy composition. I know
when things feel right and
when things are wrong. There
are technical considerations,
but it's also intuitive.

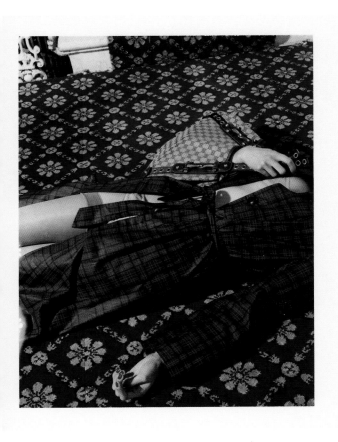

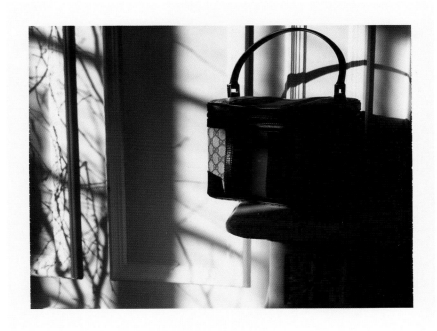

Toby McFarlan Pond: Still life

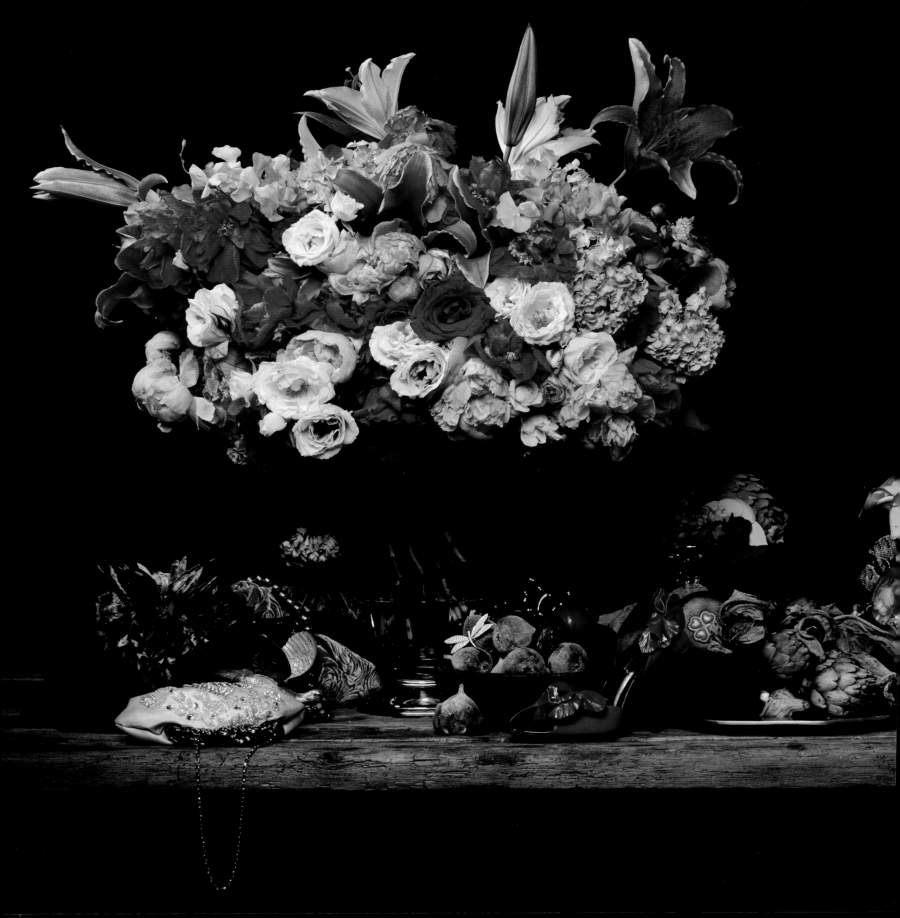

Left and below:
Yield to the Night
Published in *Pop*,
autumn/winter 2004.
I try not to kill whatever it is I'm
photographing. I like the way
light reacts with things. I like the
way light falls on things.

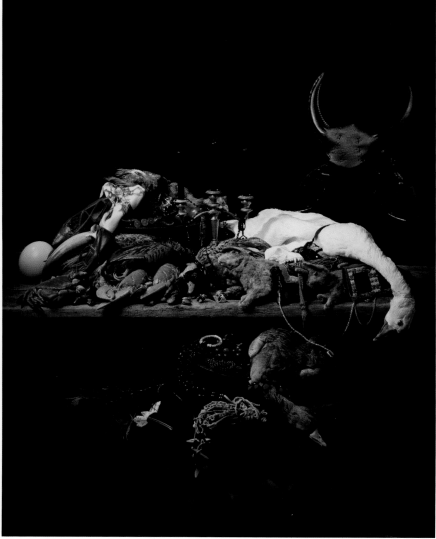

Toby McFarlan Pond: Still life

MK: Do you find when you are working on an advertising job, say shooting a fragrance or a car, that the art director or client want to take something of that freedom of ideas from your editorial work and apply it more strictly to their product?

TMP: Yes. If you are in the right magazines it gives you some sort of status. Actually it is a really good advert for you. I did something recently in New York where we took an idea from *Pop*, exactly the same thing, but used a different company's jewelry, and it worked perfectly. Cars are interesting because they really want to keep pushing the envelope, but there are so many people involved that you often end up toning it down a bit. It's about compromises. You meet in the middle. You are getting paid to do a job. Some of the things I've done commercially of late, for example for Calvin Klein, have been more out there than the things I've been doing in editorial. For them it was a case that we had the bottles and there was a loose concept. The first was water, the second was electricity, and that was it. They came to me with ideas, but not a finished visual. I've done that in the past, particularly with French agencies which sell a finished visual that you have to recreate, and that is fun to do once in a while. Usually it's solving problems, and it's one thing to have an idea, but it's another thing to take that idea and make something elegant or aesthetically pleasing, or to get the right composition.

Right and far right:
Strange Beauty
Published in *Pop*,
spring/summer 2005.
It's one thing to have an idea,
but it's another thing to take
that idea and make something
elegant or aesthetically pleasing,
or to get the right composition.

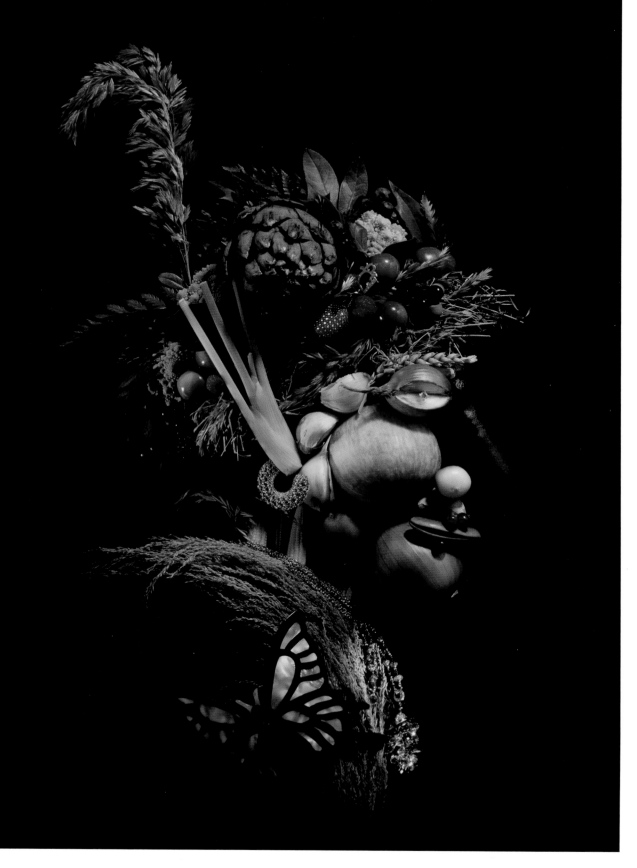

Toby McFarlan Pond: Still life

MK: Is there sometimes a need to find a balance between a concept or idea and just letting the object stand alone?

TMP: Interestingly enough, there was a big shift back in the late '90s toward the product. I was trying to do more interesting things, so it wasn't so literal. I wanted to invent stories through light and playing with exposures. I've always liked messing about. Now the industry is at a point where it is about product photography again. My portfolio is more chaotic and I think that comes through Katie too: she always wants more than one credit on a page. I really enjoy composition and bouncing things off other things. I know when things feel right and when things are wrong. There are technical considerations, but it's also intuitive.

MK: Let's talk more about the process of getting editorial and advertising commissions.

TMP: It's all about relationships. No one wants to work with a difficult person. Someone said to me a long time ago, "It's all about your reputation." People get to know what you do. It's an incredibly competitive world and it's really subjective, but I think if you are right for something, you are right for it. One of the hard things about commercial photography is if a job goes badly, at the end of the day the responsibility is with the photographer. If you think the idea is no good, you shouldn't do it. It's really important that you take responsibility for your work, even if it is commercial. Sometimes the thing you are looking at through the camera doesn't make a pretty picture, but you keep working at it. Sometimes I'm looking through the camera thinking, "How am I going to get this done? It's killing me!" But I've never given up on anything. An ugly bag is an ugly bag. You just have to work a bit harder to find something in it. It's what you get paid for. Well-designed things are easy to photograph.

MK: Is most of your work done in camera? How important is postproduction to your process?

TMP: In a lot of my early work for *Arena Homme Plus* and *The Face*, I never did any retouching. It was all done in camera. I was known for that. You can make multiple exposures or do things like rephotographing transparencies. There are lots of happy accidents. That's the joy of doing it; spending a couple of days messing around with lights and cameras and gels. I'm not a retoucher, I'm a photographer, so I use retouchers. I shoot on film except when the client really wants it [digital]. The technology isn't there yet. The details in the shadows and the highlights lose definition. It's easily corrected, but it involves more retouching afterward. I'd rather spend less time doing that and more time in the studio.

MK: Let's move on to talk about the work you did for Adidas. I really like this campaign. When did you do it?

TMP: 2004.

MK: Who commissioned it?

TMP: TBWA\Chiat\Day in San Francisco.

MK: The reflection concept of old school and new school is a strong one.

TMP: That was theirs. They came to me with an idea about the history of Adidas, and it was the idea of what went before, so you have a '30s or '40s or '70s shoe reflected with its new model. It was a simple concept, but I liked the historical context. There is copy that goes with each of the ads which says what the shoe was and why it is so valuable. They got the shoes from the archives in Germany. The best things are simple ideas done well.

MK: Did you have any latitude in choosing the shoes?

TMP: No. They did a lot of research, and we also had to go with what we could access from the archive. My only thought was that it shouldn't be tricksy.

MK: What you've done is make the reflection of the new shoe actually the old shoe.

TMP: Each shoe was shot separately and the retoucher put them together.

MK: Can we break it down a bit more?

TMP: It was shot on a few occasions because we did so many variations. It is shot against a white background. I became a bit obsessed with shooting the old shoes traditionally, so I spent a lot of time forming shadows which you also could have done through retouching. We were using regular flash heads. Just open heads with black wrap, which is a foil you use to make light more directional, and maybe some of them had honeycombs on to kill the light down. In the end I lit it with about seven lights and a few mirrors. I silhouetted the shoe against a background, and then I lit the shoe independently of the background. There is light under the table firing at the background and then there are sidelights and top lights and backlights. It was so nice to have a good length of time to do it. Instead of rushing, we were only doing about four shots in a day, so it gave us a chance to light it properly and really consider it.

Adidas worldwide advertising campaign
Commissioned by TBWA\ Chiat\Day, published in 2004. This shoot is indicative of how I work. It's not really complicated, but it's about making something look better than it does in real life. It's all about the lighting.

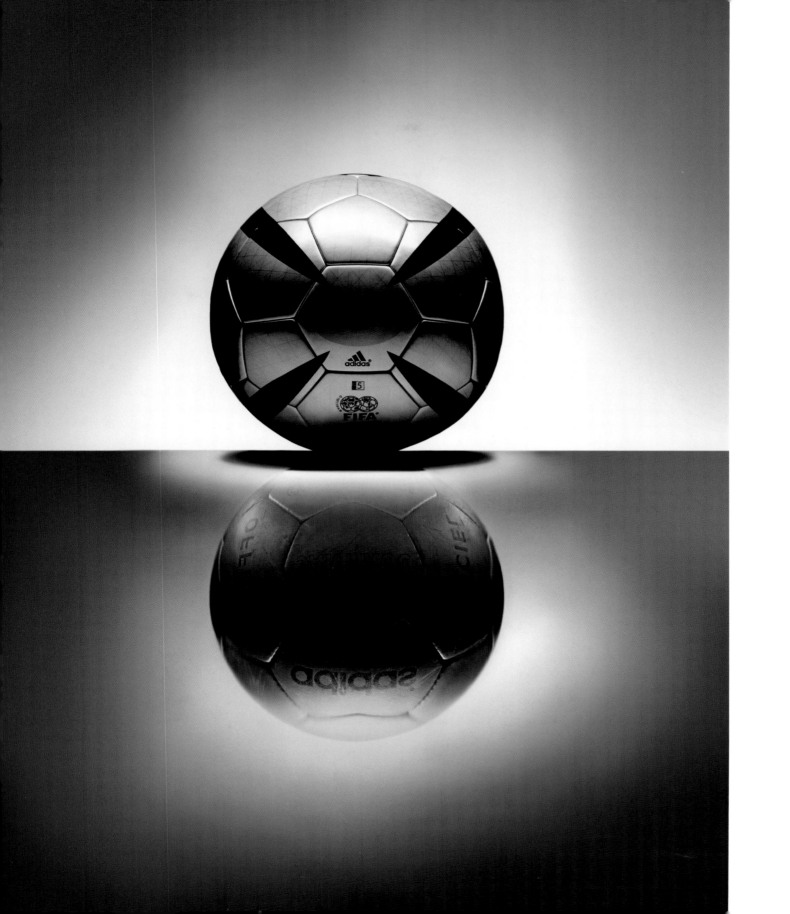

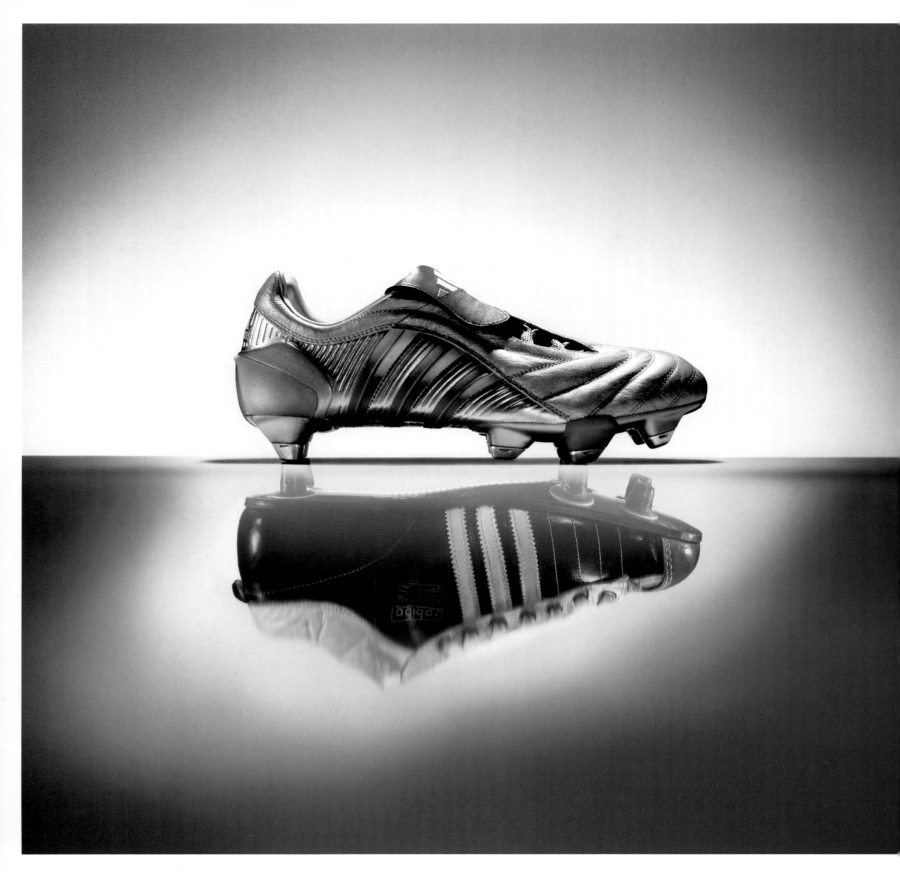

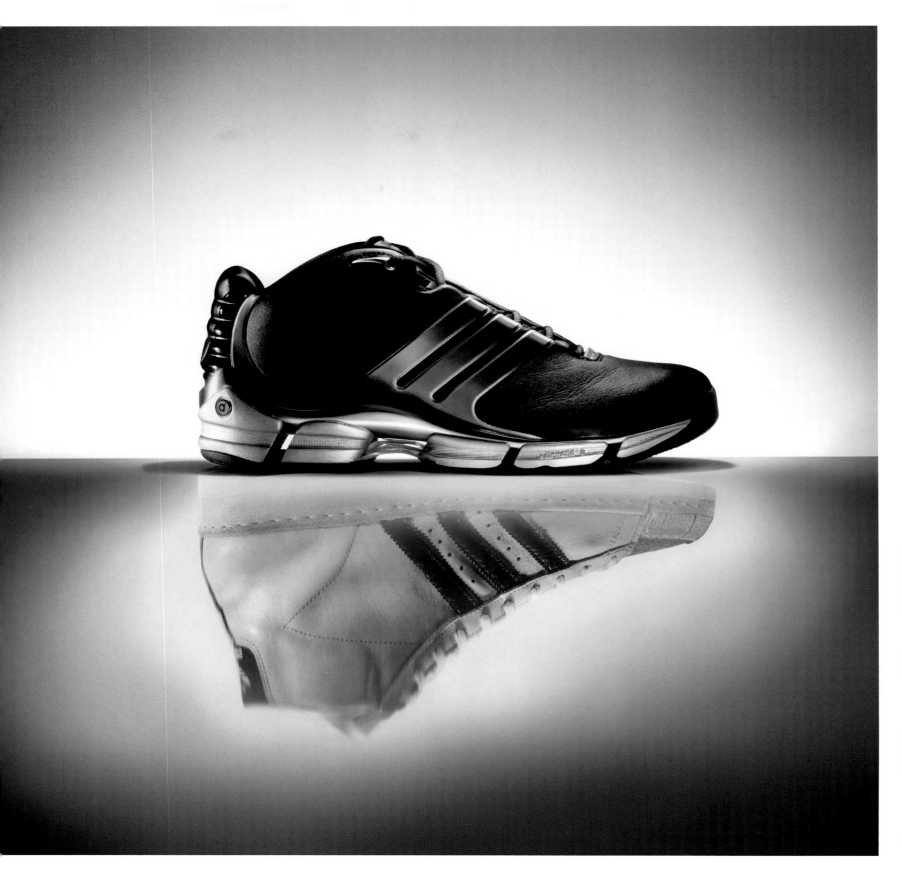

131

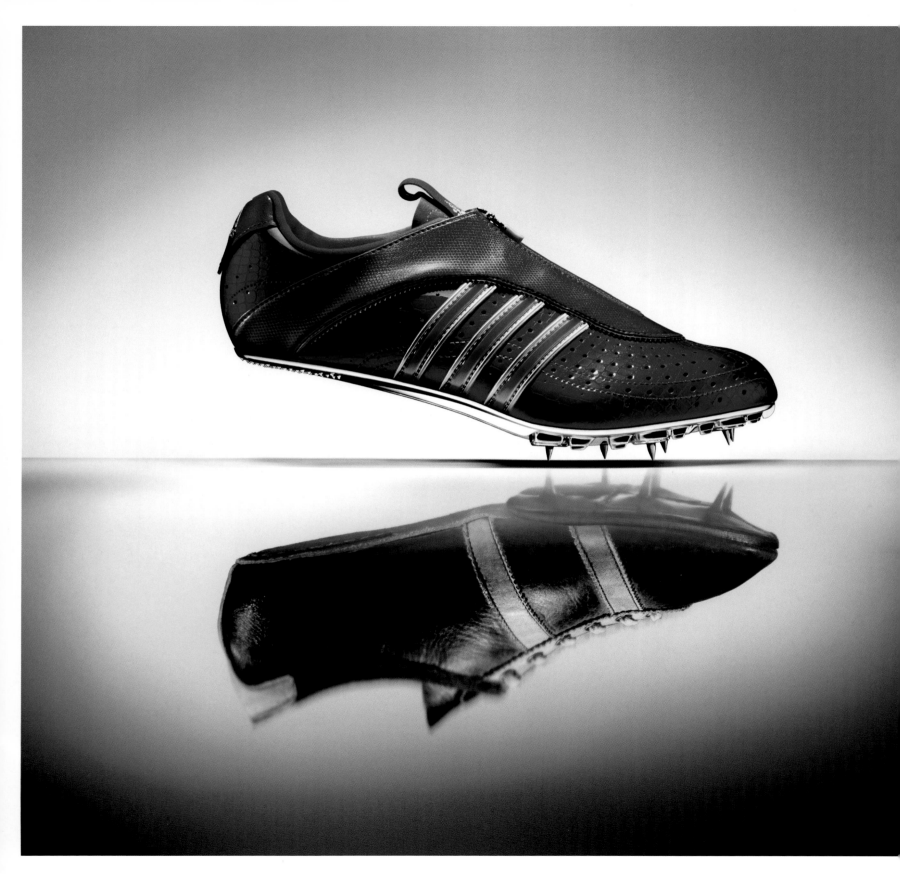

MK: What surface are the shoes on?

TMP: It's on white Plexi. It's the simplest material. We tried glass and black Perspex but they didn't work. Plexi gave us the result we wanted.

MK: What team did you work with?

TMP: There were three assistants. I had a prop guy who took care of the backgrounds and making sure the shoes all looked fantastic. Adidas didn't have a 1966 football that they were prepared to lend us, so we got a copy of the Santiago football and we had a modelmaker age it.

MK: How involved were you after the shoot?

TMP: With some jobs you're involved in postproduction and with others you aren't. This one I wasn't, but they kept me in the loop about how it was going and listened to my suggestions. Pretty much what you see is what it was, for example, the shadows were all there, but maybe they just extended them a little bit. The main thing was that the reflection shots were put in. They used the actual reflection of the old-school shoe in the Plexi, not the shoe itself. When I shot the new shoe I didn't have to worry about the reflection. Then they were put together. The focus is important. If it were shot digital there would be less detail.

MK: How important is the color?

TMP: The color is very important. In the spiked running shoe here is a pearlescence in the flash which we shot separately. It was very reflective. The chromed base looks good if you introduce black into it. It looks dramatic. You have to consider everything. It is like a meditation on the object. We had a long debate about how to make the tongue on the Beckham shoe look right—the shape of it. It was about decisions. And with the reflections it was like, "Should we lose some detail? Should we have the stitching? Let's keep the leather looking aged…" This shoot is indicative of how I work. It's not really complicated, but it's about making something look better than it does in real life. It's all about the lighting. But more important than the technical side of things is how you want something to be, that you have a picture in your mind and you know how to get it out.

MK: Let's look at the high-top boot [left].

TMP: I like this one. We called it the Darth Vader shoe. We allowed the lovely creases in the leather to stay. It was a conscious decision not to make the old shoes look pristine. We let them be what they were. A slightly old, battered shoe can be very appealing. It was tricky to light the football because it was round and shiny. But you can see that the distance between the cells in the ball is exactly the same, and I spent a lot of time considering proportions. The shoot is actually quite humble; it is just saying this is something from history and this is where they are now. It's what they are that is important.

Left and previous spread:
Adidas worldwide advertising campaign
Commissioned by TBWA\ Chiat\Day, published in 2004. I became a bit obsessed with shooting the old shoes traditionally, so I spent a lot of time forming shadows which you could also do through retouching.

Toby McFarlan Pond: Still life

Workshop

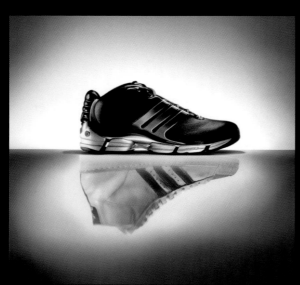

This lighting diagram illustrates a multiflash technique similar to that used by McFarlan Pond in creating the image shown here. The shoe was shot on a white Plexi surface, against a white background, using regular, open flash heads with black wrap (a foil used to make light more directional). Adding honeycomb diffusers to the flash heads kills the light down. For this particular image, McFarlan Pond silhouetted the shoe against the background, and also lit the shoe independently of the background. Sidelights, top lights, and backlights were all used. In all, around seven lights were used, along with two or three mirrors. (The shoe in the reflection was shot separately, and the two images put together in postproduction.)

McFarlan Pond's essentials

The only essential thing is your mind. You can make stuff out of anything. A Leatherman is always good, and failing that a Swiss army knife, Blu-Tack, invisible thread (fishing line), and gaffer tape. It's all about the gaffer!

Specification

CAMERA: **Fuji GX-680 with 180mm lens**

LIGHT: **Broncolor lights with Pulsar F4 flash heads; Graphic A4 pack**

FILM: **Velvia 100F**

EXPOSURE: **1/125 sec at f/32**

Suggested reading

Concorde, WOLFGANG TILLMANS, Verlag der Buchhandlung Walther König, 1997

Grace: Thirty Years of Fashion at Vogue, GRACE CODDINGTON, MICHAEL ROBERTS, ANNA WINTOUR, Steid Publishing, 2002

In Camera, Francis Bacon: Photography, Film and the Practice of Painting, MARTIN HARRISON, Thames & Hudson, 2005

Instant Light: Tarkovsky Polaroids, GIOVANNI CHIARAMONT, Thames & Hudson, 2004

Raised by Wolves, JIM GOLDBERG, Scalo Publishers, 1995

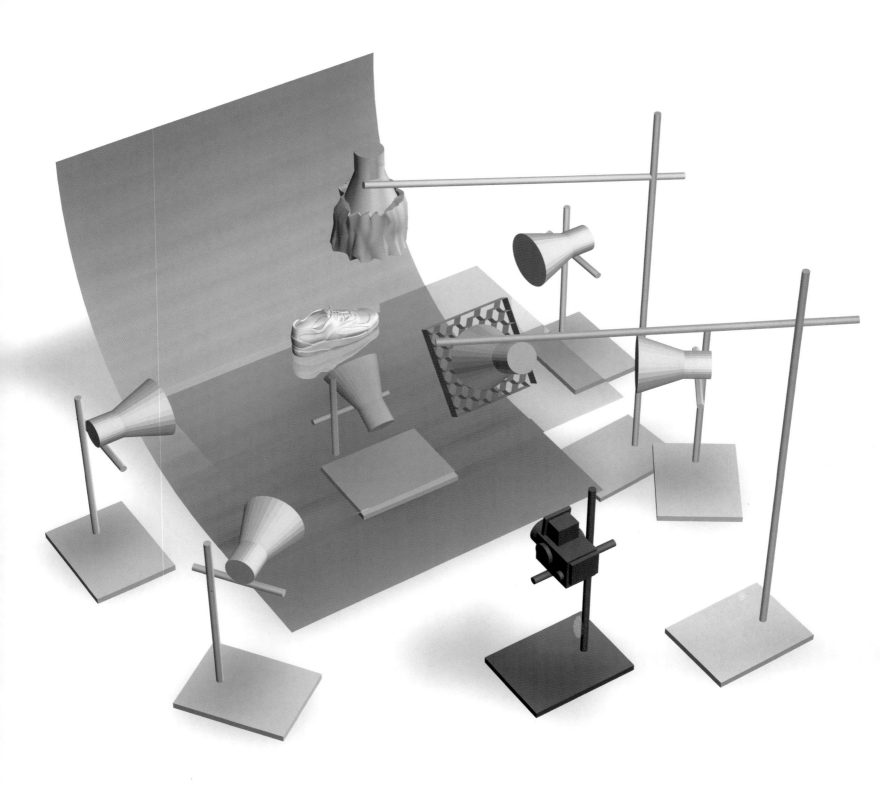

Studio setups

Norwegian-born Sølve Sundsbø began his career assisting Nick Knight. With no formal training, he is now one of the most sought-after of his generation in the fashion industry. Sundsbø has shot advertising campaigns for Yves Saint Laurent, Hermès, Nike, and Lancôme, with editorial credits including *V*, *Visionaire*, *Pop*, *i-D*, *Dazed & Confused*, *Numéro*, and *Vogue* Nippon. His method combines simplicity of approach with a perfectionist's eye for detail, and a technical sophistication, both in camera and in postproduction, enabling him to create effortlessly beautiful, dynamic, cutting-edge imagery.

Sundsbø's practice is, for the most part, studio based. Traditionally, or until cameras, flash, and equipment could be more easily transported and used outdoors, the studio space was the primary working location of the professional photographer. A studio essentially provides a blank, malleable space in which to work, and to build and develop an idea. This might involve something as simple as using a colored backdrop, but equally, could involve more complex preparations utilizing set builders, props, and elaborate lighting systems. A studio setup allows the use of special effects, and of both natural and artificial light, in a controlled environment, unaffected by weather conditions, with a dependable power supply and light source. This enables longer, more flexible working conditions. While there is no reason why a living room or basement can't provide a perfectly good working studio, it is less common for established photographers to have their own studio premises than to hire a facility. Major photographic studios can assist with equipment hire and catering as required. In addition, they often offer discounted rates for editorial or test shoots, particularly to known assistants.

The story discussed in this chapter—imaginatively conceived, immaculately executed, and combining an innate sensitivity to the clothes and the model—exemplifies many of the qualities on which Sundsbø's success is based. Commissioned by *V* magazine, the idea of creating the impression of a flower, with layered fabrics synthesizing into petals, originally came from stylist Anastasia Barbieri. In this regard, the story is reminiscent of Lillian Bassman's 1949 shoot for *Harper's Bazaar* for which a Piguet dress was photographed as two mirrored halves, with the model's head thrown back and elbows held out to the side so that the diaphanous fabric resembled butterfly wings.

Stories such as this one by Sundsbø and others by Richard Burbridge, David Sims, Mario Testino, Glen Luchford, and Heidi Slimane, made issues of *V* from the early 2000s the strongest and most exciting for years.

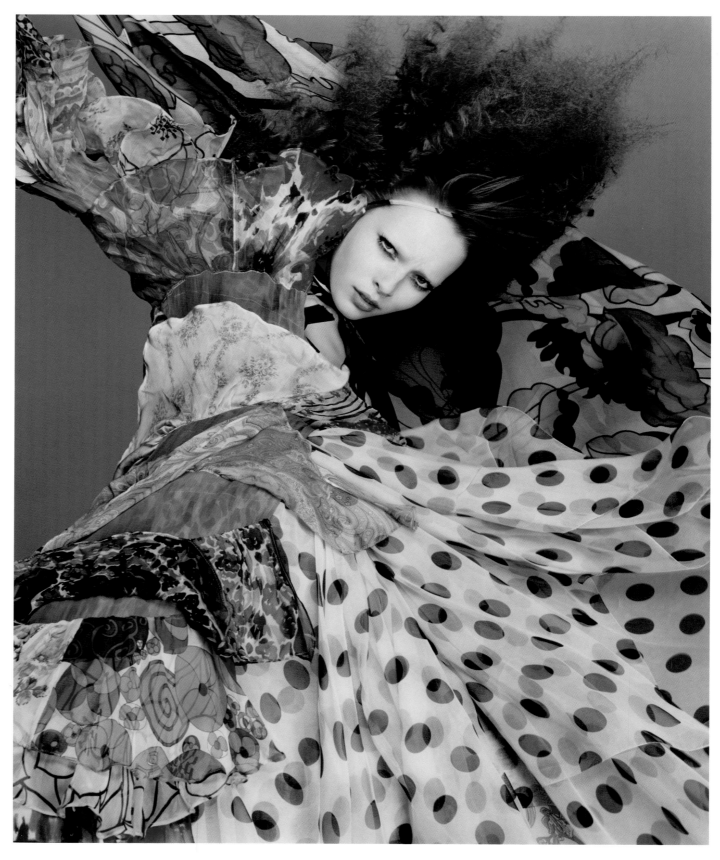

MK: Sølve, I'd like to talk to you about the particular challenges of working in a studio. You are a very successful fashion photographer. You've done so many great things and you're still young, which I think is the dream of most people starting out in the industry. Could you tell me how it began for you?

SS: I'm from Norway, which is pretty far removed from the fashion industry I deal with today. When I started I was taking pictures of my friends skiing or bands playing gigs. So a lot of it was very graphic and simple. Fashion photography seemed like a way of accelerating the things that I really liked in what I was doing. I really admired Nick Knight and wanted to assist him or Craig McDean. I started college in London and through Craig I got to work with Nick. It was really bizarre; that feeling of being completely outside everything and then working for someone who was right in the middle of it. Everything that I do now is very colored by that experience of being put in someone's world as intensely as I was as an assistant. The work I do now is still influenced by those years, and by Nick.

MK: For how long did you work with him?

SS: Three and a half years. It takes time to move away from that, which I think is a common experience for a lot of photographers.

MK: Knight works a lot in the studio. Do you think that explains part of your interest in studio photography?

SS: I love graphics and illustration. I like simple things pared down. It leaves more to the imagination. I like it when you can see that something comes from the imagination. What I love about the studio is that you have an absolutely empty space to start. Sometimes in photography you want to cut down a tree or tear down a building that is in the way; or you want the light to be behind you not in front of you; or that landscape would look amazing at four o'clock but it's only one o'clock. Outside you have to deal with all those things. In the studio, if you want to move a light you can move it straight away. If you want to have a red background you can make it red. You can change things quickly and play around. I think daylight photography is for people more patient than me! It's a different kind of energy, not better or worse. What is amazing in studio photography is that you can create the mood that you want everything to be in. If you think of it as a box or a frame, everything that goes into that frame comes from the people you work with and from your mind. That can be very difficult sometimes if you don't have an idea, but it is the best thing in the world if you have a strong idea because you can control it. You can make sure that what you want to come across

will come across. I do work outside as well and I love it, but that is more like improvisation. It is important for me to work like that from time to time because I can let go a bit more. You don't have to feel like you are responsible for the entire scenario; you are much more able to capture something.

MK: Can you remember your first shoot?

SS: When you are a photographer and you go into the studio for the first time you might think, "Oh my God I can do it." You light it, and you have a camera, and you shoot it, and you think it is amazing because it looks like a studio photograph. You can literally put anything in front of the camera, and you start and you think it looks great. It's a very special experience. I remember that feeling, but that is not enough. The most important thing you have to remember when you go into a studio is to make sure what you take in there is interesting, not just how you photograph it. Because what you bring into the studio is what you are going to get back. It sounds a bit without compromise, but that's what it is. It's a reductional thing. You take away everything except for the one thing that you brought in there, so it has to be good.

MK: Is that the most important thing you have learnt up till now? That it's what you take in there that counts?

SS: Yes, but as well as being prepared, you have to be very open at the same time. This story is a good example of that because it is a conversation between a stylist [Anastasia Barbieri] and a photographer. In this case I wasn't sure what to expect, because when we first spoke the idea was that she wanted to make the girl like a flower. From that idea I thought about how that would happen. What clothes would she bring for that? Or are we going to paint flowers on the girl's face? Are we going to do double exposures so that the girl might blend in with a flower? It wasn't quite clear. We had a very limited time, from 9.30am till 6.30pm, and I had to edit and start postproduction the next day. It was a really tight deadline. It turned out that Anastasia wanted to put more than one dress, more than two dresses, sometimes even three dresses on the model. It became clear that the clothes could become petals. Then we had Sam McKnight, who is an amazing hair artist, and also amazing with wind machines. So we created the effect of petals with the model's arms and legs. To get the clothes to make these shapes we had to move them. You have to inspire the girl to move and you have to move the clothes with the wind machine. As soon as you get one picture that illustrates what you want to do, which is often the hardest part—from the hair, the makeup, the clothes, light, attitude, background color, everything—if you get one picture that says

Bloom
Published in *V*, spring 2004.
What is amazing in studio photography is that you can create the mood that you want everything to be in. If you think of it as a frame, everything that goes into that frame comes from the people you work with and from your mind.

Sølve Sundsbø: Studio setups

all that, you kind of have a map of where you want to go. Sometimes you don't get that on the first day; sometimes you don't get that till 5.00pm the next day, so then you have to shoot the whole story from 5.00pm till 12.00 at night. Sometimes it takes two days to get to that point, to establish a character and get everything right. So it's kind of like a laboratory in that you experiment and play and try things out.

MK: So preparation and what you take into the studio are crucial not only literally, in terms of props, but also in terms of energy and knowing where you want to go. Are the team dynamics and experimentation also important?

SS: Absolutely. The dynamic within the team is super important. In a way you are a director at the same time as a photographer, but often with a lot less resources.

MK: Who might be in your team?

SS: It's different people. You have a stylist, a model, a couple of your own assistants, hair and makeup, and you very often have a manicurist. And if it is a commercial job you have the client, which can be anything from two to twenty-five people. When there are a lot of people on set, sometimes your assistant's job is to keep people out of the shooting space, because you stand with your back to everyone, but the model sees them and you are trying to get that person to perform for you. They might not be able to play exactly the role you intended them to play, but you go with it. If you have someone who is good at dancing, you think that maybe you can then use that, or if you have someone who is really good at athletic or classical poses you think, "OK, maybe that is what I will do." Some girls need a lot of direction and some girls you can just let them go. With the flower story [Bloom], the setup was really simple. It was one light for most of the time, and just one camera. The light was falling off to a gray background and we had four wind machines to get the clothes to move. It was shot on film. If you shoot on digital you can see what you get straight away, but it's actually quite nice not knowing because when you don't know what you get, you keep searching a bit harder and you try things. When you shoot digital, as soon as you achieve what it is you wanted, you stop and move on. With film you might get something amazing without knowing it, keep on shooting till you think you have it, and then when you go back and edit you think, "Wow I didn't know I had that." Getting those spontaneous moments is one advantage of shooting film that I never expected; where the eyes just go the right way and the arms are doing the right thing, everything feels like it is what you wanted it to be. It has a grace or it has an aggression, but it has something that is *the* moment. Photography is still about capturing moments.

Bloom
Published in *V*, spring 2004.
What I love about the studio
is that you have an absolutely
empty space to start.

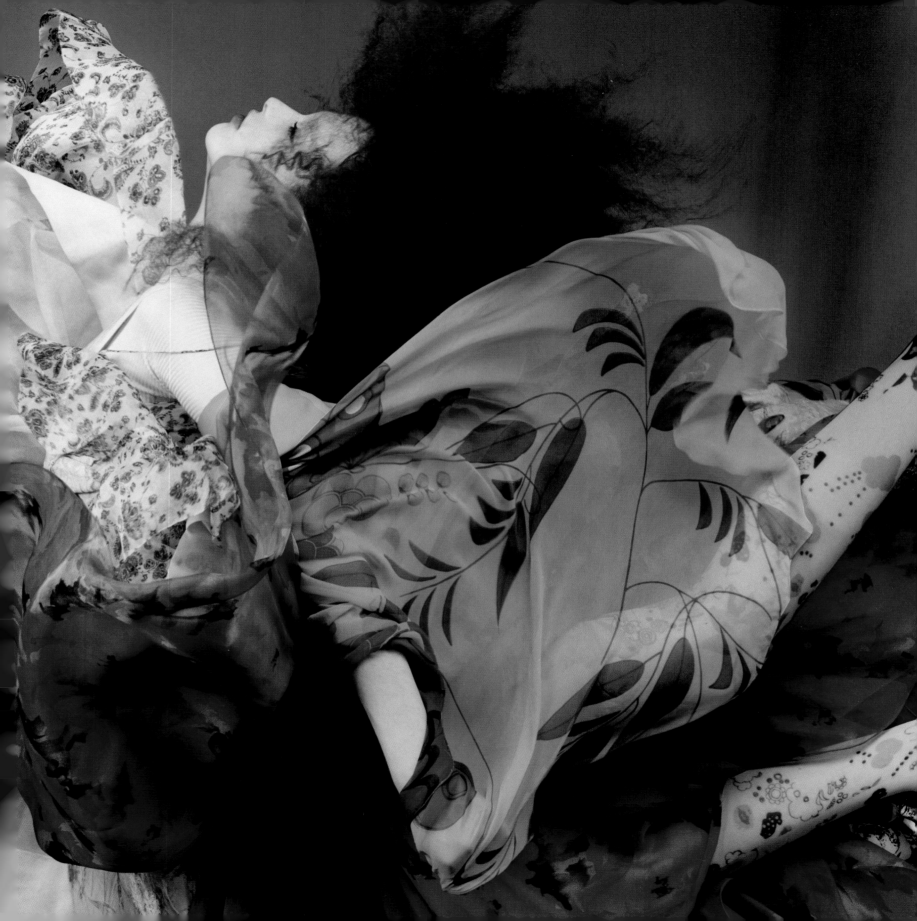

MK: Can you tell me a bit about what you did before you went into the studio to make the story?

SS: We had everything there because I wasn't sure, as I said, what Anastasia was going to bring, because she was talking about the flower aspect and I wasn't quite sure how to interpret it. The image with the Dior dresses [see pages 144/145] was the first one we did. Before I got that picture we tried three or four different lighting things really quickly. Sometimes you don't want to exhaust something straight away so you try a light from the front and a light from behind and then a light from the side. You just try three or four different things to see what works. We very quickly established it was not about anything complicated or technical. It was about a very pure, simple idea executed really well in the most old-fashioned way of shooting, which is just one light. As soon as you have that established, you can go in and concentrate on what to do because you don't really want to have to be thinking about the light the whole time, or technical things. You want to think about communication with the model and, in this case, getting the clothes to do what you want them to do. We wanted the fashion to be dynamic and energetic, and I needed to capture that. If you've only got one light it is much simpler to do that. Obviously the light moves all the time and you have an assistant who knows where it should be. So you try to train them to know that if the model's head goes down, the light goes down, if her head goes up, the light goes up. The light doesn't get fixed. A lot of people think that as soon as you get a nice light in one Polaroid, that's going to be great for the rest of the day, but obviously if someone turns their head to the right, you have to have someone moving the light all the time.

MK: How did you learn about what works best with light?

SS: You learn it by looking at photographs and you learn it as an assistant and by being in a studio and seeing how a photographer works. First you need to know what you want. I use different lights almost every time. I can't really light the studio three days before I have what I'm going to light, because the light depends on what I'm photographing. Or it might be the same light used differently in every single picture, closer or farther away, which changes the quality of light. You need to understand quality of light and you need to understand the difference between a hard and a soft light, or what happens when you move a light farther out or farther in. Now, with digital photography, people are getting much better at lighting much quicker because you have a camera and you take a picture and you can see if it's too dark, then you make it lighter. If you've got a rough understanding of what you are doing, you learn it really quickly because you see it the same second.

Bloom
Published in *V*, spring 2004.
This story was about a very pure, simple idea executed really well in the most old-fashioned way of shooting, using just one light.

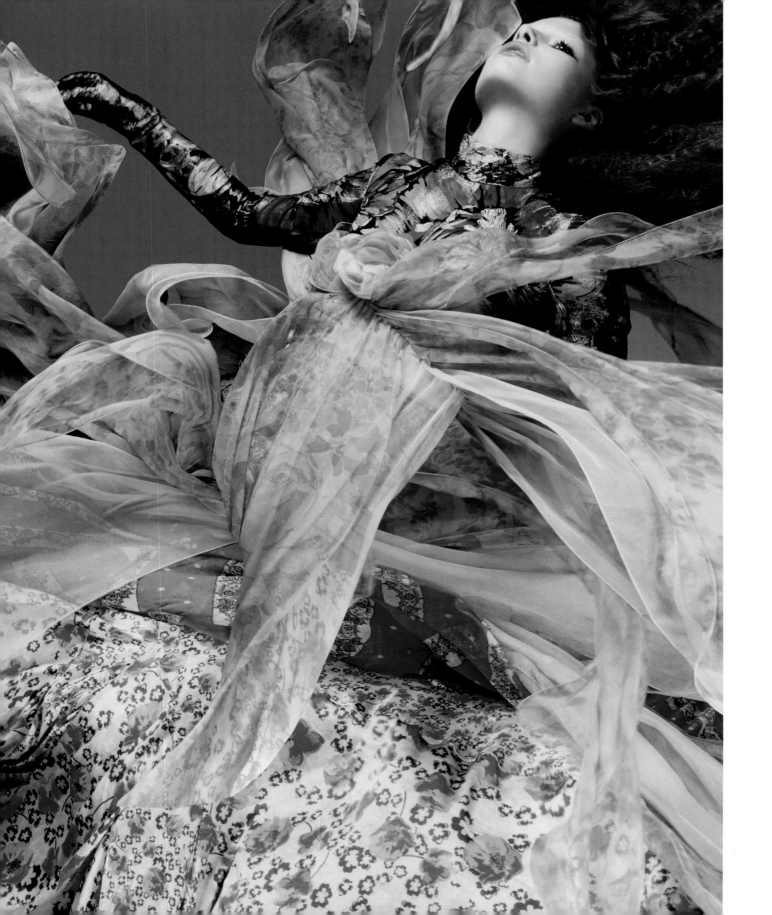

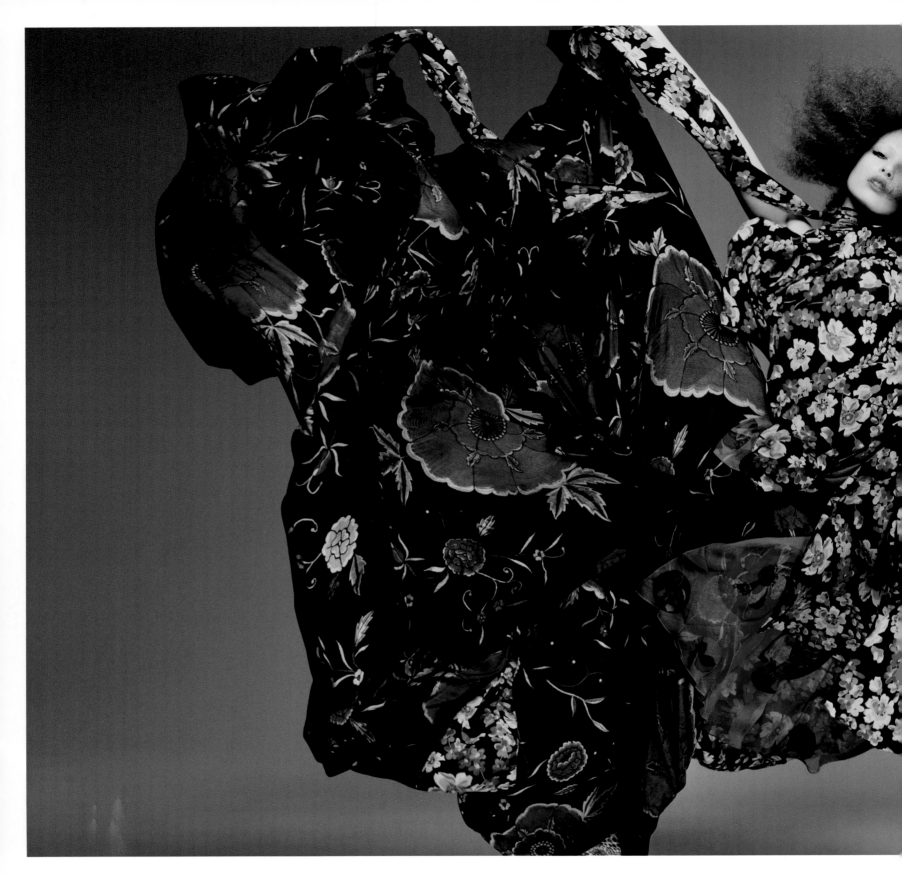

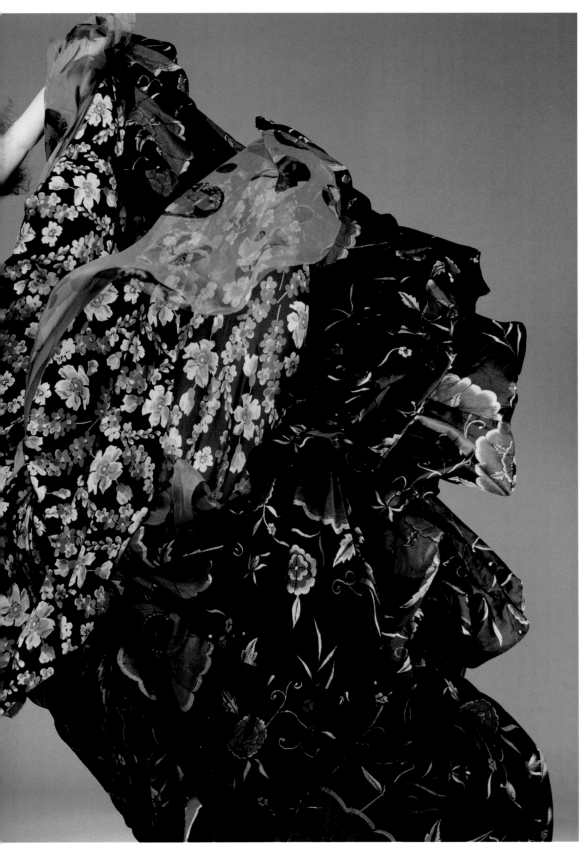

MK: So let's go back to the first image with the two Dior dresses. Can you tell me about the light?

SS: The light is coming from quite high above. It is quite far away from her so it has a huge spread. I had a reflecting light coming in from the right-hand side, so in this shot there are actually two lights. The second light is from below on the right. It is a classic example of an impossible image. I knew that I wanted her to look like a butterfly or a flower, but however much we shot, the dress only flew up on one side, either the right or the left. Even if she lifted her arms up high, as she did in this picture, it always seemed to stay down on one side. So we shot a picture when it went up on the right and then a picture when it went up on the left. We did it as Polaroids and stuck them together, and it worked, so I thought, "That's the way to do it." We shot it on film. We shot the right side again and again, then the left side again and again. Then when I got it back I could say, "Well, the right side is perfect in this shot and the left side is perfect in that shot." Then we literally just cut and pasted. In this case the right-hand side is in one picture, and then from her arm down to her foot is stuck on the left side.

MK: She looks like she is jumping.

SS: She held the dress in her hands, bent down to put the dress by her knees, and then just jumped up and did a star. The clothes were lifted up by her arms and the wind kicked in and we shot it. She was a great model because she was very relaxed in the process of doing that.

MK: Your role as a director in getting her to understand how to move is obviously very important.

SS: You shoot something and you get it right, and then you need to find a way to shoot something that you didn't expect. If you have a good model she can give you that. So you shoot something on film to get everything to feel right, and then you shoot a couple of Polaroids to see if things work. If they work, then you shoot a little bit more so you know you have it, and you think, "OK, now let's relax and play and have some fun and try to do something that we haven't already done." You don't shoot Polaroid when you do that, or in the case of digital you shouldn't look at your screen, you should just shoot.

Bloom
Published in *V*, spring 2004.
As soon as you get one picture that illustrates what you want to do, from the hair, the makeup, the clothes, light, attitude, background color, everything, you kind of have a map of where you want to go.

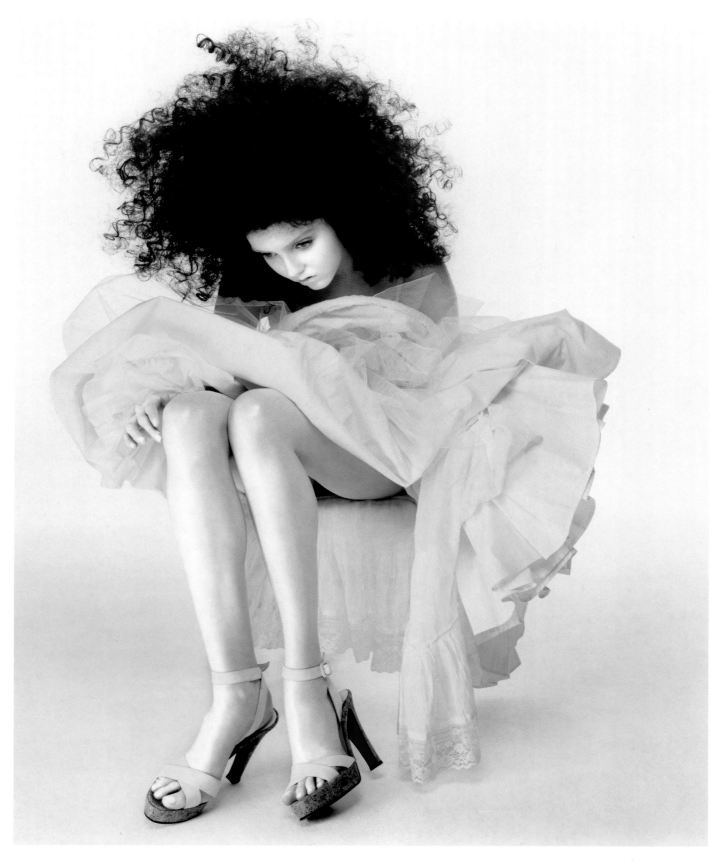

MK: Are any of the pictures a result of that time when you were just going for it?

SS: Most of them are. You can't really predict what's going on because everything is moving so much. You talk to the model all the time, and it's quite funny because if fashion photographers listened to themselves they'd be embarrassed. There are so many clichés flying around the room! You try to direct and you might say, "Your left arm looks fantastic, but can you lift your right arm a little bit higher?" This story is off the floor, but you can shoot on a trampoline so the model is weightless.

MK: That's interesting, because some people might think of studio poses as being very still and frozen, but what you describe has an energy that really goes against that idea of a model standing still with her hand on her hip.

SS: You just have to create your own little world in the studio. You have to have the right music. In contrast, some of my pictures are quite frozen. In this story [Summer Whites], which was also for *V* magazine, it was completely about the character and creating a doll-like world. It uses sets, but I struggle with sets in the studio and often just throw them out or forget to photograph them, because I always try to see what I can get out of the character. A set has to be absolutely spot on.

MK: Sølve, you mentioned to me that the process of editing in the flower story was really important.

SS: The more I look at it the more I think of all the shots I threw away to get the story to work. You need to think of it as more than an individual image, as part of a bigger story, and it can be really hard to get it right. Sometimes in the process of making the images you achieve something better than what you set out to do, but you are not capable of seeing it because you are just hunting for your idea and everything else seems like a failure other than that one thing. You have to try to be open-minded and forget about the things you set out to achieve and see if there is something else there more interesting.

MK: How did you approach shooting clothes to make good fashion photographs when all the layering makes it quite complicated? The fashion and color is so important to the photographic concept of the story. You've really worked the fashion.

SS: I think the fashion idea came from the Comme des Garçons dress [see page 148], which was a dress put together from different garments, so there is a yellow pleated skirt stitched onto another fabric, stitched onto another fabric. The idea came from the Comme des Garçons collection. To have access to the clothes is difficult for a student, or if you are just starting. So you might be a very good photographer in terms of technical things like exposure and light, but you have to remember that there is also an understanding of fashion. You can't copy that. It is something that you have to work out for yourself. You need to have something interesting to communicate. In a studio you have to make up that story. A lot of the color comes from Anastasia. To get the clothes right took a lot of time. You have to try different things. One of the most important things you learn is that you can have a good idea, but if there is one rule it is just that at the end of the day the person has to look amazing. No matter how great the fashion is, if the person looks terrible you are unemployable. No one will hire a photographer who can't make a person look great. It's about a combination of things: the hair and makeup, the angle of the head. You might have an amazing photograph, but if the model looks awful you don't have an amazing photograph. You can change a head on the computer though, if you get it right in another shot. You shouldn't get hung up on what is shot in camera and what is postproduction. There are no rules as such. Obviously there are guidelines, like keeping it simple and keeping it flexible. I think they are the main things. You don't have to have access to a studio to learn about lighting. If you have a digital camera and a simple bulb light, you do your own light course. It's like anything; the more I practice, the luckier I get.

MK: What has excited you or continues to excite you about fashion photography?

SS: The digital work that emerged from around the mid '90s was pretty amazing. You could start making pictures of things you couldn't before. You had a whole new tool, and I think it revolutionized the way that people were looking at images.

MK: Has your career unfolded as you thought it would?

SS: I've had a lot more fun than I thought I was going to have and I've done a lot more than I thought I would do. It's been a lot more of everything. It's a hard job. It takes over everything.

Summer Whites
Published in *V*, summer 2005.
This story was completely
about the character and creating
a doll-like world.

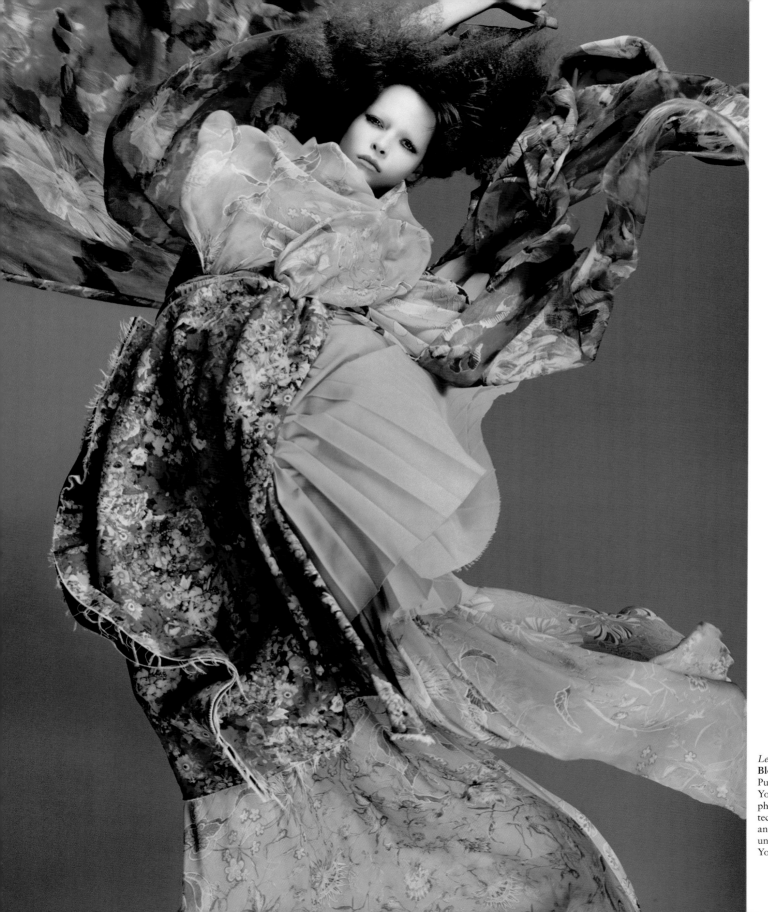

Left and right:
Bloom
Published in *V*, spring 2004.
You might be a very good
photographer in terms of
technical things like exposure
and light, but there is also an
understanding of fashion.
You can't copy that.

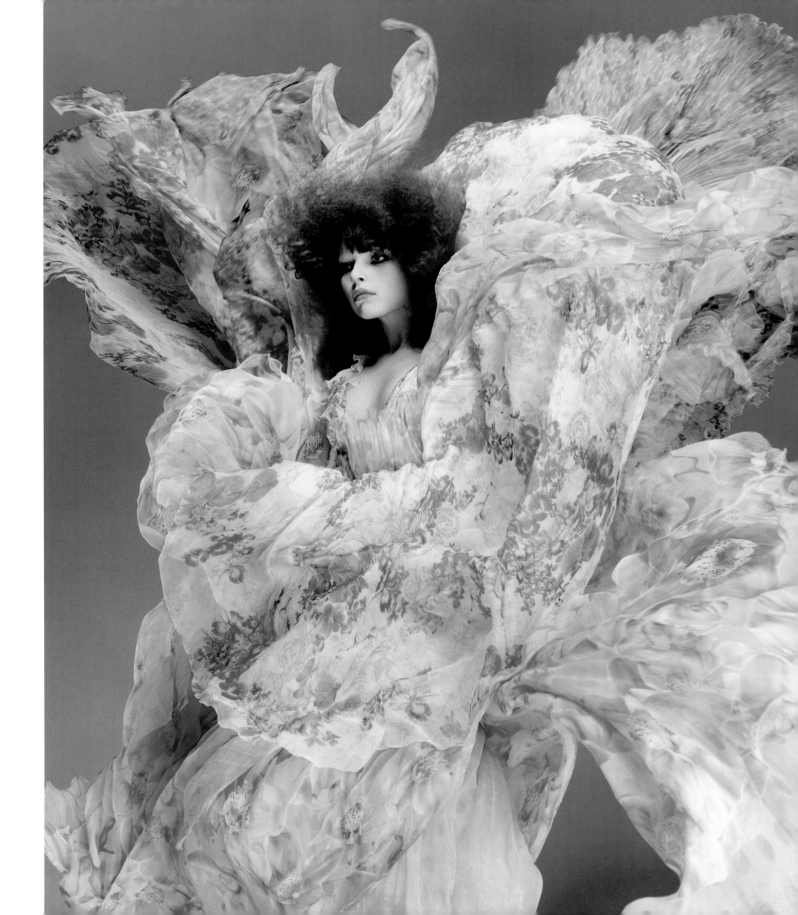

Workshop

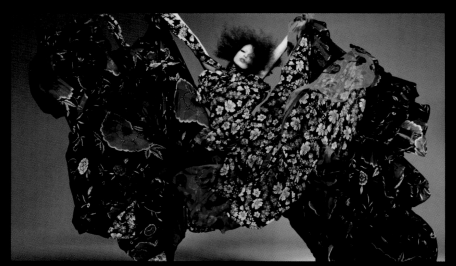

The lighting setup illustrated is based on the setup Sundsbø used for his series of flower images. He positioned the light to come in from quite high above, and fall off to a gray background (an infinity cove). It was set away from the model to create a big spread. For this particular image, a second, reflecting light coming in from below on the right-hand side was also used.

Sundsbø's essentials

• Mamiya RZ67 Pro IID

• Broncolor flash

• Linhof tripod

Specification

CAMERA: Mamiya RZ67 Pro IID

LIGHT: Broncolor flash with umbrella

FILM: Kodak Portra 160NC, rated ISO 80 and pushed half a stop

EXPOSURE: 1/400 sec at f/22

Suggested reading

Anything by:

HARRY CALLAHAN

RALPH EUGENE MEATYARD

IRVING PENN

MINOR WHITE

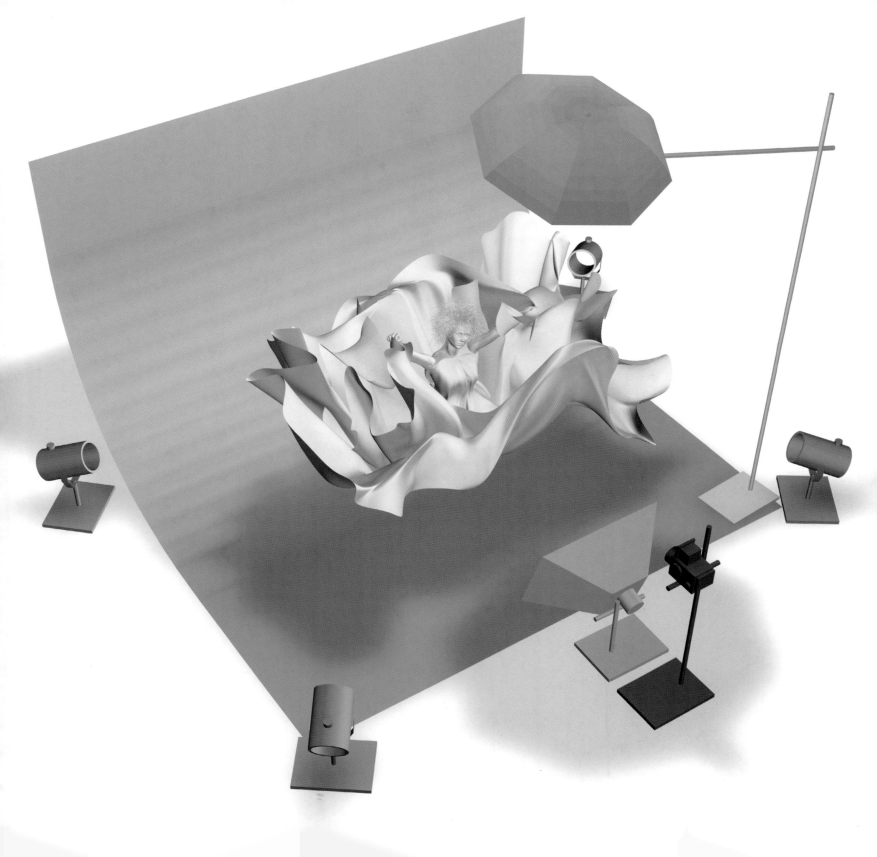

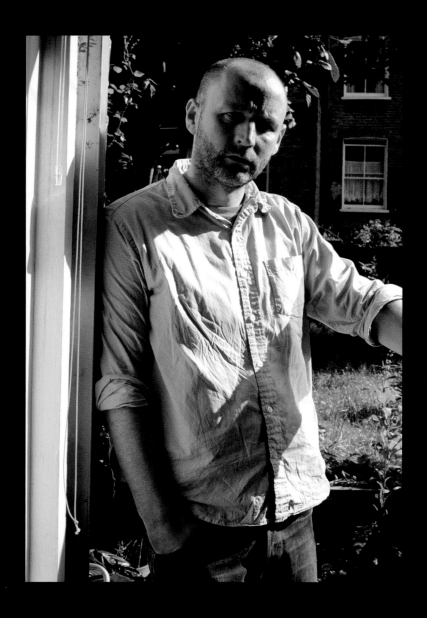

Natural light

Paul Wetherell has been working commercially, producing portraits, fashion, and landscape imagery, since 1997. Among his numerous editorial credits are *Self Service*, *10*, *Pop*, *The Face*, *W magazine*, *V magazine*, *032C*, *i-D*, and *Doing Bird*. His advertising clients include Yohji Yamamoto, IBM, Daks, and Bergdorf Goodman. Wetherell is a much-emulated yet relatively unsung hero of late 1990s English fashion photography. His approach might be thought of as a relaxed modernism—drawing on the approach of American mid-twentieth-century photographers to lighting and the motif—transposed to the specific social and environmental conditions of contemporary London. Wetherell's practice is based on a thorough understanding and enjoyment of the technical craft and process of photography, from exposure to development and printing. Yet this technical prowess is not intrusive; it allows a refined aesthetic interpretation of the characters, places, faces, and fashion he photographs to become the overriding feature of his images.

Using natural light is common in studio practice, but also suggests a more environmental approach to the production of fashion photography, such as shooting a story outside, or on location.

Sunlight has distinct qualities of strength and intensity which translate into specific visual effects depending on the time of day, the season, and where in the world an image is taken. A morning shoot on the beach in the southern hemisphere during summer is going to produce an entirely different result from a shoot in a field or forest in the northern hemisphere on a winter's afternoon. Using natural light imposes some rigidity on the working process, as a photographer must work within the hours of daylight available, though it is also common to supplement natural light with artificial light, either ambient or specially set up. Shooting on location using natural light does, for the most part, lend itself to a degree of naturalness. It also provides a narrative that relates the model to his or her surroundings. As we see in Wetherell's images, this encourages the development of a character and identity for the models he works with, rather than a sequence of static poses. On location a photographer is often able to integrate natural or architectural features into pose and composition, in the same way that props are used in the studio, to strengthen an atmospheric effect or concept. A photographer may, of course, combine props and natural or architectural features on location as required.

Wetherell is responsible for some of the most evocative and beautifully understated photography currently being produced in fashion. His works, both on location and in a studio, utilize a range of lighting techniques. This story for *Self Service* was shot in his garden in Hackney, in east London, and elegantly demonstrates his ability to control conditions and produce subtle gradations of shadow and tone using only natural light.

Interview

PW: The starting point for L'Esthétique du Hasard was a photograph by Josef Koudelka [see below].

MK: What was it in the picture that interested you? Texture?

PW: Fabric. It was such a visual thing. I thought you could put somebody on there, which would be a nice starting point for a fashion story. When I went to see Anna [Cockburn, the stylist], I showed her the image and said I'd like to do something based around fabrics. I thought we could use them to build a sort of studio environment in my garden. So I went and bought a load of material, not so that there was one backdrop, but so that there would be many different textures hanging here, there, and everywhere.

MK: That seems quite spontaneous. Is that how you like to work? Do you ever compile ideas that you might choose to come back to later?

PW: It's different depending on who you are working with. Anna is easier than most because you don't have to go in with a lot of reference pictures of models, or of fashion shoots, or of something that is really direct and literal. You can go in with an abstract picture of fabric.

MK: Which you did.

PW: Yes. And she'll go with it and come back with other ideas.

MK: So that is something special about your working relationship with a particular stylist?

PW: Yes. With some people you have to have everything in order before you speak to them. Different stylists work in different ways. Personally, I think you should know roughly where you are going to go, but if you do too much, nothing is left to chance.

MK: Could you tell me how you got into taking fashion photographs?

PW: Through assisting Dave [Sims]. I was lucky in a way because when I stopped working with Dave I did something with Anna [Cockburn] for *The Face* almost straight away. It was kind of easy to start with, and then it got more difficult. But it was also a completely different thing when I started off. To begin with I didn't really do "fashion" as "fashion." I didn't use models. It was a completely different thing.

MK: Do you think that reflects what was happening in English photography around that time?

PW: I'd seen so much fashion with Dave. I didn't want to end up mimicking someone. I just did my own thing. I was probably quite naive to be honest. I didn't really think of it as an industry. I felt slightly uncomfortable photographing people to make them look absurdly beautiful at that stage. I preferred to use characters and different people as opposed to models.

United Kingdom. Wales. 1977.
© Josef Koudelka.
When I went to see Anna, I showed her this image and said I'd like to do something based around fabrics. I thought we could use them to build a studio environment in my garden.

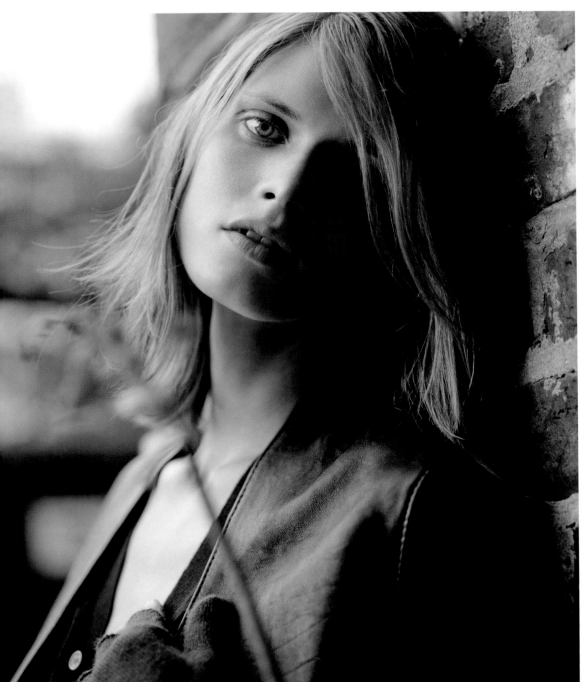

MK: You also make beautiful fashion photographs in a studio. What are some of the differences when you are preparing or conceptualizing a shoot in the studio as compared with working on location?

PW: Even in a studio I never try to create anything that is overcomplicated. I think the nicest light is simple light.

MK: So your inclination would be to shoot with natural light, on location?

PW: Well, if I can find the right location, then I'm happy. You take equipment with you so you can work with daylight. You can use frosts or flags or put black drapes down the side. You want to create a tonal range that makes it richer. So the subtleties jump out ever so slightly, but don't leap at you.

MK: You mentioned earlier that you shot your friends rather than models because you were interested in character. I still think that is an important part of your work, even though you work with models more now. How do you work with a model to draw something of this out of them? How do you create character?

PW: Recently when I shot with Joe McKenna [fashion editor and photographic stylist] for *Pop* we made it more like a love story. The model's boyfriend lives in Poland and I said I wanted the pictures to be like a set of postcards that she might send back to him. There was meant to be an emotion from her. It completely varies from job to job, and with the girl.

MK: Is a narrative important?

PW: Not always. I don't generally have a lot of figures in the shot, so there isn't a real narrative between characters. I'd say it's better for a model to express something of themselves and their understanding of where they are and what they are doing.

A Girl of Distinction
Published in *Pop*, autumn/
winter 2005.
You take equipment with you
so you can work with daylight.
You can use frosts or flags or
put black drapes down the side.
You want to create a tonal range
that makes it richer.

Paul Wetherell: Natural light

MK: Do you find that working on location helps in creating this more than working in a studio?

PW: Sometimes you struggle in a studio because you have to make people do things that look or seem artificial because you don't have anything else around you. You can't place them by a tree or get them to lean over a wall or whatever. You have to start making them pose, which I find difficult. When you get someone to pose it takes the naturalness out of it. In a studio it can be much more forced because there is nothing there for the model to relate to.

MK: But as you've already mentioned, on location you need to control the environment you're shooting in.

PW: Yes you have to control it, and as I said you can control daylight by using equipment, by softening light or creating slight shadows, or also in processing and by the way you expose your film. You can't really control the light that is available, but you can give it a different quality or feel. In bright light you might be prone to overexpose your film and then in developing, instead of pushing it, you'd pull it, just so it draws everything back and softens those harder areas. Under flat light you'd go a different way and you wouldn't tend to overexpose it so much, so you get a less dense negative, and then you'd push it in developing to get more contrasts. You can also use different printing papers to give it a different feel. With black-and-white you can choose different contrast papers to give you a slightly harder or softer feel. If you shot in sunlight and you wanted to just make it less harsh, you might overexpose your film, and then pull it slightly in developing, and print it on a flatter grade paper, or maybe a paper with a slight tone in it. It would just soften the whole effect of what you saw when you were there, but it obviously wouldn't physically alter the light.

MK: Do you use digital retouching?

PW: Yes. I think nowadays you have to.

MK: Is that an imperative from the magazines?

PW: The *Self Service* story is all digitally printed, but there is hardly any retouching. Just maybe smoothing slight lines on the face or neck. But there is no real alteration in the printing with this story. There was nothing that was really made that different. But nowadays, yes, you do use digital. Magazines expect and want it. A lot of people are obviously shooting digital. I don't mind shooting digital, but it is a very different thing. I still think film is much nicer. When you do use CMYKs you are pretty much guaranteed you will get the reproduction you see. When you print on paper you can't always guarantee that reproduction. Also, it has to do with time and editing. You can sort it all out and send images around the world via e-mails, and show the client online as it is in progress. It takes out a certain amount of hassle and stress. But it is very expensive still.

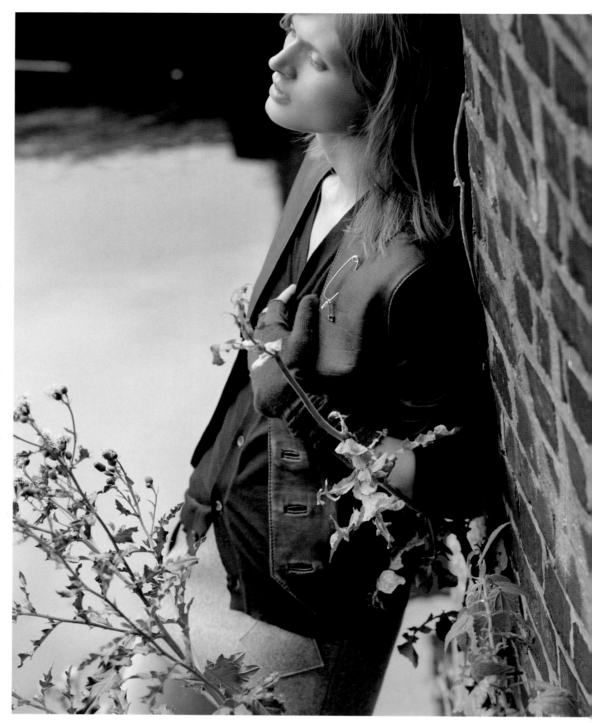

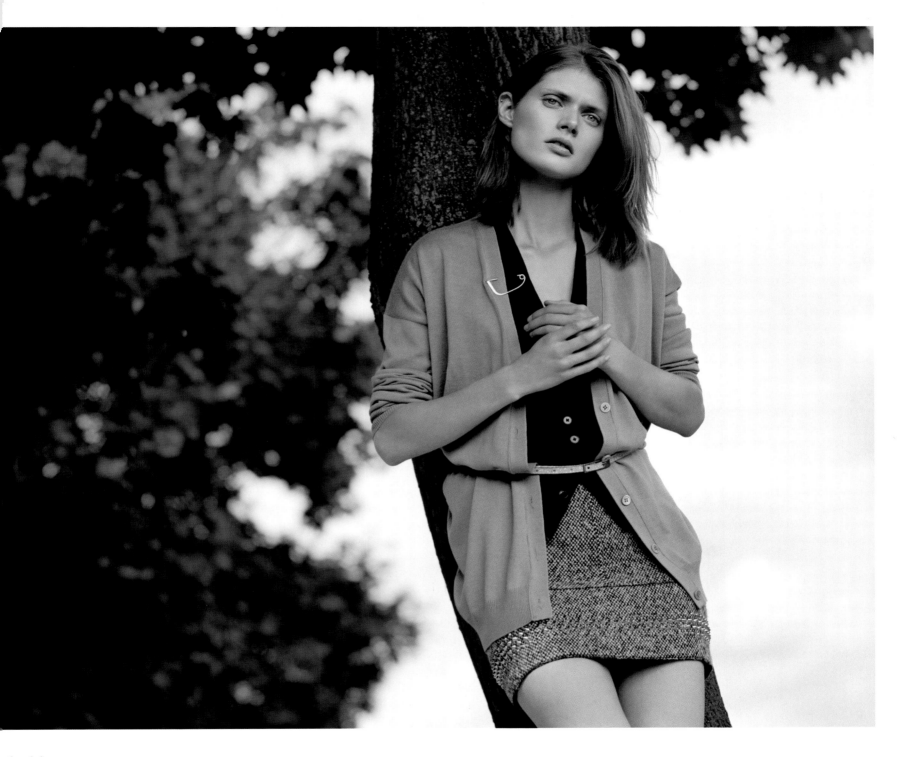

eft and above:
Girl of Distinction
ublished in *Pop*, autumn/
inter 2005.
he model's boyfriend lives
Poland and I said I wanted
e pictures to be like a set
f postcards that she might
end back to him.

Paul Wetherell: Natural light

MK: Tell me if I'm wrong, but some of the subtleties we were discussing about controlling and manipulating light in camera would be slightly different digitally.

PW: I don't think you have as much depth with digital. Part of photography is the craft. Many of the photographers I really admire—people like Emmet Gowin, Imogen Cunningham, Harry Callahan, Edward Weston—wouldn't have been anything without their technique. For example, how do you have a very strong highlight, but still retain details in the shadows and things like that? I think that's something that shouldn't really be lost because if you shoot it digitally, you can do it out of camera. Previously, if you were working in a studio and had to use eight lights, now you might put two on and say, "Well, we can darken the shadows afterward," and I think that is a shame. It takes away some of the craft of photography. I used to do all my own processing and printing so I understand that. I'm not sure that happens now.

MK: How do you process your photographs now?

PW: What I do to them always varies, but I always print at a lab. I have someone there who I've known for a long time who oversees it. I mark down what I'd like a test roll to go through at according to the lighting and the situation, and whether they should be pushed or pulled, and then they judge the negatives for me. The technicians know and understand a good-quality negative and what they can get from it. Sometimes there is a risk, if you overexpose your film and pull it, that it might go slightly thick, or if you are shooting in very low light, that you might get thin negatives, which is a worry. You want someone who can read a negative and let you know if it needs a little bit more. Even though these days you don't print them so much for fashion because they are going digitally, you should still work as though you are printing on paper. You should still aim for the best-quality negative that you can get.

MK: There also seems to be something at odds with a notion of perfection, say smoothing out a line on the neck, and your interest in character. So, for example, in Imogen Cunningham's nudes, part of the quality and interest of the photograph is in the imperfection and our awareness of the graininess of the film shot in natural light. Though she may have used hand retouching, sharpening it up too much would lose something of the magic and effect of the photograph.

PW: It's not as easy to retouch when you are using daylight. It can look very false. You can get carried away with it so you end up with an object, not a person. It's pointless going through a delicate process with daylight to eradicate it afterwards with a digital paintbrush.

MK: Let's get into the L' Esthétique du Hasard story. How did you get the commission?

PW: *Self Service* approached Anna and she asked me if I wanted to do something with her, and I said, "Yes, of course." I've worked with Anna several times before and I know how good she is. I showed her the photograph and the fabrics, and she said she would like to do something in the spirit of a 1980s Ralph Lauren or Calvin Klein advertisement.

MK: Was the casting important in getting this quality?

PW: We had a nightmare. The girl that we had booked pulled out the day before. We had to put the shoot back, and my agent Julie Brown found a new girl. I'd said to her that we were looking for someone like Brooke Shields in the '80s. I liked the idea that she might have quite bushy eyebrows and a handsome face. So Julie had a brief, but she did a fantastic job in finding the girl.

L'Esthétique du Hasard
Published in *Self Service*,
autumn/winter 2004.
There are a lot of different
tones and textures between the
blanket, her dress, and the grass,
even in the Welsh blanket itself.
As a color picture it would have
looked quite confused.

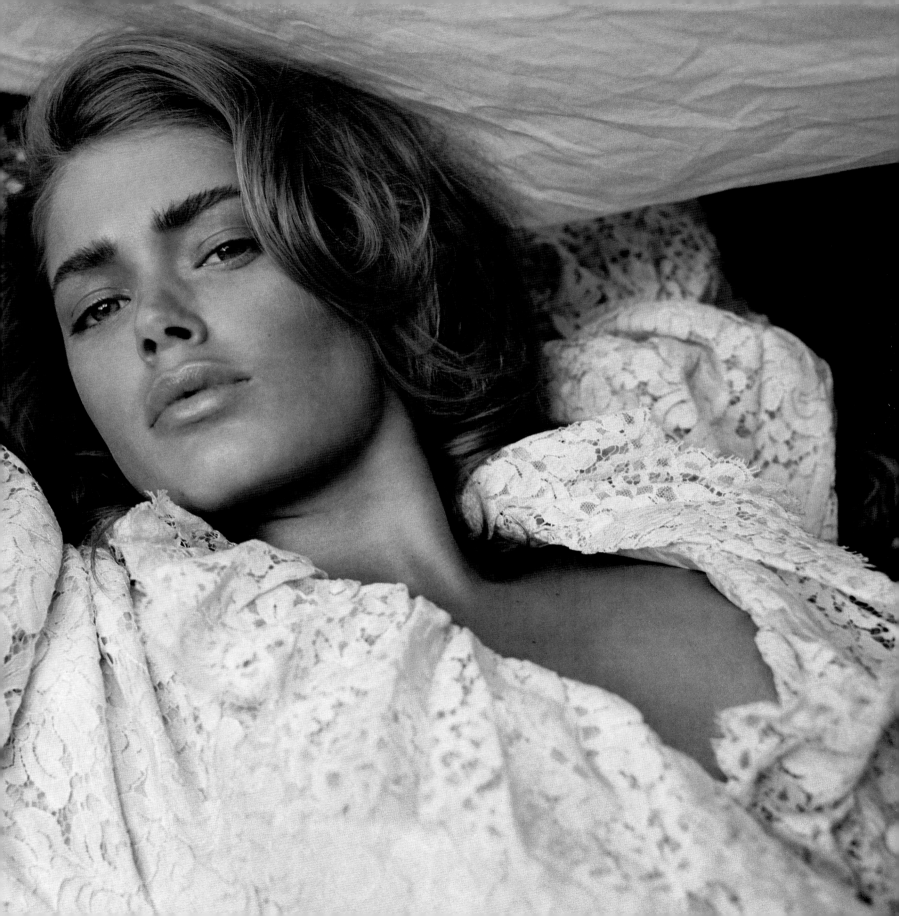

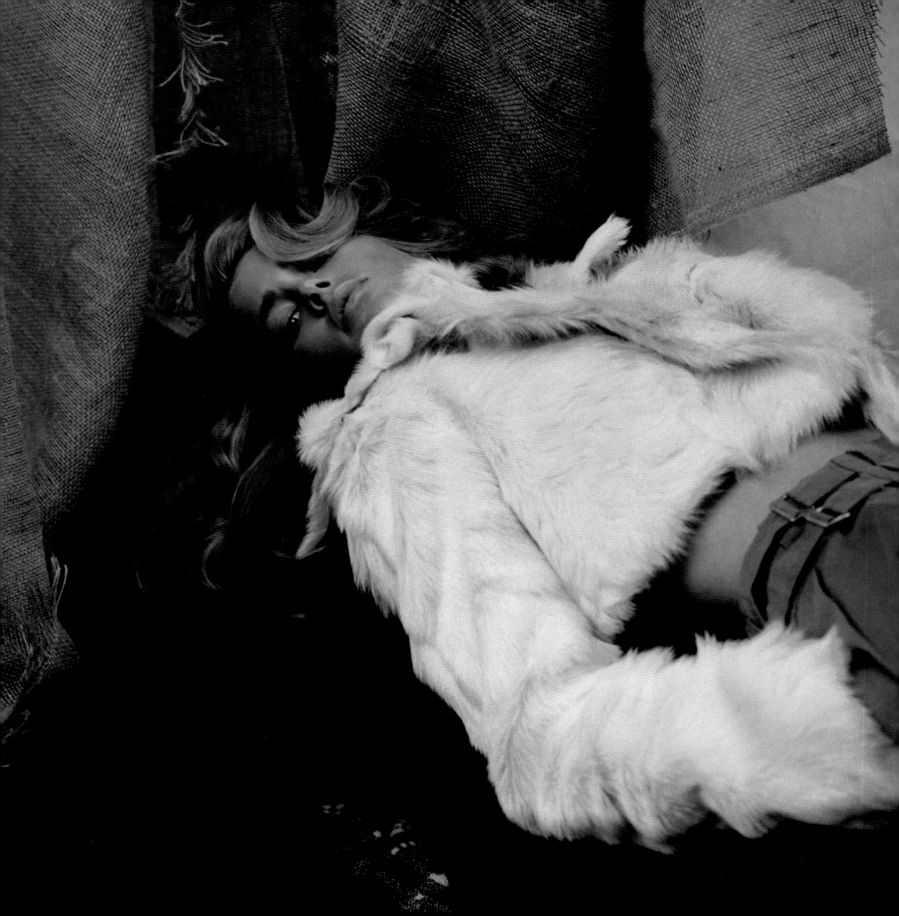

MK: Can you tell me about any other preparations you made before the shoot?

PW: I got the fabrics and then I just started messing about in the garden. I had a Welsh [plaid] blanket and I bought some plain sheets and a few different things just to have a look at them. Some of them didn't work, like the tablecloths that had fruit on them, which ended up looking a bit naff. Using a tonal range of rugs looked better: grays and whites and blacks. Hessian and muslin were good because they have a nice way of hanging. I was fortunate because I got a few girls to come round so I could do some test shoots prior, and set it up so I knew roughly how it would work.

MK: Shooting in black-and-white, then, very much suits the ideas of subtlety of tone and texture in the fabrics.

PW: When you photograph outside, sometimes color contrasts don't work. In these pictures, when you see grass close to the girl's head, it's much better tonal than a big patch of green.

MK: Also, say in the first double-page spread where the light falls off at the edges [see page 164], if there was a lot of color you would lose that effect. Black-and-white seems to allow you to shoot more complex texture.

PW: There are a lot of different tones and textures between the blanket, her dress, and the grass, even in the Welsh blanket itself. As a color picture it would have looked quite confused. You'd have had to bleach areas out, and done something more fancy for it to work. Also, remember that this is shot in my garden. It's nothing special. I think it has the potential to look nasty and cheap in color. Or at least it wouldn't have the same feeling that it does in black-and-white, where they are just a tone. The picture was all about getting textures in the fabrics, from the first moment I saw those Josef Koudelka pictures.

L'Esthétique du Hasard
Published in *Self Service*,
autumn/winter 2004.
The story was all about getting textures in the fabrics, from the first moment I saw those Josef Koudelka pictures.

MK: I think that comes across in Anna's choice of clothes too.

PW: The layers blend in effortlessly. The clothes seem natural within the environment. They don't feel like a different thing.

MK: Did Anna choose elements like the straw hat?

PW: Yes, but strangely enough she was reserved about using it. When she put it around the model's neck I thought it looked good and we should make more of it and photograph it in a way that it became the biggest part of that picture. I don't think Anna was entirely convinced by it, but she ended up liking it. Sometimes you just throw something in and it seems to work.

MK: Did you work with an assistant? What was the team?

PW: There was Anna, and I had hair and makeup stylists, and one photo assistant.

MK: Does your photographic assistant sort out a lot for you, like equipment?

PW: No. I always do it. I find it easier. I don't use a great deal of equipment, generally just flags and silks to control the daylight, so there is very little for them to do. When you're thinking about what you want to do, you work out what you need and you have it in your head, so there is no point telling someone else to do it. An assistant for me is someone who turns up on the day and is fairly quick, and knows straight away what I'm talking about.

MK: Did you shoot Polaroid?

PW: Yes. We started photographing and did a few Polaroids. The model is made up to have a tan to look more wholesome. Also, tans were more fashionable in the '80s. The makeup artist, Sam Bryant, did a fantastic job. We also talked about the eyebrows and wanted to make them quite strong, a bit like Brooke Shields. The tan added to the quality of light and gave more depth to the model, which is nice with the clothes. That all came out of the Polaroids. It's a way of seeing where you're going right and wrong, and what can change. With hair and makeup I think it is of real benefit. It was Anna who suggested that we make her tanned. It's something I would never have thought of. I was a bit wary, but again if she'd been shot in color she would have had this false tan which might have looked more overt rather than healthy.

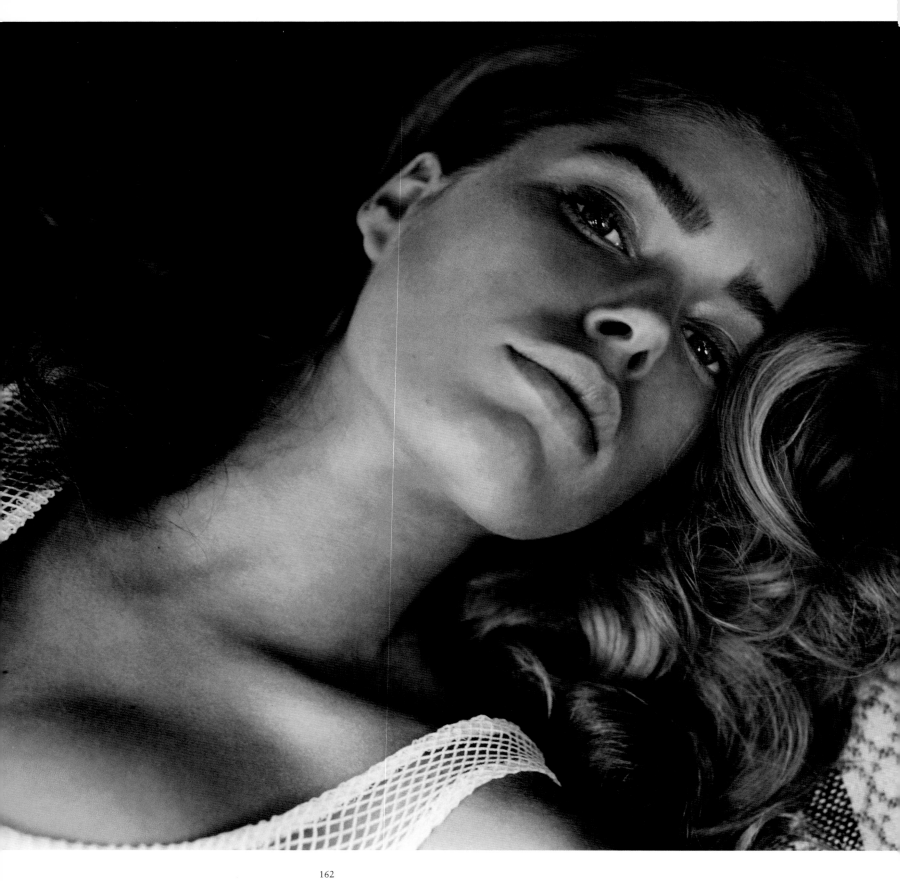

Left and below:
L'Esthétique du Hasard
published in *Self Service*,
autumn/winter 2004.
When you photograph outside,
sometimes color contrasts don't
work. In these pictures, when
you see grass close to the girl's
head, it's much better tonal than
a big patch of green.

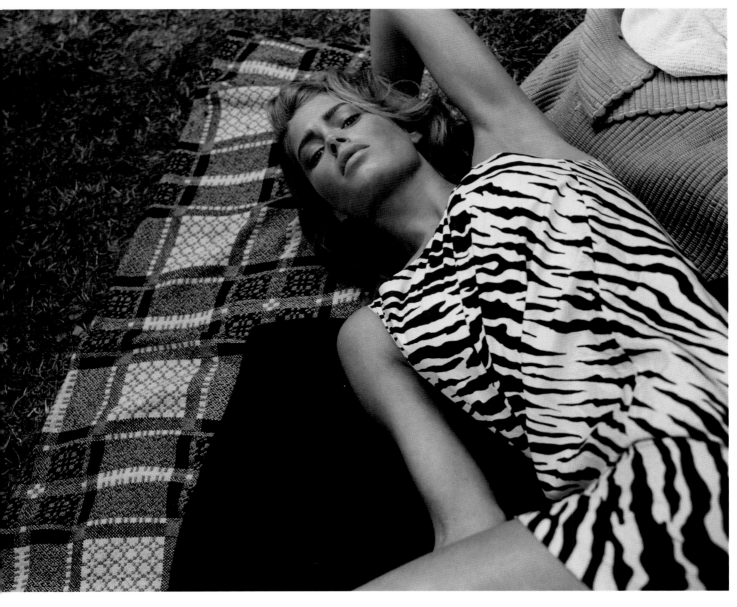

Paul Wetherell: Natural light

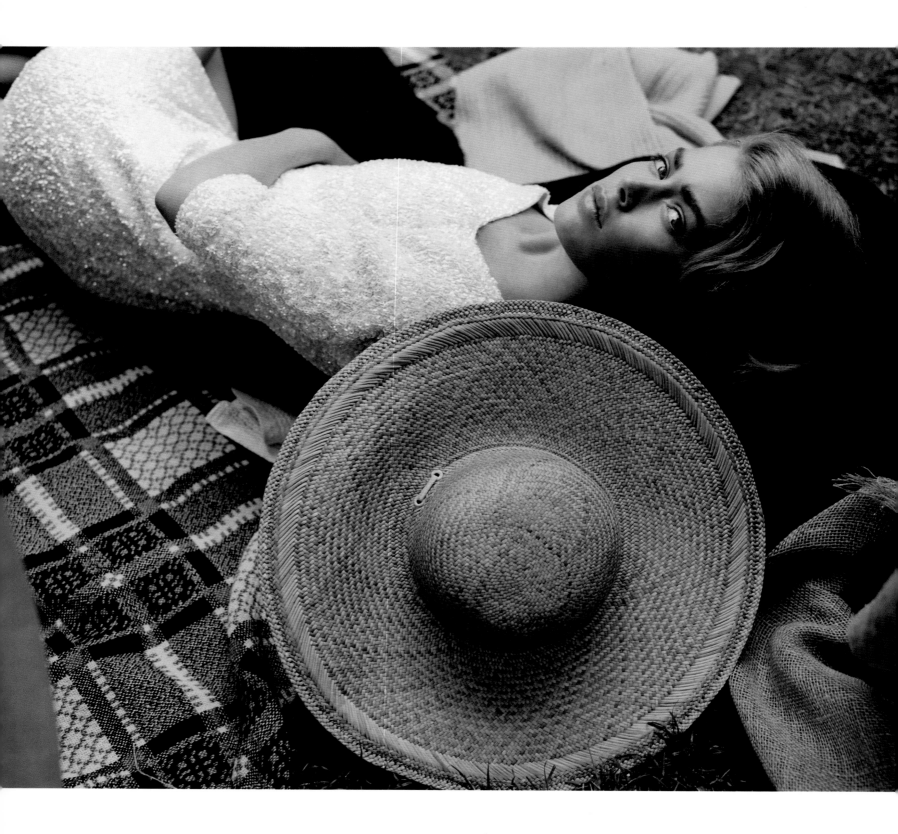

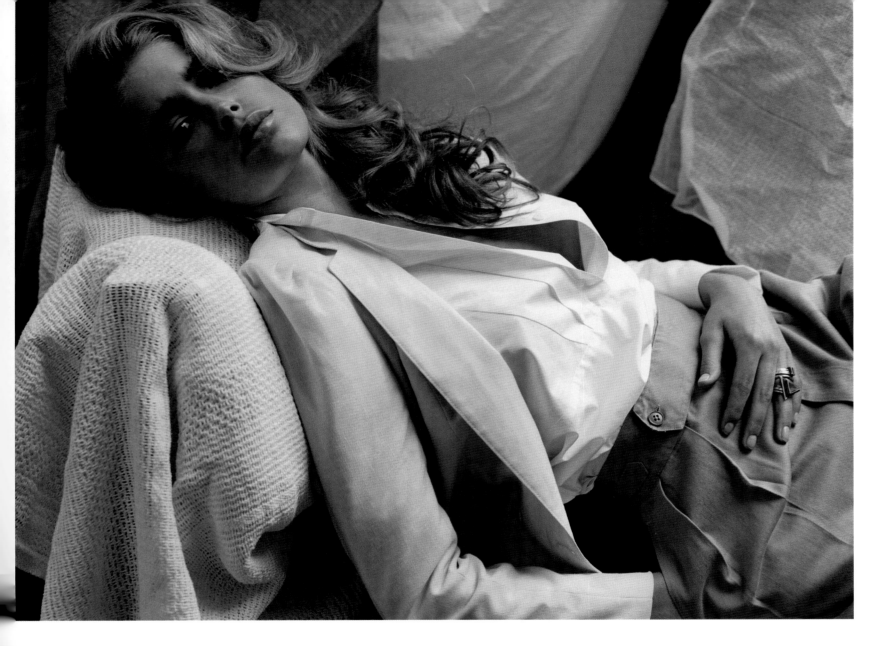

MK: Did that change the way you thought about lighting her?

PW: No, not at all. It made her more dense, which was a preferable thing. It meant I didn't have to pull the film. It meant she stood out in a slightly stronger way than if she'd had paler skin. It made her look stronger.

MK: For one particular photograph [left], you talked about creating a shadow line across her face with the hat. Let's return to look more specifically at what you did with the light.

PW: I put a black flag in. She looks slightly different in that one. It is partly the sequined dress and her hair I think; she looks younger. Putting in that bit of black just strengthens up her jawline. It's a different angle too. A lot of the photos were shot

from below or underneath, which in a way lends a more iconic feel. In the photo where she is in trousers and a shirt [above], we put a frost or silk above the model to take it down slightly, to cut out some top light. It makes it brighter in the foreground than the background, so part of her blouse is more bleached out. There was also a black polyboard coming in at the head, just to give a slight shadow, to absorb the light and give a slight darkening. To soften it. The day that we were shooting, it was very flat light, very cloudy, so in a way the makeup helped. You didn't have to do as much with the light as you normally would. You can use frosts, which are like tracing paper, at different densities in different areas to create a falling of light. As I said, this doesn't affect the light itself, it won't affect your reading, but it just changes the quality you see when you've got the film back.

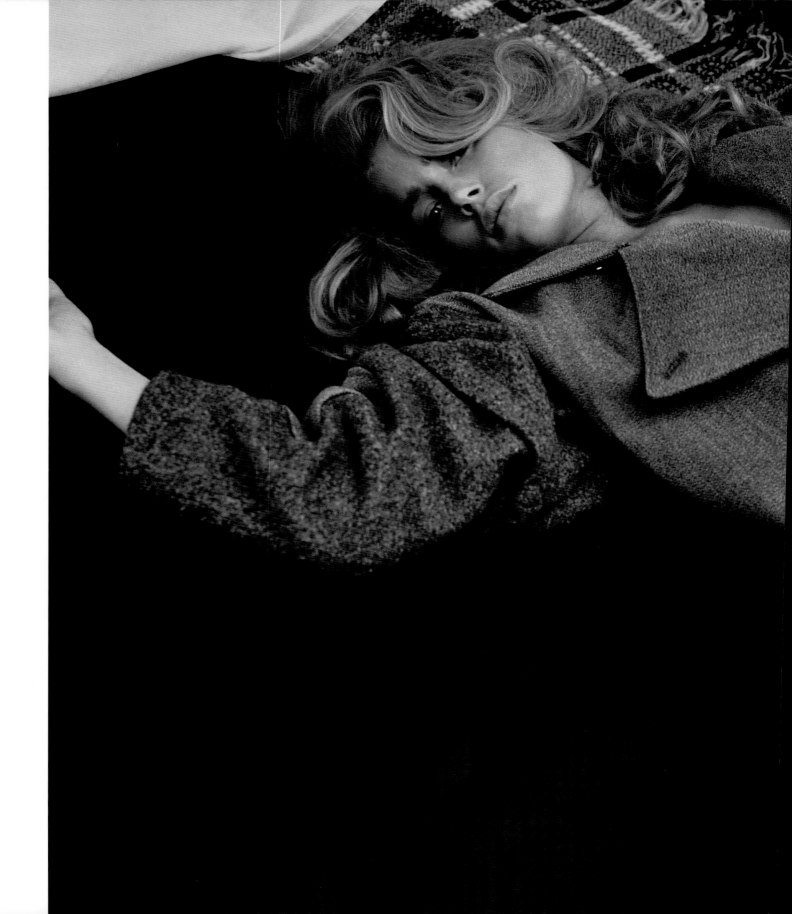

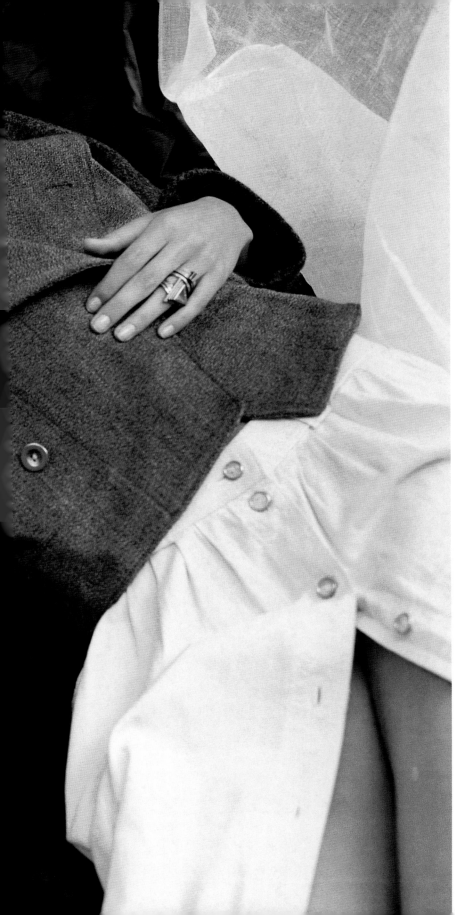

MK: What do you do if it is raining?

PW: When I did the shoot with Joe [McKenna, for *Pop* magazine] it rained. You just have to sit around and wait. You are very unlucky if it rains all day. I can't remember the last time it rained all day! Then you just have to shoot much quicker. You can do Polaroids and get the hair ready and try to get everything right. So with Joe it was shot in about four hours because it rained all morning.

MK: How quickly do you shoot? Do you shoot more quickly on location than in a studio?

PW: You have to because you are losing light and you are not at liberty to shoot to the middle of the night. Shooting daylight, you tend to be up quite early because the quality of light changes as the day goes on.

MK: Is it different shooting fashion advertising from editorial?

PW: With advertising there is a certain number of pictures you need to do in a day, and there are outfits that you have to shoot. You have to show a lot more of the clothes and you can't just say, "Let's not do that look because we don't like it." Sometimes there is very little difference, but sometimes it is more difficult. For example, if you have to shoot 12 pictures a day for four days it makes it hard to retain creative control.

MK: Were you happy with how the story looked in the magazine?

PW: Ezra at *Self Service* did a very good job. Sometimes you can get completely misinterpreted through a layout. Ultimately you lose control to a certain degree at that stage. Sometimes a magazine will drop your favorite picture or something. I've got nothing but praise for the layout. It looked different from how I had envisaged it, so it was a very nice surprise, and added to what I'd done.

L'Esthétique du Hasard
Published in *Self Service*,
autumn/winter 2004.
I don't generally have a lot
of figures in the shot, so there
isn't a real narrative between
characters. I'd say it's better
for a model to express something
of themselves and of their
understanding of where they
are and what they are doing.

Paul Wetherell: Natural light

For this image, the camera was set below the eyeline, and a silk screen was positioned above the model to take the light down slightly, and cut out some of the top light. This has the effect of making the foreground brighter than the background, and in this particular image, of bleaching out part of the blouse. Wetherell also wanted to add a slight shadow and soften the light. To do this, he placed a black polyboard at the model's head to absorb the light and achieve a slight darkening effect.

Wetherell's essentials

- Tripod
- Mamiya RZ67 Body
- Light meter
- 140, 110, and 180mm lenses
- Reflectors
- Black flags

Specification

CAMERA: **Mamiya RZ67 with 110mm lens and Polaroid back**

LIGHT: **Natural light only**

FILM: **Kodak TRI-X ISO 400 rated at ISO 200, processed as normal**

EXPOSURE: **Between 1/60 and 1/125 sec, between f/11 and f/16**

Suggested reading

Emmet Gowin: Photographs, EMMET GOWIN, Bullfinch Press, 1991

Exiles, JOSEF KOUDELKA, Thames & Hudson, 1998

Imogen Cunningham: On the Body, RICHARD LORENZ, Bullfinch Press, 1998

Lee Friedlander: Nudes, LEE FRIEDLANDER, Jonathan Cape, 1991

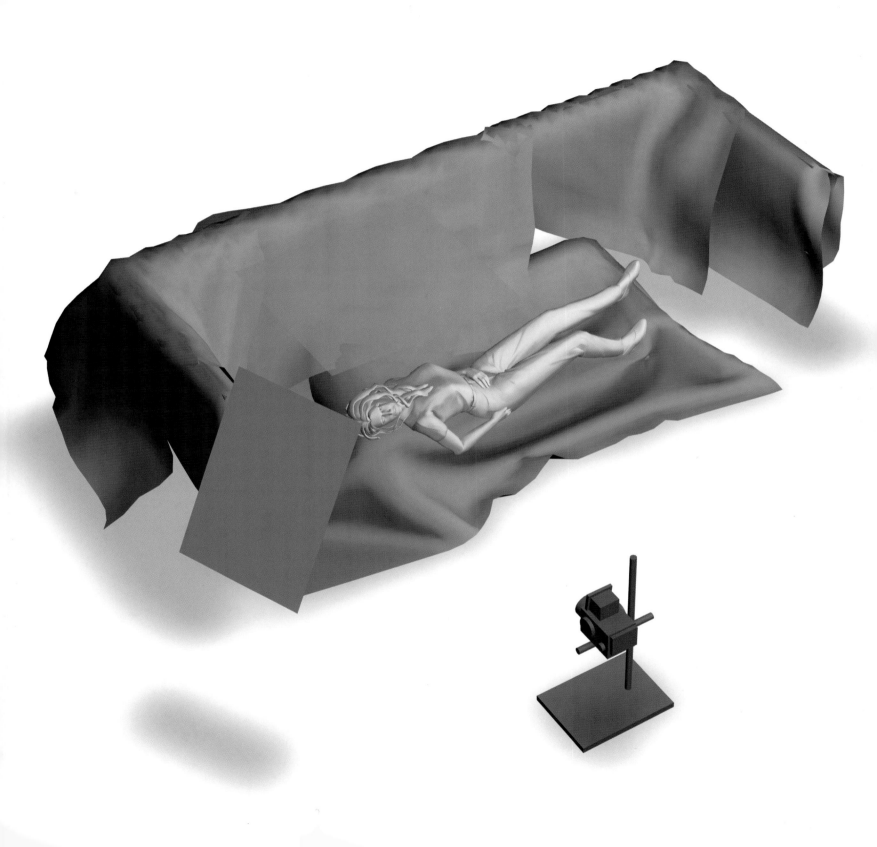

Directory

John Akehurst

Feature details
The Egg for *The Face*
Liberty Ross for *Harper's Bazaar*
Lily Cole for Chinese *Vogue*

Management/Contact details
Camilla Lowther management
www.clmus.com

Richard Bush

Feature details
Crinières (with Eugene Souleiman) for *Numéro*
Makeup story (with Petros Petrohilos) for *Vogue* Nippon
A Celebration of Color (with Val Garland) for *Vogue* Nippon

Management/Contact details
Untitled*
www.untitled.uk.com

Elaine Constantine

Feature details
Elson Street commissioned for *Pop*
Advertising campaign for American Eagle Outfitters

Management/Contact details
Marco Santucci
www.marcosantucci.com

Warren Du Preez and Nick Thornton Jones

Feature details
Aria for *BIG*
Cover for *Dazed & Confused*
Worldwide press campaign for *Björk: Greatest Hits* launch

Management/Contact details
Details retained

Jason Evans

Feature details
Grace Abounds for *i-D*

Management/Contact details
www.thedailynice.com

Dan Holdsworth

Feature details
Geographics: A project for Middlesbrough Institute of Modern Art (MIMA)

Management/Contact details
M.A.P.
www.mapltd.com
www.danholdsworth.com

Adam Howe

Feature details
Womenswear for *i-D*

Management/Contact details
M.A.P.
www.mapltd.com

Alexi Lubomirski

Feature details
Cate Shines for *Harper's Bazaar*
Jennifer Aniston's New Life for *Harper's Bazaar*
Demi Moore's Next Act for *Harper's Bazaar*

Management/Contact details
Management + Artists
www.managementartists.com

Toby McFarlan Pond

Feature details
Adidas worldwide advertising campaign
Her Dark Materials for *Pop*
Yield to the Night for *Pop*
Strange Beauty for *Pop*

Management/Contact details
M.A.P.
www.mapltd.com

Sølve Sundsbø

Feature details
Bloom for *V*
Summer Whites for *V*

Management/Contact details
Details retained

Paul Wetherell

Feature details
L'Esthétique du Hasard for *Self Service*
A Girl of Distinction for *Pop*

Management/Contact details
M.A.P
www.mapltd.com

Credits

John Akehurst

Photographer's portrait
Photographer: Immo Klink

The Egg
Photographer: John Akehurst
Stylist: Charlotte Stockdale
Hair: Malcolm Edwards
Makeup: Val Garland

Liberty Ross
Photographer: John Akehurst
Stylist: Charlotte Stockdale
Hair: Malcolm Edwards
Makeup: Val Garland
Model: Liberty Ross

Lily Cole
Photographer: John Akehurst
Stylist: Emily Barnes
Hair: Duffy
Makeup: Kelly Cornwell
Model: Lily Cole

Richard Bush

Photographer's portrait
Photographer: Immo Klink

All other images
Photographer: Richard Bush

Elaine Constantine

Photographer's portrait
Photographer: Immo Klink

Welcome Home
Photographer: Weegee
Weegee, Welcome Home, from the Hulton Archive
collection, courtesy of Getty Images

All other images
Photographer: Elaine Constantine

Warren Du Preez and Nick Thornton Jones

Photographers' portrait
Photographer: Immo Klink

Aria
Photographers: Warren Du Preez and Nick Thornton Jones
Stylist: Maria Virgin
Hair: Dejan at Premier
Makeup: Tanya Chianale
3-D artist: Václav Čižkovský
Retouching: Robert Taylor
Models: Natalia at Take 2 Model Management,
Maria at ICM Models

Dazed & Confused
Photographers: Warren Du Preez and Nick Thornton Jones
Stylist: Katy England
Hair: Alan Pichon
Makeup: Sam Bryant
Model: Erin O'Connor

Björk: Greatest Hits
Photographers: Warren Du Preez and Nick Thornton Jones
Stylist: Raven
Hair: Shop Lifter
Makeup: Andrea

Jason Evans and Adam Howe

Photographers' portrait
Photographer: Immo Klink

All other images
Photographer: Jason Evans
Stylist: Adam Howe

Dan Holdsworth

Photographer's portrait
Photographer: Immo Klink

Landscape images
Photographer: Dan Holdsworth

Publication images
Middlesbrough Institute of Modern Art (MIMA)
Photographer: Dan Holdsworth
Art director: YES
Copywriter: Paul Shepheard

Alexi Lubomirski

Photographer's portrait
Photographer: Immo Klink

All other images
Photographer: Alexi Lubomirski

Toby McFarlan Pond

Photographer's portrait
Photographer: Immo Klink

Adidas advertising campaign
Photographer: Toby McFarlan Pond
Agency: TBWA\Chiat\Day
Art director: Sean Flores

Her Dark Materials
Photographer: Toby McFarlan Pond
Prop stylist: Emily Hill
Retoucher: Rob Willingham
Fashion editor: Sam Willoughby

Yield to the Night
Photographer: Toby McFarlan Pond
Prop stylist: Emily Hill
Retoucher: Rob Willingham
Fashion editor: Sam Willoughby

Strange Beauty
Photographer: Toby McFarlan Pond
Modeler (head construction): Toby McFarlan Pond
Prop stylist: Emily Hill
Retoucher: Rob Willingham
Fashion editor: Sam Willoughby

Sølve Sundsbø

Photographer's portrait
Photographer: Immo Klink

Bloom
Photographer: Sølve Sundsbø
Stylist: Anastasia Barbieri
Hair: Sam McKnight
Makeup: Maria Olsson
Model: Polina Kouklina at Take 2 Model Management

Summer Whites
Photographer: Sølve Sundsbø
Stylist: Anastasia Barbieri
Hair: Malcolm Edwards
Makeup: Maria Olsson
Set: Stevie Stewart
Model: Lily Cole

Paul Wetherell

Photographer's portrait
Photographer: Immo Klink

Koudelka image
Photographer: Josef Koudelka
United Kingdom. Wales. 1977. © Josef Koudelka.

L'Esthétique du Hasard
Photographer: Paul Wetherell
Hair: Paul Hanlon at Julian Watson Agency
Makeup: Sam Bryant at Holy Cow, using Mac cosmetics
Photographer's assistant: Simon Bremner
Model: Doutzen at Viva
Stylist: Anna Cockburn
Stylist's assistant: Alison Elwin

A Girl of Distinction
Photographer: Paul Wetherell
Fashion editor: Joe McKenna
Hair: Samantha Hillerby
Makeup: Lisa Butler
Manicure: Glenis Baptiste
Model: Malgosia Bela
Photographer's assistants: Giles Price and Simon Farrant
Fashion assistants: Michael Philouze and Anya Ziourova
Hair assistant: Michelle McQuillam

Acknowledgments

I am indebted to the photographers whose work is the basis of this book. All were generous with time, answered my questions, and even agreed to be photographed themselves. I would particularly like to thank Jason Evans and Adam Howe whose support of the original proposal meant a great deal.

Special thanks to Immo Klink (www.immoklink.com) who took up and carried out the portrait commissions with flair, commitment, and enthusiasm; Lindy Dunlop and the team at RotoVision who have been supportive and creative commissioners; Eddie Otchere who worked hard to interpret interviews and images for the rendered lighting setups; and Julie Brown, Neil Cooper, Gregorio Pagliario, Rebecca Roberts, Stuart Searle, Eleanor Struth, and all at M.A.P London and New York whose expertise and friendship have contributed significantly to this book.

I am very grateful to the agents and assistants who were an incredible help in arranging interviews and obtaining images: Paula Ekenger at Claire Powell; Nick Bryning and Quinn D. Buggs at Management + Artists (New York); Marco Santucci and Victoria Volckman at Marco Santucci; Self Service; Emily Yomtobian at PMK/HBH; Rachel Elliston and George Miscamble at Untitled*; Nick Pavey, assistant to Elaine Constantine; and Nicole Stilman, assistant to Warren Du Preez and Nick Thornton Jones.

For encouragement, help, and belief thanks to:
Susan Bright, Tony Clark, Georgina Colby, Tom Comrie, Charlotte Cotton, Mark Dyson, Pamela Clelland Gray, Nathan Firth, Heidi Grivas, Nancy Hanley, Hugh and Anne Hazard, David Head, Ben Hehir, David Hughes, Tom Hunter, Anthony Luvera, eX de Medici, Jason Pietra, Katrina Power, Giles Price, Andrew Sayers, Louise Shannon, Vanessa Tierney, my very supportive colleagues at the National Portrait Gallery, London, and most of all Mum, Gezza, Cath and Dim, Tom and Deb, Benjo, Mary, and the three little ones.